The Heritage Game

The Heritage Game

Economics, Policy, and Practice

**ALAN PEACOCK
AND
ILDE RIZZO**

OXFORD
UNIVERSITY PRESS

OXFORD

UNIVERSITY PRESS

Great Clarendon Street, Oxford ox2 6DP

Oxford University Press is a department of the University of Oxford.
It furthers the University's objective of excellence in research, scholarship,
and education by publishing worldwide in

Oxford New York

Auckland Cape Town Dar es Salaam Hong Kong Karachi
Kuala Lumpur Madrid Melbourne Mexico City Nairobi
New Delhi Shanghai Taipei Toronto

With offices in

Argentina Austria Brazil Chile Czech Republic France Greece
Guatemala Hungary Italy Japan Poland Portugal Singapore
South Korea Switzerland Thailand Turkey Ukraine Vietnam

Oxford is a registered trade mark of Oxford University Press
in the UK and in certain other countries

Published in the United States by Oxford University Press Inc., New York

© Alan Peacock & Ilde Rizzo 2008

The moral rights of the authors have been asserted
Database right Oxford University Press (maker)

First published 2008

British Library Cataloguing in Publication Data
Data available

Library of Congress Cataloging in Publication Data
Data available

Typeset by SPI Publisher Service, Pondicherry, India
Printed in Great Britain
on acid-free paper by
Biddles Ltd., King's Lynn, Norfolk

978-0-19-921317-7

1 3 5 7 9 10 8 6 4 2

Contents

Preface

The origin of this book requires explanation—cultural heritage and economics sound like strange bedfellows.

In 1970 Alan Peacock, then on leave as a Research Professor in Public Finance at the Einaudi Foundation, Turin, used to walk to his office along the Via Lagrange, named after the mathematician, Luigi Lagrange, whose 'undetermined multiplier' is a well-known feature in texts on mathematical economics. After passing and bowing to the statue of the great man, he would soon pass a decrepit-looking *palazzo* which boasted a large shield in shabby condition, it being just possible to decipher the name, *Cavour*. Enquiry confirmed that the palazzo had been the home of this famous figure in Italian history. Alan was shocked at its neglect, particularly as, close at hand, there was a splendid carefully kept building adjoining the main square, on which was a beautiful shield commemorating the vinicultural achievements of Signor Carpano, the inventor of vermouth. On reaching his office, Alan wrote an article, carefully drafted so as not to give offence to his host country, using this contrast in the shields' condition to argue for some form of public intervention to preserve the past in the interests of present as much as future generations. He feared that he might nevertheless be accused of ingratitude and politely asked to leave the country, particularly as the article appeared in *La Stampa*. Clearly he had misread the Italian mind. One curious consequence of the article was that the firm of Carpano wrote in some embarrassment to him for they actually owned the *Palazzo Cavour*, clearly believing that he knew this already! As it happened, nothing was done, which was the general expectation, although some kind of attempt has been made to rectify matters now nearly 40 years later. Between times, Alan's interest in cultural economics extended to the production of one of the first economic analyses of heritage policy given as the Keynes Lecture at the British Academy in 1994.

This story illustrates a common phenomenon, namely that a collective interest in the provision of some good or service, in this case the preservation of a building with historical associations and which is perceived to benefit individual citizens, may generate a demand for some form of government action, but not sufficient incentive for those who demand it for any action to be taken. Economics can be sensibly employed to explain why this happens and what is done and can be done and by whom in order to formulate government policy.

It has become increasingly apparent that the cultural heritage of Sicily represents a major element in the extraordinarily rich legacy of the past in Italy, and has an immense appeal to scholars. The growth of prosperity and educational advances in Western countries have added to the pressure to present the Italian built heritage and historical artefacts as part of cultural tourism and the 'materialization' of culture has grown apace against considerable competition from other European countries. In the case of Sicily an additional consideration has been that the actual and potential stock of physical reminders of its fascinating past is of such a magnitude in cities, towns, and even villages, that historic buildings, other than outstanding constructions, such as the Graeco-Roman theatre in Taormina and its counterpart in Siracusa, may simply have to remain neglected or demolished unless they can be adapted for modern use.

Ilde Rizzo, as well as becoming a specialist in cultural economics, became closely engaged in this particular Sicilian dilemma in a rather remarkable way. One of Catania's outstanding examples of cultural heritage is the Benedettini Monastery—once one of the largest in Europe—which in its long history represents, as many outstanding European ecclesiastical edifices do, a stratification of architectural styles from the sixteenth century, and the location of important historical events. Latterly it was owned by the Municipality who presented it to the University of Catania. The University was then faced with the costs of restoring and adapting it to modern use while preserving it according to government regulations based on 'best practice' rules provided by its architectural and historical advisers. Ilde, then Vice Rector of the University of Catania, took a particular interest in how economic analysis could be used to appraise the practical results. The reader of this work, whether or not an economist, may find this appraisal, written with Professor Giacomo Pignataro, a useful introduction to how the interests of economists can be extended to this rather unusual area of discourse.

Preface

Over the years, Alan and Ilde, professionally engaged in the economics of public finance and public policy have been collaborating in several different ways, usually resulting in joint articles, but their latest venture has an even more direct bearing on the emergence of this book. The Scuola Superiore of the University of Catania began, under Ilde's leadership, a Master's Degree in the 'Economics of Conservation and Valorization of Cultural Heritage' which was one of the first of its kind to embody courses on Economics. Ilde was able to draw on the advice and professional participation of a well-known archeologist, Professor Benedetto Benedetti of Scuola Normale di Pisa, deeply involved in technological applications to cultural heritage and Alan agreed to give a course on the economics of heritage. Most of the students who have completed the course had been graduates in art history and architecture for whom economics represented an incursion into strange and potentially hostile territory, much of this being a reflection of their previous professional training. We thought it worth trying to cure the 'dialogue of the deaf' that all too frequently arises from a lack of understanding of what economics can contribute to cultural heritage policy. Economists themselves must take a large part of the blame for this, a reflection of the decline in the professional kudos attached to being a mere communicator of received wisdom.

Although this book is based on the authors' own perceptions of how economic analysis can be used to explain and influence public policies towards cultural heritage, it owes a great deal to help received over the years from a number of scholars and activists who are sympathetic to our general mission (see Acknowledgements below).

Acknowledgements

This book could not have been completed without the help and encouragement of a considerable number of colleagues engaged in studying cultural economics and the economics of heritage in particular, not to mention those engaged in the sensitive and difficult tasks associated with preserving the past. We have acknowledged the contribution of some of them in the text, and are glad to do so, but we would be less than generous if we confined our thanks only to those whose work receives specific mention.

First of all, there are our professional colleagues of long standing who must include Will Baumol, Françoise Benhamou, Mark Blaug, Stephen Creigh-Tyte, Francesco Forte, Bruno Frey, William Grampp, Michael Hutter, Arjo Klamer, Gianfranco Mossetto, Dick Netzer, Rick van der Ploeg, Mark Schuster, David Throsby, and Ruth Towse.

Both authors wish to recognize the help received in connection with their specific contributions. Ilde is fortunate in having colleagues who are working in closely related fields in her department, creating a stimulating environment and, while recognizing her indebtedness to all of them, wishes to acknowledge especially the fruitful and thoughtful collaboration with Emilio Giardina, Isidoro Mazza, and Giacomo Pignataro as well as the useful discussion with Tiziana Cuccia on contingent valuation. A special thank-you is due to Anna Mignosa who, on the grounds of her extensive and updated knowledge of the literature as well as of official documentation, has been a precious source of information and useful advice. Ilde also wishes to acknowledge the multidisciplinary stimulus from her interaction with the students of the Master in 'Economics and Valorization of Heritage' held at the Scuola Superiore di Catania and discussions with some of the colleagues teaching in the Master, namely Benedetto Benedetti, Franco Niccolucci, Paolo Paolini, and Ezra Zubrov, who have broadened her perspective

of heritage policy, largely as a result of their different professional backgrounds.

Alan's interest in heritage is certainly due to living for some years in the cathedral city of York, and he wishes to pay tribute to two colleagues, internationally known for their writings and professional skills in historical preservation: Bernard Feilden and Pat Nuttgens. He has benefited greatly from the advice and encouragement over a number of years of Gerald Elliot, John Graham, Martin Kemp, Stephen Lloyd, David Sawers, Charles Waterson, and Basil Yamey. Not only have they directed his steps towards issues that would not otherwise have been considered but have not thought it inappropriate for economists to poke their noses into cultural matters.

Both authors appreciate the considerable trouble taken by Giusi Santagati and Lindsay Kesal in the preparation of our manuscript and with having to cope with several revisions (the translation of our work into print and its emergence in the outside world was in the very capable hands of Sarah Caro, Commissioning Editor for Economics, Oxford University Press.

The obvious problems of distance (Edinburgh–Catania is 1531 miles!) were overcome through the welcome support of the University of Catania. Latterly we held our final 'bargaining sessions' 'halfway' that is to say in London. Alan, as a Fellow of the British Academy was able to take advantage of the Academy's scheme for providing accommodation for research meetings at their headquarters, a most welcome arrangement. We must also thank The Royal Society of Edinburgh for help in financing a visit by Ilde to Edinburgh under their international programme.

Finally, although we have followed as strictly as possible the rules and conventions in regard to copyright, we have been unable to locate the 'discoverer' of the text in the Appendix to Chapter 9, described as a 'British Art Historian'—despite every attempt to do so. It would be convenient if this were a subterfuge invented by ourselves, but that is not so. If the real author were to come across this example of his/her wit and humour, we would be only to glad to acknowledge in writing our debt to him or her.

Introduction

Purpose of the book

Our purpose in writing this book is to attempt to outline the contribution economics can make to the present public concern to conserve historic buildings and manuscripts, pictures, and other artefacts representing a country's cultural patrimony. This concern is not merely a reflection of the appreciation and enjoyment of such patrimony by present generations but the importance that they attach to their country's cultural achievements and the satisfaction derived from making its benefits available to their descendants. We identify this patrimony as our 'cultural heritage' in order to distinguish it from 'natural heritage', that is to say the equivalent interest in and concern for the protection of the physical environment. Of course, this does not provide the reader with a precise definition of cultural heritage. We might even be accused of being elitist now that the term culture is increasingly used in a much wider sense of embracing every aspect of the legacy of traditions of humankind.

The assimilation of such a heterogeneous list of artefacts, moveable or immoveable, may inspire some etymological criticism. Although we are following a fairly well-established conventional view of their custodians, we shall argue later that an economic analysis offers support to the idea that they are worth grouping together.

The main challenge to us is whether we can persuade both those who have a special part to play in nurturing cultural heritage and those who support their efforts, that a knowledge of how economists think offers something more than a different point of view but also some useful tools. We try to show how economics can be used to analyse and evaluate different institutional arrangements, mainly by reference to Britain and Italy. The choice is not affected by the patriotic feelings of the authors since these two countries offer evi-

dence of major institutional differences, with relevant implications for the design and the implementation of heritage policies and, for this reason, will be used as examples of 'polar' cases in the heritage field.

We therefore hope that we can offer ideas of interest to professional historians, archaeologists, architects, and surveyors of historical properties who all work to identify, prepare, and preserve both the built and moveable heritage and also those responsible for administering the services that the public have increasingly come to enjoy. Although not addressed particularly to fellow economists, we believe that those unfamiliar with cultural economics but who wish to transfer their skills to the analysis of the economic problems of preserving the past may have their entry to this field made easier by reading this book.

There is a temptation in studying heritage to be distracted by related areas concerned with art, notably the possible conflict between promoting new artistic endeavours rather than preserving past ones, and, likewise, the place of heritage cultural policies within the framework of public interest in cultural 'industries' in general. Obviously, we will make reference to such matters, but they must not lead us away from our central concerns. The Reading Lists at the end of each chapter are intended to help here.

This is not a work of scholarship dutifully garnished with learned footnotes carefully indicating source material, but it is based on the fruits of scholarship, including our own. We have thought it more useful for the reader if we provide a guide to further reading after every chapter, with commentary on their content. We have also provided a list of our own 'scholarly' contributions that might be worth consulting, although it is likely to be more useful as evidence to our fellow economists that we know what we are talking about! We have benefited enormously from discussions with close colleagues who have been in the forefront of the development of the burgeoning literature on the economics of heritage. We have also been in touch with several directors of museums and galleries and those in charge of historical buildings who are increasingly aware that economists are interested in what they are doing, even if some of them might regard us as a modern manifestation of 'the barbarians at the gate'! We try to dispel this impression. None of those to whom we are indebted is committed to our own assessment of what a heritage policy should contain.

Plan of the book

On perusing the broadsheets and periodicals one may experience the uneasy feeling that economists are on the watch for opportunities to turn their minds and skills to the exposure of the cultural professions in order to prove that their leading figures are just like other influential members of society and therefore no better and no worse than thrusting entrepreneurs in the manufacturing and financial sectors. It is perfectly true that economists study human behaviour and how it is translated into action within the constraints that limit what individuals can achieve. That attracts the suspicion that they will treat us all as specimens to be observed as far as possible under experimental conditions, and that they will try to replicate the kind of conditions for experimentation that apply to rats in cages.

By contrast, in the field of heritage preservation, there have been businessmen who have been appointed Trustees (or the equivalent) of national museums and galleries in order to instill some commercial sense into the management who have become the most ardent supporters of government funding on a lavish scale without reference to the kind of cost control that they would consider appropriate in their own corporation. They become apologists rather than advisers. Dennis Robertson, friend and rival of Keynes, used to say that economists have at least the advantage of being able to have dinner with their subject matter but this is no guarantee that this will redress the balance between sympathy with industrial and cultural leaders and the gaining of knowledge about how they behave. Despite these hazards, we place considerable emphasis on the importance of understanding and explaining the motivation of those who 'supply' and 'demand' heritage services.

We begin with an account of our perception of the 'nature and significance' of economics (Chapter 1). The economic columns of the financial press see professional economists as being in the business of making prophetic utterances on the future of the domestic and world economy and that it may be claimed that they are better—though not very good—at this than other commentators. However, one must always bear in mind that any insight into economic affairs rests on initial assumptions about *individual* actions and how these are conditioned by individuals' opportunities to use their resources in a way which conforms to their individual objectives. Individual

objectives do not change but the circumstances that they confront in order to achieve their objectives certainly do. Thinking a little ahead, those whose own welfare depends on serving the public to the best of their ability while constrained by the resources available to do so and their desire to preserve their professional reputation, such as professional historians who direct museums and galleries or supervise preservation, are subject to very different constraints. These constraints depend on whether the funding to finance their services comes directly from charges or private donations or, on the other hand, from government expenditure financed by taxing the incomes (or goods and services) of the citizenry. As the latter method is now of cardinal importance in mature democracies, we have to pay special attention to the network of transactions between cultural organizations providing access to heritage and the ultimate source of their resources. Furthermore, we must identify the conditions governing the award of public money—for example whether an award is a loan or a grant and the regulations attached to any such award.

An important preliminary decision had to be taken about whether or not we should simply describe and analyse the heritage 'industry' and the relative roles of the private and public sectors in influencing its scope and development. We have taken the plunge and in Chapter 2 offer the value judgement that heritage services are provided to benefit the 'consumers', that is those who seek to enjoy those services, and that it is they who are the best judges of their own interests. That does not preclude those who hope to benefit from heritage services from seeking information and advice from arts experts which will improve their understanding and enjoyment of this form of cultural experience, and in the course of this process their preferences may change. The aim of maximizing the welfare of consumers may itself entail action by the public authorities to help finance or even provide heritage services. If authorities are further required to improve the level of information provided to and the understanding of consumers, this may also lead to further action.

Before considering how methods of financing affect the decision making process in the provision of heritage services and the ability to satisfy demand, we think it sensible to offer some perspective on the place of these services alongside expenditure on the arts and culture in general and how this differs between countries. We have clear ideas about how this can be done statistically. However, we also have to admit to the reader that policy makers who collect statistics for this

purpose are badly served and are themselves unclear about how to link the information needed with the policy instruments that they hope to use to influence the pattern of cultural services. In the experience of the authors, as specialists in public finance and occasional policy advisers, this is not uncommon in government circles and a similar story can be told about relating data collection to policy requirements in several major areas where governments seek control over the economy (see Chapter 3). However, we can at least offer the reader some insight into why the complications of policy making begin with the apparently uncontroversial matter of what data to collect. This is not entirely a matter of politics. As statistical resources (like other resources) are limited, the professional requirements of financial control through the auditing of the accounts of government-supported cultural institutions may conflict with the economists' perception of methods of ensuring their efficient operation which require data collection of a different kind.

As well as address the issue of quantitative information, our study will considering how to identify the main economic characteristics of heritage provision. The familiar ideas of 'supply' and 'demand' seem relevant, but the problem is identifying how these are to be traced in the relations between heritage services and their 'customers'. We perform this operation by comparing a stylized set of accounts for a profit-making private enterprises and the accounts of heritage providers who are generally non-profit making concerns. In Chapter 4 we explore this comparison in detail, in the slightly unconventional manner which the exposition demands. Clearly, a profit-making enterprise pays particular attention to collecting information on the relation between its sales and its costs with a view to finding out whether the enterprise is 'profitable', in the sense that its owners are satisfied with the return from its activities as compared with alternative ways in which they can generate income. In the longer run, not only the profit rate but the associated value of the business if it were to be sold must be checked. When it comes to non-profit making concerns deriving a significant proportion of their income from private donations or grants as well as from sales, that is admission charges to historic sites and to museums and galleries (MGs) and the like, terms like 'profitability' and 'value' seem inappropriate, and other criteria must be identified and discussed. Furthermore, there can be major differences between heritage concerns about the extent to which any particular criterion guiding the management is operative. This

requires us to look at the 'big picture' which displays the flow of funds between suppliers of funds, who allocates these if other than the suppliers, and who receives them.

Chapter 5 takes us to the core question of our analysis of heritage institutions. What motivates their management, given the economic constraints within which they have to operate, and how is this reflected in their operation? We use the adaptation of the standard approach of assuming that individuals behave rationally and consider the pros and cons of courses of action which are designed to maximize their own welfare. The theory is derived from what facts are available about the behaviour of MGs' directors as revealed in their control over the stock of historical artefacts in their charge and over the additions to that stock. In this respect they have a clear advantage over businesses in the sale of goods and services where the amount and composition of the stock that they hold depends on what consumers desire to purchase. While gallery directors may be under pressure from those who finance their activities to respond to public taste, their professional views on the relative value of artefacts is influential with their 'sponsors' and can give them considerable discretion in the control of stock.

The empirical evidence points towards an important characteristic of managerial behaviour. Directors of MGs and their counterparts in the control of the built heritage, in common with other professional cadres—medical specialists and even economists—derive considerable satisfaction from having an established reputation with their peer group. Consequently, the less dependent they are on competing for revenue from visitors, the more likely they will be able to devote time to persuading their sponsors that their judgement and therefore their personal and professional satisfaction should govern the composition and the use of their 'stock-in-trade'. We risk offending the ears of those who feel that such down-to-earth terminology is inappropriate in analysing the activities of the guardians of the artistic legacy of our culture. That is a risk that is worth taking, in the hope that the reader will look more deeply into our analysis. To anticipate our later argument, we do not judge behaviour but we try to explain it.

Chapter 6 continues the line of discourse in Chapter 5 but with particular reference to the characteristics of preserving the built heritage, a peculiar feature being the vagueness of the concept of heritage. Now we come to subjects in which economics is on trial. First, can it

offer any guidance on the choice of artefacts which in some sense 'deserve' conservation in its various forms? Here those engaged in the artistic, aesthetic, and historical appraisal of heritage are being asked questions about the conformity of their judgement with that of the community expected to benefit from their efforts. Agreement is expressed through their willingness to pay for the resource costs of the proposals offered by the specialists. Measures of 'willingness to pay' are difficult to devise and analysing the results of applying these measures to the replies of potential and actual visitors to historic building and sites must be carefully interpreted. Chapter 7 offers our own survey and critique of such measures. What clearly emerges is that those funding heritage now express a growing interest in economic appraisal of this kind alongside more traditional checks made on enthusiastic proposals for the expansion of heritage provision. Secondly, what can economics tell us about the level and form of support for heritage provision? The economics of public subsidization to business is well developed and can readily be applied to cultural activities. One can overdo the emphasis on similarities, however, bearing in mind that some major economies have used national lotteries as a form of hypothecated revenue for cultural purposes and the regulatory regime applied to heritage is of major significance in restricting the property rights of those who own 'businesses' in this sector.

In Chapter 8 we examine in very general terms which tools are used to devise policies and try to show that, when dealing with cultural policies, 'government' is an expression which needs to be further qualified since, according with its institutional features, different effects are produced. In dealing with these matters Chapter 9 offers an account of the problems encountered in the evaluation of public action with respect both to investment projects and to the production of cultural goods and services. Have economists any contribution to make to the defining and application of 'performance targets' for heritage provision that are immune from the direct pressures of the market? Although we judge that economists have a better grasp of what are relevant measures of performance than those currently in operation, they foresee formidable difficulties in refining existing measures and in inventing better alternatives, influenced, no doubt, by their observations on the impossibility of fully replacing the competitive market as a spur to efficiency.

Although we were tempted to offer a summary of our findings and the conclusions drawn from them in chapter 10, we thought we ought to justify our critique of heritage policy by offering an outline of an agenda comprising proposals that specify where changes in the policy pattern might be made. The basis of these proposals is derived from our commitment to a policy based on the principle of consumer sovereignty and requires methods for reconciling the tastes and preferences of the public who finance heritage services with the artistic and aesthetic standards that their producers believe must be adhered to. This is a common dilemma in several of the major cultural services that citizens consider require encouragement from public authorities. In the particular case of heritage, it places a major responsibility on the shoulders of its suppliers in the form of a commitment to devise suitable methods for promoting investment designed to improve the quality of personal choice. We do not believe that we have come up with either the right answers or a full list of policy requirements, but we believe that even a mere statement of the 'terms of reference' for enquiries into the future of heritage policy should cover the appraisal of the proposals that we have put forward.

1

Making difficult choices

Introduction

Every discipline claiming to be a science must be based on some fundamental propositions, but those in economics may seem tenuous and imprecise. There are two: (i) human beings' behaviour patterns are consistent and human nature is constant in time and place; and (ii) every human choice involves a cost, represented by the alternatives forgone.

It is a characteristic of brilliant scientific minds to question the fundamentals of their own subject or at least to consider the consequences of assuming that they may not hold. Characteristically, Keynes offered the prospect that, in the long run, the world would be so replete with resources that the problem of the alternative cost of one's actions would disappear; at the same time, the removal of this constraint on human action would transform human nature so that we would become more contented and more civilized human beings, but his argument was based on the strong assumptions that man would limit the growth in his numbers, wars would become less frequent, and people would be prepared to listen to those, like himself, who could introduce them to the joys of the intellect and the imagination.

There has been much misunderstanding of the first proposition, even by eminent philosophers. It is based on simple observations over the centuries, such as the familiar relation between the demand for some product and its price, but does not entail passing any judgement on the individuals' choices of goods and services or enquiry into the reasons why they buy them. No moral imperative requires an economist to judge the actions of individuals by specifying some 'hierarchy of choices'—that, we are told, is best left to theologians and moral

philosophers. There is a splendid little interchange between Bene-
detto Croce, famous Italian philosopher, and the equally famous
Italian economist Vilfredo Pareto in which Croce argues that economic
actions can imply approval or disapproval but that one cannot do the
same for a mechanical action, for example the movement of the foot.
Ergo, according to Croce, economic facts cannot be examined in the
same way as mechanical facts. Pareto replies that if one man kicks
another, then the movement of the foot is a mechanical phenomenon,
but the act itself may be subject to approval or disapproval; ergo, the
distinction is otiose and observation by economists of acts of exchange
are no different from observations by medical scientists. The use of
economics to show how individuals rank their preferences for goods
and services does not entail a statement about the value, whatever that
means, of their actions. When Oscar Wilde made his famous remark 'a
cynic is a man who knows the price of everything and the value of
nothing'—it is believed that he was lampooning economics—he was
exercising his talent to amuse, but was nearer the truth than he real-
ized. 'An economist is a man who knows the price of many things but is
no more competent than others to evaluate pricing decisions' is a more
accurate, but much duller, statement!

Economists examining human actions may see themselves in the
modest role of an observer and calculator, but we have more difficulty
in explaining the implications of the second proposition. It is known
colloquially in the trade as the TANSTAFL principle: 'There Ain't No
Such Thing As a Free Lunch'. Every act of choice means weighing the
benefits of the action against the benefits of the next best alternative
course of action. Furthermore, there is no means of proving whether
one course of action is 'better' than any other, and, moreover, one
cannot even be certain that the course of action one takes has pre-
cisely the consequences that one expects. One can try to reduce the
uncertainty attached to one's course of action by seeking more infor-
mation about its consequences, but the acquisition of information
itself involves costs in the form of time and money.

For example, you have taken a conscious decision to read this book.
The information you would have about it would be bound to be
imperfect for it would be difficult for you to assess the anthropological
characteristics of the authors. You chose under conditions of uncer-
tainty, and paid the cost in terms of the other things you might have
done with your time and energy. The occasion may have surprised and
disappointed you, but at least you have acquired knowledge of what

these sorts of occasions can be like, knowledge which may be put to future use!

The 'opportunity cost' problem is fittingly demonstrated in a talk given some years ago in a French colonial province by the French Minister for Development which some Berber tribesmen were persuaded to attend. It was the Minister's custom to obtain 'feedback' from his talks about cooperation between villagers and planners and an embarrassed official was asked to report back to him what the tribesmen had thought about his speech. Pressed for an answer, the official said: 'they thought that their attendance had too high a cost because it had been a beautiful moonlit night, so they had forgone perfect conditions for horse stealing'!

Don't shoot the economists—they are doing their best!

It is common for professions to have a code and in medicine this is demonstrated by the taking of the Hippocratic Oath on graduation. There is no counterpart amongst economists, although it is commonly accepted that we have the rather grave responsibility of helping those we advise to consider and to face up to the consequences of alternative courses of action which require the use of physical resources and human skills.

Consider the following example of what Guido Calabresi, a remarkable academic lawyer who employs economic analysis, would call a 'tragic choice'. Under public pressure, a government is obliged to seek ways of reducing fatal accidents on roads. If, as we may prefer to think, the value of human life is infinite, then resources must be found and regulations introduced, which would reduce the number of fatal accidents to zero. It is clear that the resource cost of achieving this objective without preventing people driving at all, would be enormous. If any attempt is made to prevent accidents by raising the cost of accident liability to careless drivers as an alternative to investment in safer roads, there would be an outcry at the restrictions that would be necessary. In very poor countries, any attempt to reduce fatal accidents on roads to zero would entail the use of scarce resources which could result in people dying of starvation as an alternative to being knocked down on the public highway. An analogous situation arises in considering the implications of a health service policy which assumes that its object is to prolong human life as

much as possible. It is usually the poor economist who has to think the unthinkable and take the responsibility of giving voice to it—for whether we like it or not policy makers are forced to price human lives.

Now consider what is involved in government decisions to support the arts. One naturally accepts that aesthetic judgements about the quality of artistic productions are best made by those who command the respect of their fellow professional artists, although an economist is bound to point out that even these informed judgements are matters of disagreement amongst themselves about what is 'good art'. However, it would be a false step in the process of policy making if we deferred entirely to the judgement of such professionals about the allocation of resources to further their cherished projects. A Royal Commission on Ancient Monuments in Britain, in keeping with many other countries, has taken great pains to list buildings of historic interest and one suspects that they have enough work on hand to employ them for nearly a century, by which time the stock of 'heritage' will have been replenished by buildings now being constructed. The implication of this activity is that resources have to be found to preserve all the entries on the list. An analogous approach is implicit in those who make judgements on the output of new artefacts, musical compositions, and plays, not to speak of the conservation of works already in existence. Our opera, ballet, and theatre companies all complain about being 'underfunded' and sincerely believe that the term has some technical meaning. The optimal expenditure on cultural pursuits, as in our previous examples, is illimitable. A funding body, with limited resources, is forced to make unpopular, if not tragic, choices, in which those who obtain funding claim they do not get enough and those who are refused funding complain that we neither know how valuable their contribution to society is nor care about their aspirations.

But the matter does not end there. Artists and writers, and their promoters, are no exception to our first law of economics and employ their particular talents in trying to induce governments to exempt them from resource constraints; and these talents, as we shall see, may be formidable. Only the sustained clamour by so many professions to be given special treatment by government makes it possible for politicians to resist the histrionic displays of outraged artists who call them 'philistines'. Worried at the growth in public spending and finance in the late nineteenth century, William Gladstone observed that 'the income tax is turning us into a nation of liars'. Bearing in mind the large number of supplicants for public funding from all

sections of society, the corresponding aphorism today might be: 'the prospect of government subsidy is turning us into a nation of special pleaders'. Of course, the 'special pleaders' are always the others! 'I am underfunded, you are looking for a cash hand-out, he/she wants a pension for life', as the selective declension of 'to subsidize' might be stated. Economists are left with the unpopular task of disentangling the effects of such special pleading.

You may be left wondering why any sensible person would want to be an economist. The training is hard, the scope of the subject is vast, the subject matter, human action, cannot easily be observed under controlled conditions, and so the practical results are in dispute. Worse still, more often than not, the conclusions reached are unpalatable, indicating that the imaginative schemes of industries and governments are often unrealistic. Do we hear psychologists muttering, *sotto voce*, 'a clear case of sado-masochism'? One is almost forced to agree with them, for the obvious alternative explanation—economists are paid more than others for being in a dangerous occupation—does not seem to be true. It is not even as if an economist's skills make him a fortune on the stock market. 'As you are so smart, how come you are not rich?' is the common jibe of businessmen to economists. The reply is: 'being a ballistics expert does not turn one into a good tennis player.'

There are two reasons why we survive and, indeed, may sometimes flourish as a profession. The first and most obvious one is that there is a demand for our services in all walks of life, even in the field of culture and the arts. We have our uses, even if we are regarded as a necessary evil. As the Nobel Laureate, Stigler, has remarked, 'the tedious humour about the differences of opinion among economists...or our infatuation with abstract thinking are really envious jibes....How much sweeter is envy than pity.' His words over-emphasize, perhaps, our remoteness from those we try to advise and instruct. More often than not, economists are brought in as members of a team, searching for a solution to a common problem. Their contribution must not only be substantial but seen to be such. While this may not always happen, when it does suspicion and envy can give way to understanding and even admiration, however grudging.

The second is that there is no shortage of recruits both to the economics profession as such and to those professions where a knowledge of economics is perceived as useful. There seems to be an inherent attraction in studying a subject in which oneself and one's colleagues are part of the subject matter. The human instinct to

analyse and to measure can be satisfied. If we derive satisfaction from trying to improve the welfare of others, economics appears to be of assistance, even if its role is to cast doubt on feats of human imagination. After all, mainstream economics' forecast of the inevitable breakdown in collectivism finds its own roots in the principles of economics, although it was beyond the scope of economics to forecast precisely when, where, and how it would happen.

Misunderstandings

Economics is therefore a human science which formulates and tests hypotheses about how individuals alone or in some form of association—communities, governments—use their material resources. It studies human behaviour rather as biologists study animal behaviour, which immediately gives rise to two doubts: whether human behaviour is predictable and the suspicion we all have at being observed and subjected to experiments.

Biologists and the like are interested not only in the features of the animal kingdom. They regard such study as helpful in understanding the 'big picture', which for many of them is the origin and evolution of species, and associated environmental changes. Economists, too, after drawing conclusions about human behaviour based on 'micro-analysis', are interested in 'big pictures'. From the very start of modern economics this has included such matters as what makes economies grow and what causes differences in growth between countries and also what are the consequences of growth. This leads them to consider questions about the effect of growth on the distribution of the world's wealth, and its long-run consequences for the use of the planet's resources. But it is only recently that this interest has been extended to the economic aspects of the conservation of the artefacts of the past, the main subject of this work.

Decisions about how the resources of a country are used have increasingly been taken by central and local governments, formally at least, on behalf of its citizens. This has tempted economists to extend their study of behaviour to situations where decisions are not taken about resource use simply by private purchases and sales. Hence the adaptation of their analysis to cover group behaviour, including political behaviour, and bureaucratic behaviour. This gives rise to analytical difficulties, including amassing empirical evidence, and it also entails

questioning the assertion that when people act 'in the public interest' somehow their behaviour changes, and they think only of the 'public good'. Those engaged in public service of one kind or another may resent this intrusion by economists into the study of their motivation and what its consequences are. We have no option but to do so, and simply ask for the chance to show where it leads.

The analytical approach to the study of human behaviour is frequently the source of misunderstanding. This is particularly true in the study of attitudes towards heritage as a source of enlightenment and enjoyment. Economists might label it the 'Ruskinian myth'. John Ruskin thought that 'political economists', by studying how individuals produce and allocate material resources, were only concerned with material ends and gave such ends precedence over the 'finer' aspirations of man, a misunderstanding which is still prevalent amongst his intellectual successors. He missed the simple point that all forms of human endeavour, representing what for him and many of us are the most laudable ends, require the giving up of material resources which could be employed in other uses. Yet this fallacy seems to be embedded in the psyche of art historians and art experts, even to this day.

Another source of misunderstanding arises from the economist's concept of a 'market'. The popular idea of a market is one where there are buyers and sellers, with the former exchanging command over resources in the form of money for goods and services supplied by the latter. Certainly, this idea describes a large proportion of economic transactions, but the idea of a 'market' can be extended to cover all forms of exchange where negotiation takes place and contracts are made and which involve the exchange of property rights. This extension is exemplified in negotiations between government departments funding museums and galleries and the management of the latter over the annual grants, which entails 'bargaining' over the funding provisions. This avoids the trap of assuming that 'market' situations, in the narrow sense, bring into play less worthy ends, such as maximizing the satisfaction of buyers or maximizing the profits of sellers, than those in 'non-market' situations where motivation is claimed to be of a higher or superior order.

Characteristics of the heritage 'market'

The demand for heritage services has now reached a dimension where it should become an identifiable item in individual and collective

expenditure, and where simultaneously there is concern about the availability of the supply of historical artefacts to satisfy this demand and how far this is determined by geographical and institutional factors, such as the location and ownership of property rights.

A 'potted' history of the evolution of heritage demand as an economist might regard it—an admitted travesty of historical analysis—may be helpful. The first stage in Europe is represented by the aristocratic interest in historical artefacts aroused by their classical education and opportunities to purchase them from individuals and public authorities whose 'reserve price' was low. They purchased them as 'positional goods', that is goods which enabled them to impress members of their own class. Italy was a fertile source of supply, both in terms of immobile heritage such as Venetian *palazzi* and mobile items such as painting and sculpture (that is not to say that they did not derive a personal aesthetic satisfaction). Concurrently an art market developed with art dealers. Of course, this is still an active element in heritage demand.

The next stage is the development in public education alongside economic growth and growing industrialization. Here we may detect a mixture of motives, ranging from a genuine concern by philanthropists for educating the poor—even claiming that access to the arts would reduce class conflict—to concern by entrepreneurs that artisans should improve their training in design. Such a training should embody access not only to courses in design but to examples of 'good art'. Hence the growth, both nationally and regionally, of local museums and galleries, notably in France, the UK and the USA in the mid-nineteenth century.

A final stage is to be found in a collective interest in the conservation of the past associated with the growth in nationalism and the preservation of a national identity, all this against the background of the fear that artefacts which represented historical episodes of importance were disappearing or in a poor state of repair, or were inaccessible because they were privately owned and could be disposed of abroad. This stage is associated with the expression of an important facet of human behaviour, namely the desire to preserve reputation with future generations who might not be very pleased if cultural resources, including heritage artefacts, were to disappear. However, this stage is also co-terminus with the extension of what was once the preserve of the few to become the interest of the many, that is the growth of domestic and international tourism, and the willingness of tourists to pay for access to historical sites, museums, and the like.

A large proportion of the goods that we generally buy are manufac-
tured, that is they represent the transformation of raw materials into
finished products and are easily reproducible. Their selection and
purchase depends directly on individual tastes and preferences. How-
ever, historical artefacts were not originally produced to satisfy some
future demand but to satisfy contemporary tastes, typically those of
rich aristocrats and of religious foundations. Artefacts become iden-
tified as heritage goods and are demanded when they receive the
imprimatur of archaeologists and art historians who recognize their
historical or aesthetic significance to carry on the analogy with manu-
factured goods. We may say that they 'become' heritage as the result,
or the output, of a production process in which art historians and
archaeologists are the producers (this is discussed in more detail in
Chapter 8). The 'stock' of historical artefacts cannot be added to by
organized production but only by accretion through their discovery
or recognition as part of a legacy of past 'treasures'. Of course, de-
pending on the forces of supply and demand, this does not prevent
the production of fakes, often on a large scale; and there are many
famous examples.

The demand for heritage goods had a profound influence on the
mode of supply because private owners of heritage goods did not
initially acquire them in order to profit from their sale or display
them to the public. The community and collective demand became
satisfied by the setting up of museums and galleries and historical
complexes which were not operated at a profit. This generated an
interest in giving effect to the transfer of historical artefacts to the
control of public bodies, not necessarily by transfer of ownership
through sale. In the case of France, a large part of the initial public
stock of heritage was acquired through the surrender of property at
the time of the Revolution and afterwards through the plunder of
Napoleonic armies. In the case of the UK, punitive inheritance tax-
ation led to the government accepting historical artefacts in pay-
ment. In both these countries the public authorities have compiled
registers of heritage artefacts, classified them according to 'import-
ance' to the nation, have controlled their sale and, where possible,
have demanded private owners give access to the more important
items. An even stronger case is offered by Italy where the historical
artefacts owned by the public sector, if older than fifty years, are
considered 'heritage' by definition, unless the lack of any artistic,
historical, archaeological, and anthropological interest is assessed

through a complex administrative procedure. A different regime holds for the heritage artefacts belonging to private owners which are listed and subjected to a tight discipline of protection. In short, an attempt is made to influence the stock by restricting ownership rights.

The evolution of economic analysis of heritage

Until Ruskin made his outburst, there was relatively little attention in economic treatises devoted to the above described developments. Ruskin's belief that economists were philistines may not have been entirely unfounded, for the famous utilitarian philosopher and economist, Jeremy Bentham, had trailed his coat in arguing that there was no hierarchy of tastes so that trivial games were as 'important' as poetry. It was this attitude which led to Ruskin's attempt to put a ring fence round artistic creation so as to exempt it from the analysis of its 'opportunity cost', that is from the material consequences of assigning resources to artistic supply at the cost of alternative uses of these resources. However this is a quarrel about value judgements, and not about facts and analysis.

An obvious point of departure for economic analysis was the market for artefacts and, curiously enough, it was a painter who became an art dealer and a museum director who wrote some of the first essays in this area: Roger Fry (1866–1934). Following the thoughts of the American sociologist, Thorstein Veblen, in the latter's *Theory of the Leisure Class*, Fry analysed the art market and put particular emphasis on the importance of purchases as 'positional goods' (see above). However, he did believe in the hierarchy of tastes and its determination by art experts like himself. He took action to try to induce changes in taste so that 'good' works of art would survive and improvements would be made in artistic design (he was, incidentally, a close friend of Keynes). What is also interesting is that he did not believe that government intervention to encourage artists and to preserve the past was a good idea, arguing that government intervention would eventually stultify artistic creation. He was a precursor of the present-day intense interest of economists in the working of the art market and such issues as art as a form of investment.

The real impetus which has directed economists towards the study of the arts is associated with the growing importance of public authorities, not only as an influence on the demand for historical artefacts but also as a supplier of heritage services. Public expenditure and

public regulation become policy instruments and therefore enhance interest in the precise objects of official policy, how these policies are carried out using resources, and whether these policies are in some sense efficient (see, again, Chapter 8). In particular, as governments rely for decisions on expert advice, there is a close interest in how this advice is generated. Also the advisers have become a major influence on the *management* of the institutions supplying heritage services to the public.

Hoping that we have clarified how economists approach the study of the conservation of the past, we can now specify how they endeavour to increase understanding of the issues to which decisions about influencing it give rise. In the forefront of our minds is the object of showing what economics can contribute to the practical problems of heritage policies with which arts administrators have to deal.

It seems sensible to begin by painting a general picture of the policy dilemmas and why it is essential to use economic analysis to explain how these arise. The resolution of these dilemmas must be preceded by learning how to examine the data which can reveal the complicated structure of the provision of heritage services, particularly in Western-type economies. This structure is a consequence of decisions taken both by government and private agencies which entails a detailed examination of their motivation. The overriding feature of the heritage 'market' must be the issues that rise in formulating and implementing public policies which are, by their very nature, controversial.

Further reading

This chapter has tried to give the reader an insight into the way the economist's mind works in studying cultural institutions. There are some problems in mapping out a programme of further reading. The majority of readers, one supposes, have a personal knowledge of 'economizing', both at the workplace and in the home, and personal introspection should confirm how, say, the TANSTAFL principle governs their activities. At one time economics teaching, particularly in classes during the nineteenth century, were designed to improve the knowledge of the working man and were zealously conduced by earnest economists, notably Philip Wicksteed (1844–1927), as reflected in his writings such as *The Commonsense of Political Economy*. It is difficult to offer the reader a modern equivalent to this excellent work.

Nowadays, introductions to economics have the same austere and forbidding aspects as equivalent works in physics, and impress on the reader how they must have or quickly acquire a knowledge of calculus. There are, however, two books by young(ish) American economists that fit with our conception of making economics palatable and even enjoyable. They preserve one aspect of the Victorian desire to offer both instruction and entertainment. These are: John Macmillan, *Reinventing the Bazaar: A Natural History of Markets* (Macmillan is Professor of Economics, Graduate School of Business, Stanford University) and Steven D. Levitt and Stephen J. Dubner, *Freakonomics* (Levitt teaches economics at Chicago, and was a winner of several honorific professional awards in the USA at a surprisingly early age. Dubner, journalist and columnist, writes in prestigious periodicals such as the *New Yorker*). Both books contain the message that economics can be fun. Fair enough, but their profusion of examples of economic analysis of human behaviour are confined to private enterprises or to private households. The reader, however, must be convinced that the same choice dilemmas illustrated by these authors have a wider application. We know of no complementary work, other than this one, which fulfils that requirement.

There will be readers already pursuing economics courses or who are already trained in the subject who wish to move closer to the stage beyond being equipped with some economic analysis. A useful standard introduction to cultural economics, which considers in some detail the economic problems of museums and galleries, is James Heilbrun and Charles M. Gray, *The Economics of Art and Culture*, together with Ruth Towse (ed.), *A Handbook of Cultural Economics*.

A test of their knowledge of the economics of the arts is offered by V. Ginsburgh and D. Throsby (eds.), *Handbook of the Economics of the Arts and Culture* (there are several articles dealing, *inter alia*, with analysis of the management and control of historical artefacts. The opening chapter by the editor, a well-known expert in cultural economics, is a first class introduction to the subject for social scientists).

Finally there is a book which has excited a good deal of attention because it shows how the economist's approach to the study of human behaviour can provide a general explanation about the evolution of societies and the particular part that trust plays in their development. This is: Paul Seabright, *The Company of Strangers, A Natural History of Economic Life*.

References

Ginsburgh, V. and D. Throsby (eds). 2006. *Handbook of the Economics of the Arts and Culture*, Amsterdam: Elsevier.

Heilbrun, James and Charles M. Gray. 2001. *The Economics of Art and Culture*, 2nd edn, Cambridge: Cambridge University Press.

Levitt, Steven D. and Stephen J. Dubner. 2006. *Freakonomics*, Harmondsworth: Penguin Books.

Macmillan, John. 2003. *Reinventing the Bazaar: A Natural History of Markets*, New York: WW Norton.

Seabright, Paul. 2004. *The Company of Strangers, A Natural History of Economic Life*, Princeton, NJ: Princeton University Press.

Towse, Ruth (ed). 2003. *A Handbook of Cultural Economics*, Cheltenham: Edward Elgar.

Wicksteed, Philip. 1910. *The Commonsense of Political Economy*, 2 vols, London: Routledge and Kegan Paul.

2

Examining reasons for public intervention

Introduction

In major countries, the growth in heritage services is associated with ever-larger participation by public authorities. This is represented not only by public presentation of artefacts to the public in museums, galleries and historical sites, but by the extension of government regulations covering the use and disposal of private building and land with heritage connotations. Of course, the growth trend varied in form and in intensity according to the nature of the historical artefacts. For example, the incidence of major wars during the twentieth century had a marked effect on the creation of monuments with the specific intention of offering future generations reminders of their country's past. This represents an exception to the usual position in which artefacts which become categorized as part of heritage are originally created for the benefit of their current owners.

It has been argued that it was inevitable that the collective demand for heritage services could only be fulfilled by state intervention, more particularly involving growing state responsibility for the care of historical artefacts and for identifying them as being in the public interest to preserve and display. Prominent *aficionados* of culture supported the contention that in the reconstruction of war-torn economies after the Second World War only experts in town and country planning were in a position to advise on aesthetic principles which would identify the 'correct' style and layout of buildings and their interiors and derive from them an 'appropriate' taxonomy for identifying what items should be preserved. The enhancement of the

role of the 'experts' in the decision-making process was the necessary corollary to this viewpoint, but could not be achieved other than by public action. Contractual arrangements made through the market between individuals would hardly guarantee that aesthetic principles would be properly invoked.

The economist's approach, as already outlined, throws considerable doubt on both the logic and the realism of this position. Aesthetic principles can only be derived from subjective value judgements and even if one were to accept that the principles identified by experts should govern the amount and pattern of heritage artefacts provided by the action of public authorities, there is no guarantee of a consensus view amongst themselves (see Chapter 8). But going so far as to accept that expert choice is paramount, no public authority would draw the conclusion that the optimal expenditure or the regulative regime, is uniquely determined by preparing an inventory of artefacts drawn up by experts. This presupposes that heritage provision has no opportunity cost. The ultimate decision on the size of any heritage budget must lie with the political authorities and even in centralized democracies of the West European variety, central and local governments cannot ignore the opinion of those who elect them when it comes to deciding on the pattern of public expenditure and the distributional impact of the taxes to finance them.

It is true that current levels of public expenditure on preserving and displaying historical artefacts by government institutions coupled with regulatory control over the disposal of private artefacts may be low down on the scale of public scrutiny about government actions, compared, say, with public intervention in the supply of health or education. However, heritage issues are becoming much more prominent in public discussion as a result of growing concern about the influence of rapid economic growth on the natural and physical environment. For example, technological advance has improved the process of identifying historical artefacts and modes of preserving them. It has rapidly reduced the relative cost of communication, consequently reducing the relative cost of viewing them. At the same time, technology has enlarged the possibility of distributing information about heritage and of improving knowledge about it. In fact, as a result of the great effort which many private as well as public cultural institutions devote to the construction and update of their websites, anyone can virtually visit a museum, an exhibition, or an archaeological site while sitting in his armchair at home and,

therefore, individuals' awareness about heritage is likely to be enhanced overall.

It is entirely sensible if economists confine themselves to describing and analysing such changes without making any judgement about whether they are desirable. Increasingly, economists have become enthusiastic about inventing methods for measuring the value placed by individual citizens on the conservation of particular artefacts (see Chapter 7 below) and, although such methods have distinct limitations, they have come to be recognized by public authorities responsible for heritage provision as a corrective to pure speculation which denigrates public attitudes to conserving the past. However, we hope to make a case for bringing to the fore the idea that economics throws light on what are the appropriate elements in heritage policy and which institutions are best suited to carry it out. Our case therefore requires us to clarify our own value judgements and to illustrate how they determine our appraisal of how policies have evolved and their appropriateness in modern democratic societies. This chapter offers a general introduction to our approach.

The rationale for State intervention

Adam Smith asserted that the overriding purpose of production was to satisfy the needs of its consumers. This is a widely held value judgement of economists as well as being a good general description of the thrust of economic activity in mature Western countries where heritage plays a growing role. However, turning this judgement into a guide to political action involves further interpretation. The Smithian principle implies that the interests of consumers are paramount, but there is argument about whether consumers know where their interests lie. A stronger version of the principle maintains that consumers are the best judges of their own interest, redefining it as the principle of consumer sovereignty (c.s.). This commits us to accepting that consumers' best interest is served by their own choices, which are reinforced by making purchases in free markets where producers' power is circumscribed by competition.

While this provides a general guide to the scope and nature of government intervention, there may be circumstances where markets cannot be created so as to facilitate freedom of choice, and that consumers themselves may be uncertain about the ability to choose

in their own interests. Both these caveats play an important part in the design of heritage policies, although we shall challenge the view that they offer full justification for the forms of state intervention actually in being or desired by those who claim that their value judgements on cultural matters are of a higher order than those of the general public.

The first thing to note about this statement of the c.s. principle is that it assumes that in practice a market can be created in the goods and services in question. Suppliers are willing to compete in providing goods and services provided that they can deny supply to those not prepared to pay for them (excludability). When excitement is generated by the rare event of an eclipse of the sun, the event cannot be denied to anyone deriving pleasure from viewing it and the enjoyment is independent of the number watching it. It is claimed that many artefacts classified as heritage goods have these so-called 'public goods' characteristics by being 'non-excludable' and 'indivisible'. Thus there is no means of exacting payment for the service provided from those enjoying it unless they offer payment voluntarily. But if individuals benefit whether they pay or not, why should anyone pay if others can escape from payment?

It is simple to offer an imposed solution with the public authorities deciding on what parts of the natural or built environment should be preserved and taxing the public in order to pay the costs of preservation. However, such a solution should not be taken for granted, since its capability for representing individual preferences depends on many considerations such as who shall actually decide what should be preserved and what principles will govern their actions, what substitutes can be found for competition in ensuring that heritage services are efficiently provided, and who shall actually pay for these services. One might concede that the recognition of market failure may make a case for public intervention in the name of those anxious to enjoy the service, but finding some way of approximating a market solution does not presuppose that the only solution requires that heritage services must be owned and operated by the state.

An example may offer the reader some indication of how to identify 'public' goods in heritage artefacts and the methods used to ensure that their services remain available to the public. Edinburgh Castle stands on a rock with a commanding view of the city below and of both the local hilltops and even distant Highland peaks. The view of the Castle alone provides a service reflected in the continuing stream of artists and photographers deriving inspiration from it. There is no way of exacting payment for this service and enjoyment by one

person does not preclude its enjoyment by another. This publicness feature of the Castle is reinforced by its associations with the history of Scotland and the extent to which this encourages demand for the preservation of symbols of national identity. It will also be characterized by architectural historians as unique at least in a physical sense, for if it disappeared it would be irreplaceable. However, one notes that if the Castle's only function had been confined to being a fort, it would probably have become a decaying ruin by now. Through the years, it has acquired alternative uses as a barracks, a national military museum and hospitality centre for official occasions. It is replete with historical artefacts illustrating Scottish history and the exclusion principle requiring charging can be applied through control of entrance to the Castle and its buildings. Additionally, the view from Edinburgh Castle is stupendous, offering a further benefit to those who pay directly for the other services. The charges represent only part of the cost of maintaining the Castle, but help to cross-subsidize those who derive their enjoyment of it as part of the panorama of Edinburgh and cannot be charged. Those paying the charges presumably derive a utility from entry in excess of what they would be willing to pay, sufficient for them to ignore their contribution to the utility of any free riders.

Most examples given of publicness identify artefacts whose functions and relative importance change over time. Indeed, their state of preservation as an example of heritage generally depends on the viability of the artefact as capable of being adapted to present use. We should therefore not be surprised to find that conserving artefacts in which the publicness content is claimed to be of national importance, however defined and by whom, does not preclude using the price mechanism as at least a supplement to taxing the public at large. In short, so far as the built heritage is concerned, pure publicness is rarely to be found or, at least, it may be coupled with other features.

The problem of market failure can be looked at in another way. Can heritage services with publicness features be provided by voluntary arrangements? There are certainly copious examples of private enterprise at work which allows those people interested in the past to obtain historical services for payment. Three examples illustrate different aspects of the market in such services.

Our first example considers the case where private owners of artefacts have their exclusive enjoyment, although these may be considered as an integral part of a country's heritage. For instance, a considerable and important part of the British built heritage consists

of castles and historic homes, many of them still owned by aristocratic families. Expanding opportunities to enjoy heritage services as part of public policy, might have suggested to the public authorities buying out the owners or even compulsory acquisition with or without payment of compensation. The 'British' solution has been to grant exemption to owners of historical properties from its relatively high inheritance and capital transfer taxes in return for granting access to the public for a specified number of days per year. Their marketing methods have grown in subtlety over the years. Originally perceived primarily as offering family excursions, they have now substantially broadened the range of attractions they offer and cater for a wider range of tastes, including everything from adventure playgrounds to zoos and garden centres. In the course of the years, they have followed the practice of their counterparts in industry by combining to form their own trade association, hoping thereby to influence government measures in favour of their interests.

Secondly, there are examples where the exclusion principle can be applied, at least in part, but there may be restrictions placed by the providers of the service themselves on using a pricing system to cover costs. Thus, in principle, religious bodies might be able to charge for the viewing of the interior of cathedrals and churches, but do not wish to discourage the propagation and extension of the faith, quite apart from the restrictions which the faith itself might place on charging in the first place. Here the aims of the organization place a constraint on the raising of revenue by conventional pricing and it is common to rely on persuasion to make voluntary contributions from visitors and to emphasize to the civic or regional authorities how much its invisible 'export' income from tourism relies on the attractions of its historical religious foundations. An interesting illustration is provided by the imminent collapse a few years ago of the famous Minster at York which, although the largest cathedral in Northern Europe, was discovered to have no foundations. Church of England membership had been rapidly declining, yet a public appeal raised £2 million in a matter of months and the cathedral was not only saved but splendid new Roman relics were discovered in the Undercroft which, very sensibly, the ecclesiastical authorities now charge to view!

Thirdly, the recognition of market failure may encourage private action through the establishment of 'clubs' with members who join together to support a common interest in supplying heritage services to themselves which would otherwise not be made available through the

market, and who derive satisfaction from encouraging others to join them. These clubs range from quite specialized entities, for example conserving artefacts illustrating the history of fishing or the conservation of old steam trains, to those with more general aims making themselves responsible for major segments of heritage provision. The most prominent example of the latter in the UK is the National Trust with its counterpart The National Trust for Scotland. It began largely as an owner of extensive property and land 'held in trust' and has become the largest single private landowner in Britain. Its membership has grown from 7,100 in 1939 up to 1 million in 1980 and stands to date at 3.5 million, which is considerably more than the combined membership of all the major political parties in Britain. Inevitably, the expansion in its interests has made it not only a presenter of historic homes and their memorabilia but also a campaigner for restoration of properties. Its very size and interests as a major player in the heritage 'market' has involved it in close contact with governments that perceive their role as the main arbiter on the meaning and scope of national heritage policies. It has also raised questions applicable to all major non-profit making bodies, including other Non-Governmental Organizations (NGOs) which pressurize governments to promote environmental conservation, about their own system of governance, and the role played in it by the membership.

The extent of such a phenomenon varies across countries, in connection with the prevailing social aptitudes and shared social norms as well as the institutional and fiscal arrangements adopted in each country; for instance, a somewhat different situation occurs in Italy, the role of players such as the National Trust is smaller than in the UK, the equivalent being Fondo per l'Ambiente Italiano (FAI), founded in 1975. It has 75,000 members (2006) and owns/operates 36 properties, obtained through donations, purchases, or by concession. Interestingly enough, FAI somehow refers to the English National Trust as an example. These are matters that merit further investigation in a work concentred with the economics of heritage (see, later, Chapters 4 and 8).

The quality of choices

Economic analysis designed to identify whether or not resources are being employed to improve the welfare of individuals and, hopefully, to define their optimal welfare position—clearly a tall order—finds it

convenient to assume that in any comparisons of states of well-being, tastes and preferences remain constant. This neglects the strong possibility that individuals view 'improvement' not simply as 'more of the same', but as 'better quality'. This presupposes an incentive for individuals to invest in knowledge designed to enlarge their satisfaction. Hence the paradox that given tastes and preferences may embody a desire to change them.

A society characterized by freedom of choice and consumer sovereignty coupled with competition providing alternative sources of supply of goods and services might be claimed to accommodate such improvements in satisfaction. The very opportunity to have the freedom to choose can offer a concurrent investment in knowledge about the goods and services on offer and therefore a greater possibility of making 'better' choices. The relevant question here is whether such an opportunity favours growing support for the satisfaction derived from heritage services.

What this entails is a growing appreciation of the personal benefits to be enjoyed from heritage and the general benefits to society which individuals themselves recognize as important. David Hume puts the case very eloquently: '(the arts) draw off the mind from the hurry of business and interest; cherish reflection; dispose to tranquillity; and produce an eloquent melancholy, which, of all dispositions of the mind, is the best suited to love and friendship' (Hume 1742). However, both Hume and Adam Smith did not believe that investment in taste would be open for all to enjoy, implying, no doubt, that a precondition for the desire to cultural improvement could not be a function solely of the range of choices available but also of educational opportunities not then widely available to the general public as they are in our day. Such opportunities are a necessary precondition for acquiring consumer knowledge through, for example, obtaining proficiency based on personal skills of the kind which heritage production itself requires. They also help to reduce 'consumer resistance' to acquiring such knowledge, although this may be a slow process, given that the benefits from cultural investment are only apparent after it has taken place.

We are comfortable with the notion that the formation of tastes and preferences can be justified by the Hume/Smith arguments for the benefits accruing to individuals from 'refinement' of tastes and with the association of this personal judgement with support for education systems which promote enjoyment of culture in general

and concern for heritage in particular. We are less certain of the extent of arguments that claim that the growing refinement in tastes offers a major contribution to society in general, what economists label as an 'externality'. The evidence is slim that any major form of culture is a necessary condition for making us better people, and that this justifies public subsidies or public regulations requiring cultural institutions to make appropriate provision, although some arguments, such as the stimulus to creativity and innovation deriving from the arts as well as the positive impact of culture on social cohesion and identity, deserve attention in the policy design. This issue of externalities will crop up later in our discourse but all that is required at this stage is not to forget that there may be alternative means for reaching the same ends by public action which may be more efficient, that is less costly, and more effective, that is more readily adapted to achieve them.

However, there is an important gloss to put on the usual description of the meaning of consumer sovereignty as applied to heritage and, indeed, to other forms of cultural enjoyment. The individual's appreciation of them depends on his or her exposure to them. They are, in economics jargon, 'experience goods'. Mark Blaug has rightly emphasized that, as such, demand for cultural goods is generated through investment in that experience, carrying the implication that those for some reason denied that experience are being excluded from their enjoyment. This proposition, which we accept, suggests some form of collective action in order to improve access to heritage services. As there is no guarantee that there will be symmetry between the results of voluntary collective action and improvement in access to such services in accordance with what is generally regarded as appropriate, a case is made for government support. We shall see later that devising policies to offer this support is not an easy task.

Although reserved for later discussion, we must make it clear that some economists have argued that no such dilemma really exists, for heritage services, as with other cultural provision, are 'merit goods' and that what constitutes 'merit' can be safely left to the experts, that is to say largely to those in charge of providing them. The experts are assigned the task of deciding on what is good for us. The merit wants argument is particularly associated with the very well known economist, Richard Musgrave. He resolves the problem of consumer sovereignty by the argument that individuals may readily accept that experts should act for the community even though their own views, may diverge from expert opinions and decisions. However, this takes

us no further in solving the problem of the amount and form of public support, which would in any case require individuals' approval through the political system, at least in democratic countries, thus providing at least some opportunity for the exercise of consumer sovereignty through the ballot box.

Having accepted that public action is needed to fulfil the need for individuals to have equal access to taste-forming opportunities that the market alone cannot provide and to account for the externalities generated by heritage, we are bound to consider the rules that govern the form it should take. We have already accepted that art and architectural experts and historians fulfil the important role in the process of certifying what is worth conserving and restoring, with particular responsibilities when their activities are publicly financed, which may include regarding them as prime candidates for administering museums and galleries and heritage sites. This does not require that experts be given *carte blanche*. The sovereignty of the consumer cum taxpayer cannot be achieved to the same degree through the political system, for this would require unanimity in political decisions which voting systems do not deliver. Some form of contractual agreement between those who supply the funding, the taxpayer, and those who use the funds on our behalf is the best that can be done to approximate to the requirements of our consumer choice rule. Giving content to an agreement of this sort, taking account of the realities of political life, including the present-day commitments to particular ways of supplying heritage services, cannot be easy. But we must have a go at doing so in later chapters.

Interdependent preferences

It was pointed out earlier in this chapter that, in the Edinburgh Castle example, 'free riding' by others may be tolerated by those willing to pay toward the cost of heritage service. This is a weak version of the proposition that individuals derive satisfaction from conferring benefits on those other than themselves, or, in other words, that the welfare of individuals is interdependent. This early example does not offer positive expression of this proposition because individuals buying the heritage benefits provided by visiting the castle may be simply indifferent to the benefits conferred on free riders if, indeed, they are aware of their own 'generosity'. However, plenty of examples may accord with our own experience that individuals derive positive

benefits from helping others, such as their children or near relations, to enjoy cultural activities in which they themselves would not willingly participate. This interdependency may extend to what is known as 'option demand' where the individuals may support, for example, the maintenance and display of historical artefacts although without any intention of visiting them, and with no knowledge as to who will benefit form this action, and with no request on their part that they wish some form of public recognition for doing so. This is because they may attach some personal satisfaction to historic symbols preserving national identity, such as the Tower of London or the Leaning Tower of Pisa, even though their acquaintance of them may never go beyond photographs. A somewhat similar attitude can be found in people whose ancestors emigrated more than a century ago—Italian Americans in North America offer an example—and nowadays still maintain a strong feeling of Italian identity which in some cases lead to support for heritage in towns of origin.

Our description of option demand concerning transfers between donors and donees considers interdependence as a way of benefiting those presumably not able to articulate their own preferences, although this does not imply that they necessarily participate in the decision by donors on the amount and form of the donations. The exchange relationships resulting from this situation may be quite complicated. In the case of heritage artefacts, donors may prefer to offer such support indirectly by donations to appeals by suppliers of heritage services to support restoration and preservation work on buildings or by gifts of artefacts such as art collections. A common practice is to donate only to non-profit making providers of heritage services, including state institutions, covered by restrictive covenants which specify the terms of provision, notably the condition that there must be viewing access to the public.

This practice gives rise to an interesting argument about the necessity for state intervention. It may reasonably be claimed that the best guarantee of ensuring that individuals benefit from interpersonal transfers of the kind described is by state action and, going further, by state provision of access to artefacts, including those donated. The state can ensure that gifts are not re-sold, whereas profit-makers would prefer the option of a contract which allows re-sale, perhaps after a given period of time, so acquiring a beneficial if restricted property right. One prominent donor of valuable pictures to British museums and galleries has even specified that he would deny offering

support to those charging admission on the grounds that charging restricts access. On the other hand, the interests of donees may be different. For any given value of the benefits that donors have in mind, they could prefer to have control over its allocation in order to give expression to the choices of the heritage services that they wished to enjoy. It is doubtful if this option would appeal to donors who derive their satisfaction from their identification with a specific gift and are much less likely to offer support for heritage services.

Encouragement to the transfers of resources to fulfil the satisfaction derived from giving is a characteristic of policies of state intervention, as found in measures of tax exemption, for example by allowing deduction of their value from the tax base for inheritance taxes and legacy duties. Additionally, reference should be made to the transfer of real resources to support heritage represented by services in kind. This is of critical importance in the UK for both historic homes and museums and galleries where voluntary labour is offered, principally by retired professional people with an interest in heritage matters, to perform a great variety of tasks, notably as guides for visitors (see Chapter 3). However, there is no mechanism which would ensure that any voluntary transfer of resources will be as extensive or as uniform as to provide the services where it is considered by government to be most 'needed', that is to say to support those lacking the opportunity for economic and social reasons to have the opportunity and cultivate the desire to become enthusiasts for the conservation of their national heritage.

What cannot be denied is that there is ample evidence indicating an interest in the past in mature economies which extends beyond the conservation and display of its artefacts for the satisfaction of present generations towards the fulfilment of that function for future generations. This is presumably an extension of the deep-seated human desire to be remembered, notably present in the continuing existence of material bequests from parents to their families, but also entailing willingness to preserve artefacts that their successors hopefully will enjoy as property held in common. This desire is taken for granted by architectural historians, many of whom regard the most precious professional legacy that they have been donated from the past to have been conferred by John Ruskin and William Morris. One of our favourite quotations is from Ruskin's *Seven Lamps of Architecture* (1903, Chapter IV, *Works of John Ruskin*, Allen & Unwin, London): 'It is again no question of expediency or feeling whether we shall

preserve the buildings of past time or not. *We have no right to touch them.* They are not ours. They belong partly to those who built them and partly to all generations of all mankind who are to follow us'. William Morris in his *Manifesto for the Society for the Protection of Ancient Buildings* (1877) used more sober language, concluding his plea to save 'ancient buildings' by protection rather than by the need for restoration, with the words 'we must protect our ancient buildings, and hand them down instructive and venerable to those that come after us'.

These are admirable sentiments, forcibly expressed by influential thinkers, but the success of their appeal depended on their ability to induce their fellow citizens to change their behaviour or at least to examine their consciences in the hope that their campaign would achieve widespread support. We prefer to take human nature as it is, which, as we have indicated, certainly does not deny a strong and growing interest in preserving the past, but recognizes, once again, the 'isolation paradox' which bedevils the public goods problem. My willingness to provide funding for protection or preservation of historical artefacts may be secured, assuming that results can be enjoyed by all, only if others are willing to do the same. Also, the source of my willingness lies in the benefits that *I* enjoy in benefiting future generations in the hope that they will consider that the benefits to them will be positive. This uncertainty about the value of these benefits and the fact that future generations can have no say in what will be protected or preserved by way of historical 'treasures' reinforces the conclusion that only public authorities can remedy a situation where a market solution would not appear to be able to achieve the desired provision of historical artefacts demanded by the public. We are back to the familiar problem of how to ensure that the public authorities' decision-making process reflects, as far as possible, the tastes and preferences of the public (one can arrive at this conclusion without recourse to Ruskin's belief that buildings have rights of their own!).

An agenda for appraising public policy: a preview

A *prima facie* case having been made for public intervention, provided it reflects the wishes of those for whom heritage services are designed, we can now provide the general outline for an agenda to guide our further analysis.

1. It is accepted that the crucial role of the expert is to advise the public authorities on the historical artefacts, mobile of immobile, that deserve consideration for preservation and restoration. How this is done requires close examination. It does not necessarily imply that the contents of any list has to be confined to the advisers' choices, nor that they should have the absolute right to decide the order of priority in determining which items should be selected for heritage status. This is not to deny that considerable skill is necessary in identifying historical artefacts, in preparing an inventory when their location and provenance may be difficult to establish, and in predicting not only where archaeological evidence will emerge of hidden treasures but also how their own professional judgements may change as a result of discussion and debate amongst themselves. We believe that by examining the administrative organization of methods of supplying heritage services and analysing the behaviour of those who operate them that we can throw fresh light on some of the policy problems arising from public intervention (see Chapters 4, 6, and 8).

2. Making the general case for intervention involving a role for the public authorities which requires it to rectify under-provision of resources by the market can only be properly implemented if there is some sensible way of calculating the amount of resources required. Some method of valuation has to be used in order to take account of the public's demand for the current extension in available heritage services and also to take account of its demand for resources to benefit future generations. The underlying problem points towards some form of cost–benefit analysis comparing future benefits with current ones for alternative levels of current additional investment for heritage purposes (see Chapter 9). There are difficulties enough in producing meaningful results even when this technique can rely on the availability of reliable data and clear indications of the 'trade off' between the value of benefits provided now as against those available in the future, as is commonly encountered in large-scale government investment programmes. But the difficulties are magnified in cases where, in the presence of public provision, given the isolation paradox, it is problematic whether one can elicit the value attached to current benefits by present generations and their investment in heritage artefacts taken now. It is easy to see why governments sensitive to

voters' views on heritage seek a way out by convincing the latter that they should rely on the experts to undertake the valuation for them, although they may support procedures for offering the public some kind of a voice in the decision-making process. Economists have fairly recently offered the counter suggestion that there are ways of eliciting valuations of heritage projects in non-market situations and governments have paid some attention to their efforts (see Chapter 7). We must therefore report our own comments and criticism on these efforts.

3. Governments have in place a variety of ways of providing heritage services which include public 'production', as in the case of national museums, and the provision of grants and loans to (largely) non-profit making private organizations. These institutions and measures are designed to provide services in a way which largely sets the market aside and the use of competition as a method for stimulating efficient provision of services. Therefore, the economic analysis of the behaviour of those who are responsible in charge of state-owned or supported methods of provision can be extended to an examination of the consequences of their actions as agents of government policies (see Chapter 9). This leads naturally to a consideration of whether these policies accord with our own conception of the criteria that should be used to devise and appraise policies.

Further reading

Our emphasis on the derivation of the preferences of individuals, whether acting alone or in concert, from their subjective valuation of the choices of goods and services available to them automatically leads us to conclude that valuation cannot be left only to experts. As we have explained, this does not mean that individuals' choices cannot, in some sense, be improved by consulting those who have a specialized knowledge of the characteristics of historical artefacts which would increase their enjoyment of them. It is only right to point out that there are some economists who consider that this affords specialists the right to claim that their valuation of the treasures of the past is somehow separate and superior to those who have no expert knowledge. Where this leads to differences in approach

from ours is not in the economic analysis of cultural services, but in respect of policies towards them, and particularly in regard to whose opinion matters in devising such policies. In any case, the fact that experts frequently are the senior managers of the production of heritage services, that is to say gallery directors and custodians of built heritage, means that expert opinion on what we 'ought' to enjoy is in fact influential with governments and that in itself is a good reason for economists interested in government decision making to know something of how they arrive at their views.

The following two works might be rather tough going for those with no prior knowledge of economics but they should be brought to their attention. The *locus classicus* of this approach is *Economics and Culture* by David Throsby. Throsby is one of the most respected figures in cultural economics who has done much to develop the subject and to place it firmly into the mainstream of economic thinking. A complementary work spanning a wider field of speculation about the relation between aesthetics and economic is that of Gianfranco Mossetto—see his *Aesthetic and Economics*. This work requires a familiarity with welfare economics and is aimed primarily at Mossetto's peer group. One must add that the author, Professor of Economics at the University of Venice, also has an intense practical interest in the administration of culture and has played a major part in promoting improvements in the accessibility of Venetian art treasures and cultural events to an international audience.

It is only a step away to maintain that artefacts which are acclaimed as representing the highest achievements of the human race must be set aside and afforded special significance. Their contribution to making us better people seems proved beyond doubt and strengthens the case for paying particular attention to the views of the cultural *cognoscenti* and for endowing them with a special influence on cultural policy. Not so, writes John Carey who has written this splendid attack on the pretentious nature of such claims in *What Good are the Arts?* It will help the reader to relax after a strong dose of philosophical speculation and one does not have to accept his point of view in order to enjoy its vivacity of style and entertaining humour.

Finally, perhaps the last word should go to those whom we recognize as the *cognoscenti* and who are expected to guide us in our estimation of the value of heritage. Their views must command the greatest respect as advisers on the choices that have to be made in deciding on the dimensions and content of supply of heritage services. It would be

difficult to offer a better explanation of their legitimate position in this process than that of one of the most distinguished writers on the history of art in recent times, namely Ernst Gombrich. It is interesting that his defence of the authority of the art critic and historian is given *in extenso* in an essay entitled 'Art History and The Social Sciences'. He is clear that he cannot argue for his expertise as representing a claim of 'objective judgment'. Moreover, he recognizes that even if a consensus emerges amongst his fellow experts on the value of particular works of art, it is rarely if ever a stable one, a view that he substantiates in his demonstration of the inability of his kind to forecast the judgements of their successors—see E. H. Gombrich, *Ideals and Idols: Essays on Values in History and in Art*. What he does claim is that 'collateral information' based on the knowledge and practice of the arts is essential in order to make an informed value judgement and only his like are in a position to provide it. What the expert enables us to construct is what Mossetto (op. cit., chapter 6) labels a 'certification process', similar to that provided by consumer associations for more everyday goods and services. Gombrich's work also includes an enlightening correspondence with the art historian, Quentin Bell, where both agree generally that claiming that they offer 'objective judgment' in aesthetic matters is not sensible (see 'Canons and Values in the Visual Arts', Gombrich, op. cit., pp. 167–83). Quentin Bell sums up their joint positions as that of 'sitting on the fence', not willing to desert the ranks of their peers as judges as to what is good and bad art but at the same time not willing to claim that their value judgements must be paramount. He concludes: 'intellectually, sitting on the fence does not make a very comfortable seat; but affords a wonderful view of the scenery'!

References

Carey, John. 2005. *What Good are the Arts?*, London: Faber & Faber.

Gombrich, E. H. 1979. *Ideals and Idols: Essays on Values in History and in Art*, London: Phaidon Press.

Mossetto, Gianfranco. 1993. *Aesthetic and Economics*, Dordrecht: Kluwer Academic Publishers.

Throsby, David. 2001. *Economics and Culture*, Cambridge: Cambridge University Press.

3

Facing the facts

Introduction

Dealing with data may be perceived as dull and boring and perhaps we concede any possibility of keeping the attention of the reader by introducing our main topics with data about heritage concerning its relative importance in the choice pattern of resource use. This is a logical requirement, but we risk being regarded as apostles of that famous Dickensian Utilitarian, Mr Gradgrind, who worshipped facts. To avoid this charge, we have tried to reduce the strain on the reader by giving only main tables of data in the text and explaining the gap between what we want to know and what is known. An Appendix to this chapter explores some recondite matters on the preparation of descriptive statistics in case there are readers who are interested in their origin.

A notable feature in the cultural life of high-income countries is the growth of interest in preserving particular cultural traditions. These traditions are embodied, largely but not exclusively, in artefacts such as public, ecclesiastical or private buildings, outstanding artistic works, and sites of famous battles or burial grounds, all ascribed some historical significance or perennial emotional appeal. The activity of conservation is clearly necessary because buildings deteriorate and historic sites become overgrown, the former once destroyed being irreplaceable, at least in a physical sense, and the latter often otherwise untraceable. Governments and latterly international organizations have increasingly assumed that they have a particular responsibility to increase supply independently of demand pressures from the public. This reflects the influential presumption that there are obstacles in the way of relying on suitable responses by private

individuals or firms to achieve some preconceived optimal level of supply. This, in turn, is reflected in the increasing involvement of governments' financing and regulating of private sector provision and the extension of their own activities as custodians (and effectively owners) of immense collections of works of art displayed in publicly owned museums and galleries and the ownership of land containing historic sites (see Chapters 5 and 6).

Many different influences have produced a situation where interest in heritage has increased from the Antipodes to the Arctic. Certainly the increase in standards of living have reduced the relative cost of visiting heritage buildings and sites for a growing proportion of the working population, both through a rise in incomes, which has increased the demand for personal means of transport, and a reduction in hours of working, which has increased opportunities to make visits. However, heritage is only one of the alternative ways in which individuals and families can enjoy cultural events and pursuits. What is remarkable is the relative popularity of visiting heritage buildings and sites, and museums and galleries, compared with, say, attending performing arts events. Of course, participation rates must be influenced by the relative cost of cultural activities, particularly the influence of government support, and will vary through time depending on the incidence of policy changes and how these affect the cost to participants through subsidies to arts organizations or, in the case of heritage, on the incentives offered to or restrictions imposed on private suppliers of heritage services, such as the owners of historic buildings. This interaction of private and public influences on the demand for heritage must have an economic dimension which warrants further investigation.

At the same time, the 'economic importance' of culture, in terms of income and employment opportunities, is increasingly emphasized and, therefore, the allocation of resources in the cultural field is widely advocated as a tool to foster local development and to improve urban economic conditions. Again, the claims on resources need to be adequately supported by some form of measurement.

Heritage and descriptive economic statistics

Economists introduced to the economics of heritage through an account of this kind will be crying out for more precise definitions of the subject of discourse and, of course, some numbers. Before we can talk

about the growth, development, and possible future of heritage, we certainly must consider which activities correspond with its provision and represent these activities in some numerical form.

Conserving the past is an activity sanctioned by the wish of individuals, acting alone or as communities to preserve particular cultural traditions. As already observed, these traditions are embodied, largely but not exclusively, in artefacts, both public and private buildings, and outstanding examples of artistic works, as well as material items with a particular historical significance, such as battlefields. The activity of conservation is required to sanction the prevention of the destruction of these artefacts. The impetus to action is commonly assumed to lie with a national government, the general presumption being that the conservation of national identity is highly dependent on an appeal to a national heritage.

This preliminary attempt to define heritage follows conventional lines but raises different kinds of questions with different groups of specialists claiming a role in policy implementation, and frequently different answers to the same questions within and between each group. The specialized interests and expertise of economists lies in identifying the system of transactions which leads to the matching of supply with demand for heritage provisions, and in trying to explain the motivation of those who participate in that system.

Enough warning has been given that, so far as identifying and collating information to meet the requirements of the economist, we are in for a bumpy ride. We start with the attempts made to place the position of heritage in the economy and to show how that position has changed through time. This is conventionally done by totting up the expenditure on heritage, suitably defined, for several years and comparing it with the annual flow of goods and services in the economy as represented by its national income or what is called in technical language the 'Gross National Product' (GNP). Recognizing the point that heritage is one of a number of alternative means of spending on leisure pursuits and, in general, of allocating resources, one can add in a comparison of heritage expenditure with other cultural services, and with an indication of the relative position of heritage in different countries. Now consider Table 3.1.

The reader has every right to be somewhat bemused by what is presented and explanations are required. The reader should know that this table alone seems to have required a large amount of effort in order to produce a rather meagre set of results. This is confirmed by

Table 3.1. Initial estimates of the contribution of cultural industries to GDP for five countries

	Australia 1998–9		Canada 2002		France 2003		UK 2003		USA 2002	
	A$ millions	% GDP	C$ millions	% GDP	€ millions	% GVA	£ millions	% GVA	US$ millions	% GVA
Advertising	2,464*	0.5	2,856*	0.3	11,858*	0.8	5,000	0.7	20,835*	0.2
Architecture	788*	0.1	1,084*	0.1	2,524*	0.2	4,000	0.5	19,111*	0.2
Video, film, and photography	2,397*	0.4	3,909*	0.4	5,155*	0.4	2,200	0.3	39,076*	0.4
Music and the visual and performing art	952*	0.2	2,576*	0.2	3,425*	0.2	3,700	0.5	30,294*	0.3
Publishing / written media	6,590*	1.2	19,427*	1.8	11,283*	0.8	14,950*	2.1	116,451*	1.1
of which: Printing	5,640*	1.0	na	na	4,851*	0.3	6,350	0.9	45,662*	0.4
Radio and TV (Broadcasting)	3,474*	0.6	5,305*	0.5	4,878*	0.3	6,200	0.9	101,713*	1.0
Art and antiques trade	74*	0.0	1,082*	0.1	413*	0.0	500	0.1	195*	0.0
Design (including designer fashion)	313*	0.1	1,226*	0.1	363*	0.0	5,630	0.7	13,463*	0.1
Crafts	na*	na	na	na	na	na	na	na	na	na
Total of above	**17,053***	**3.1**	**37,465***	**3.5**	**39,899***	**2.8**	**42,180***	**5.8**	**341,139***	**3.3**
Total economy (GDP or GVA)	542,831	100.0	1,069,703	100.0	1,434,812	100.0	732,395	100.0	10,469,601	100.0
Libraries (including archives)	792.2 #	—	1,236*	0.1	na	na	na	na	1,112*	0.0
Museums	716.4 #	—	550*	0.1	148*	0.0	na	na	3,294*	0.0
Heritage sites	na	na	672*	0.1	na	na	na	na	508*	0.0
Electronic games	na	na	na	na	8,169*	0.6	20,700	2.8	129,636*	1.2

*OECD estimate.
income data.

Source: OECD (2006), International Measurement of the Economic and Social Importance of Culture.

the process by which these results were achieved (the reader wishing to penetrate further into the mysteries of preparation, is referred to the Appendix of this chapter, para. 1). It is clearly not what is required for our starting position, for it refers to a limited list of countries, only records one year of figures (and these are for different years), and there are gaps in even the most basic information required on heritage and museums. We are therefore not in a position to take this table as a framework for revealing useful data about, for example, the economic importance of heritage and, of course, even less about the various forms of heritage provision, how they are provided, what they cost and who enjoys them. Sometimes in economic investigation it is possible for the economists to rearrange existing data, usually requiring the help of those who have collected it, but number crunching of this kind requires time, patience, and particular skills—and there is often considerable uncertainty as to whether the end-product will be satisfactory. It is unattractive to researchers as reflected in the price of economics labour. In our case, the self-provision of statistics was impossible, if only because those who could help us would not necessarily be permitted to devote resources to an activity which might appear to represent an implicit criticism of the approach of their employers.

Faced with problems in presenting the structure and growth of heritage in economic terms, another method is frequently exploited, namely the use of data on *employment*. Table 3.2 is a compilation which gets as close as we are able to our requirements—but, as we shall see, still not satisfactorily close.

We have not even reached the stage of being able to separately identify heritage services. Some probing reveals that heritage is hidden somewhere in the category 'artistic and cultural activities' but the category itself is a mixed bag of activities including motion picture, video, broadcasting, together with news agencies and libraries, theatre and other performing venues as well as those employed in museums, archival centres, and heritage services. At a rough estimate, heritage services may represent about half of the total employment under this heading and therefore something like 1.2 per cent of employment in the identified cultural occupations. But the borders are blurred since employment linked with heritage might also be included, for instance, in the category 'architectural activities' as far as those involved in restoration projects are concerned (we shall not provide a guide through the labyrinth facing those who attempt to penetrate this murky area further, but an indication is given in para. 2

Table 3.2. Employment in cultural activities in 2002

In thousands	Publishing (221)	Artistic and cultural activities (921–5)	Retail sale of books, newspapers, and stationery	Architectural activities	TOTAL cultural activities	TOTAL employed working population	% represented by cultural activities
UE-25	**957.2**	**2,120.2**	**277.0**	**399.8**	**3,754.2**	**165,609.9**	**2.3**
[23 countries]							
Belgium	19.2	49.3	6.2	8.9	83.6	3,933.6	2.1
Denmark	26.1	33.3	5.3	7.7	72.4	2,613.4	2.8
Germany	262.7	414.0	60.9	88.0	825.6	34,364.4	2.4
Greece	16.1	41.0	5.1	7.4	69.6	3,277.6	2.1
Spain	66.6	165.8	20.9	30.2	283.5	15,118.3	1.9
France	95.4	284.8	34.2	49.4	463.8	20,705.7	2.2
Ireland	9.2	25.4	3.1	4.5	42.2	1,610.4	2.6
Italy	95.3	161.7	23.0	33.2	311.4	20,438.4	1.5
Luxembourg	1.0	1.5	—	—	3.0	183.8	1.6
Netherlands	67.0	103.2	15.3	22.1	207.6	7,626.5	2.7
Austria	18.6	38.3	5.1	7.4	69.4	3,469.0	2.0
Portugal	17.6	33.3	—	—	62.1	4,448.3	1.4
Finland	15.7	40.8	5.1	7.3	68.9	2,249.0	3.1
Sweden	24.2	72.5	8.7	12.6	118.0	4,207.4	2.8
United Kingdom	177.9	467.8	58.1	83.9	787.7	27,805.4	2.8

(*Continued*)

Table 3.2. (*Continued*)

In thousands	Publishing (221)	Artistic and cultural activities (921–5)	Retail sale of books, newspapers, and stationery	Architectural activities	TOTAL cultural activities	TOTAL employed working population	% represented by cultural activities
Czech Republic	14.1	54.5	6.2	8.9	83.7	4,427.4	1.9
Estonia	–	13.6	–	–	19.4	538.1	3.6
Cyprus	0.9	3.3	–	–	5.1	293.6	1.7
Latvia	–	11.3	–	–	16.2	813.1	2.0
Lithuania	8.0	21.5	–	–	36.0	1,121.7	3.2
Hungary	11.0	55.3	6.0	8.6	80.9	3,595.9	2.2
Malta							
Poland							
Slovenia	3.4	10.5	1.3	1.8	17.0	816.0	2.1
Slovakia	4.7	17.5	–	–	27.1	1,952.9	1.4
Other countries							
Bulgaria	8.2	28.6	–	–	44.9	2,452.6	1.8
Iceland	1.4	3.5	–	–	5.9	143.7	4.1
Norway	20.0	28.0	–	–	58.5	2,176.0	2.7
Switzerland	19.4	34.9	4.9	7.1	66.3	3,521.6	1.9

Source: French Ministry of Culture and Communication, Department of Studies and Prospective (DEP), 'Definition and production of harmonized Statistics on Culture in Europe' Batch 1: Cultural Employment, June 2004.

of the Appendix about the statistical expeditions to do so, including the hazards involved in trying to solve the vexed question of how to identify a 'cultural industry').

Before the reader grasps at this particular strand of information, at least we should tabulate some of the headaches that the poor statistician faces:

1. There is the vexed question of definition. This might appear to be simple, once the various organizations, private and public, whose main purpose is to supply heritage services have been identified— but how wide is the definition's scope? Statistics tend to be the by-product of administrative structures, with the result that if heritage services are split between different administrations, they may not use these definitions consistently among themselves and may have different perceptions about which data to collect to fulfil their objectives. A good example is to be found in the administration of museums in the UK. Without a detailed institutional knowledge, the economic investigator might not know that the administration of public museums is split between the cultural and defence ministries. The role of the former seems central to our interests, but this would be to neglect the military museums, notably the Royal Navy's National Maritime Museum at Greenwich and the Imperial War Museum in London, which attract thousands of visitors with a particular interest in past military events. In Italy similar issues arise with respect to museums managed at different levels of government (regional, provincial, local) as well as for those belonging to the Church, the most important being the Musei Vaticani which is one of the most popular heritage sites in Italy, visited by more than 3.5 million persons per annum. It is not even mentioned in the official ranking of most visited museums provided by the relevant Ministry, which covers only state heritage institutions.

2. Employment statistics are slippery customers whatever the economic question under investigation, notably in respect of trying to detect differences between types of employment, and its degree of intensity, for example whether it is whole or part-time employment. Part-time employment in heritage institutions is common, particularly in private museums which may only be open on certain days of the week or times of year, but the main problematic element is *voluntary employment*, particularly in the UK: important

heritage institutions such as the National Trust—relies heavily on voluntary support, notably from retired persons with an interest in domestic history. We shall consider later the conundrum of how to value these services, which arise in considering the costs of production. It is sufficient to say here that volunteers can make up as much as half of the staff in historic properties and in significant cases can be an even higher proportion.

3. At the time of writing, a long-standing discussion has taken place in international institutions, such as the EU and UNESCO, about the classification of 'culture', in international comparisons of culture's relative economic importance. These appear to favour an ingenious scheme devised for an erstwhile UK Secretary of state for Culture, Media and Sport which re-classified the arts as a dimension of so-called 'creative industries', divided into thirteen separate categories listed alphabetically as advertising, architecture, art and antique markets, crafts, design, designer fashion, film and video, interactive leisure software, music, performing arts, publishing, software and finally computing services, television and radio. It would take us far beyond the scope of our own enquiry to probe the logic behind this disparate grouping and the claim that all their activities or even any of them are in any meaningful sense 'creative' as compared to the inventions of new and improved manufacturing products in activities outside the list. However difficult to understand the logic, as Ruth Towse (2006, p. 4) has put it: 'Ministries of Culture have embraced (creativity) wholeheartedly: it empowers them to be in the forefront of the quest for economic growth. What the various categories appear to have in common is their dependence on copyright'. This is rather confusing for, as Towse has put it succinctly and pointedly, 'the link copyright, creativity and economic growth is made to seem a causal one, but in fact there is little evidence (on which) to base this assertion' (Towse, op. cit., p. 6).

However, we have to monitor our attempt to make international comparisons of the relative importance of heritage within the context of *the choices available to consumers* and if choice means a consideration of alternative ways of satisfying a demand for cultural sustenance by individuals, the juxtaposition of such strange bedfellows makes little sense. It is regrettable that the empire-building ambitions of ministries

of culture, which could have a rational basis if confined to the arts, have to be constructed around dubious attempts to justify their contribution to our welfare with reference to the pursuit of copyright protection. However, at least we know where we may have to continue to look for data on heritage within this curious pile of 'creative' activities, but it remains the case that international comparisons become increasingly difficult to make as does the argument for public support for heritage services, if detached from the choices of consumers, whether as direct purchasers or as members of an electorate.

The pattern of demand for heritage services

The basic difficulties of presenting information on the relative position of heritage in relation to other cultural opportunities can only be partly illustrated by concentrating on its supply characteristics. The other obvious procedure is to consider what is spent by those who support and enjoy heritage services either through the 'box office' or through their willingness to pay taxes to support them or, latterly, by participation in state lotteries which assign part of the winnings to 'good' causes. However, valuing heritage services by quantifying the public's willingness to pay taxes or to buy lottery tickets implies that there is a direct correspondence between payments made and the sums allocated to heritage purposes, which there is not. The 'budget' for heritage services will be part of the vote of a particular ministry and what is allocated to expenditure on supporting providers of these services in the form of subsidies and loans will require political approval and, importantly, the advice of government civil servants and the efficiency of the administration. In other words, we cannot give data on 'consumption' which aggregates both personal payments and 'assigned tax revenue' to each category of heritage services demanded because any assignment of revenue would not correspond to actual decisions taken within government. So it does make some sense to follow the common practice of estimating *household expenditure* only as a starting point for studying the structure of demand.

Table 3.3, based on OECD information, provides a picture of spending by households on cultural activities in the broad sense and for quite a wide range of countries, with expenditure expressed as a percentage of gross domestic product (GDP) (see Appendix, para. 3). Scepticism arises however, when one discoveres that 'recreation and

Table 3.3. Household expenditure on recreation and culture as a percentage of GDP

	1991	1992	1993	1994	1995	1996	1997	1998	1999	2000	2001	2002	2003	2004
Australia	6.5	6.6	6.9	7.2	7.4	7.3	7.4	7.4	7.4	7.4	7.3	7.2	7.2	—
Austria	6.4	6.6	6.7	6.5	6.3	6.4	6.4	6.6	6.8	6.9	6.9	6.7	6.6	—
Belgium	—	—	—	—	4.9	5.0	5.1	5.1	5.2	5.3	5.2	4.9	4.8	—
Canada	5.2	5.3	5.4	5.5	5.6	5.7	5.7	5.8	5.8	5.8	5.8	5.9	5.8	5.7
Czech Republic	—	—	—	—	5.6	5.9	6.4	6.2	6.1	6.2	6.2	6.2	5.9	—
Denmark	5.1	5.1	5.1	5.1	5.1	5.3	5.3	5.3	5.4	5.2	5.1	5.0	5.0	5.1
Finland	—	—	—	—	5.2	5.6	5.4	5.3	5.4	5.4	5.4	5.4	5.5	5.6
France	4.9	4.8	4.8	4.8	4.8	4.8	4.8	4.9	5.0	5.1	5.1	5.2	5.2	5.2
Germany	5.3	5.2	5.2	5.0	5.0	5.0	5.0	5.0	5.2	5.3	5.3	5.1	5.0	—
Greece	3.5	3.4	3.3	3.4	3.9	4.1	4.0	4.0	4.2	4.1	4.1	4.2	4.2	4.2
Hungary	—	—	—	—	4.5	4.4	4.2	4.1	4.1	4.3	4.4	4.3	4.4	—
Iceland	6.0	6.1	5.9	6.6	6.6	6.5	6.1	6.2	6.4	6.5	6.3	6.2	6.2	6.1
Ireland	4.8	4.8	4.6	4.4	4.1	4.2	3.7	3.5	3.1	3.3	3.3	3.0	2.8	—
Italy	4.3	4.4	4.4	4.4	4.3	4.4	4.4	4.5	4.5	4.6	4.6	4.5	4.4	4.5
Japan	6.0	5.9	5.9	5.7	5.6	5.5	5.5	5.5	5.5	5.4	5.4	5.3	5.3	—
Korea	3.9	4.0	4.0	4.2	4.3	4.2	4.0	3.4	3.6	4.1	4.2	4.4	4.0	—
Luxembourg	4.6	4.7	4.4	4.5	4.5	4.3	4.2	4.1	3.9	3.6	3.9	4.0	4.0	—
Mexico	2.2	2.3	2.3	2.2	1.9	1.8	1.9	2.0	2.0	2.0	2.0	1.9	1.9	—
Netherlands	5.5	5.4	5.4	5.3	5.3	5.2	5.3	5.4	5.6	5.4	5.4	5.4	5.1	—
New Zealand	5.4	5.5	5.8	6.1	6.3	6.5	6.7	7.0	7.1	7.3	7.1	—	—	—
Norway	4.7	5.1	5.2	5.3	5.4	5.5	5.5	5.8	5.8	5.2	5.3	5.6	—	—
Poland	—	—	—	—	—	—	—	—	5.1	5.4	4.7	4.6	4.7	—
Portugal	3.4	3.5	3.6	3.6	3.8	4.0	4.1	4.2	4.3	4.0	4.0	3.9	4.0	—
Slovak Republic	—	—	—	—	—	—	—	—	4.6	4.8	5.4	5.2	4.7	4.6
Spain	—	—	—	—	—	—	5.2	5.4	—	5.7	5.7	5.6	5.6	5.6
Sweden	—	—	5.3	5.2	5.1	5.1	5.2	5.1	5.6	5.7	5.8	5.7	5.7	5.6
Switzerland	5.3	5.3	5.3	5.3	5.3	5.2	5.2	5.1	5.2	5.1	5.0	5.0	5.0	4.9
United Kingdom	6.5	6.6	6.7	6.7	7.1	7.3	7.4	7.6	7.7	7.6	7.6	7.8	7.8	7.9
United States	5.5	5.5	5.7	5.9	6.1	6.2	6.2	6.2	6.3	6.4	6.4	6.4	6.4	6.3

Source: OECD, (2006), Factbook.

culture' includes expenditure on camper vans, tickets to football matches, and cinemas visits

In addition, the usefulness of any comparisons is vitiated by the large differences in the proportion of household expenditure on the total costs of the various services identified in this category, depending on the extent to which the providers of them are in the public or private sector.

But where is heritage expenditure in these broad categories? This is a good question. We can just about put together some sort of an answer with reference to the countries that we know best, but the data are hardly satisfactory. Thus Table 3.4 is the best we can obtain for Italy, however it does give a rough idea of the upward trend in expenditure in money terms. Similarly, for the UK (Table 3.5), but while more detail is given, it is felt that the miniscule amount of expenditure on museums and galleries and houses and gardens (Item 9423) while accurate, would need probing to find out if it conforms to what is generally perceived as heritage services, even allowing for the fact that the proportion of finance provided by central and local governments may be high.

Simply recording the expenditure on heritage—and we only obtain an approximation to that after intensive digging—gives no indication of the *volume* of the services obtained. In the case of a commodity such as soap, the physical counterpart to expenditure will be the

Table 3.4. Household cultural expenditure in Italy by type: year 2000 (million euros) and percentage change 1990–2000

Domain	2000	% Var. 00/90
Cultural goods and services	550.0	44.4
Museums and sites*	149.8	124.6
Performing arts*	400.2	27.4
Cultural industries	9,162.5	8.6
Press	2,482.1	−21.0
Books	2,870.0	14.9
Radio	131.2	7.3
Television**	1,954.3	77.6
Cinema	529.4	17.5
Home-Video-DVD	627.4	20.3
Recorded music	568.1	−6.5
Total	**9,712.5**	**10.1**

* Income from ticket sales.
** Increase rate is mostly due to the introduction of Pay-TV.

Source: Rapporto sull'economia della cultura in Italia (1990–2000).

Table 3.5. Components of household expenditure in UK 2005–06 (based on weighted data and including children's expenditure)

	Average weekly expenditure all households (£)	Total weekly expenditure (£ million)	Recording households in sample	Percentage standard error (full method)
9 Recreation and culture	57.50	1,427	6,706	2.0
9.1 Audio-visual, photographic, and information processing equipment	7.60	188	2,250	5.3
9.2 Other major durables for recreation and culture	1.90	48	167	16.4
9.3 Other recreation items and equipment, gardens, and pets	10.10	251	4,614	3.6
9.4 Recreational and cultural services	17.90	444	6,395	2.7
9.4.2 Cinema, theatre, museums, etc.	1.90	46	1,097	5.1
9.4.2.1 Cinemas	0.50	13	625	5.2
9.4.2.2 Live entertainment: theatre, concerts, shows	1.00	25	353	8.5
9.4.2.3 Museums, zoological gardens, theme parks, houses and gardens	0.30	08	261	9.4
9.5 Newspapers, books, and stationery	6.50	161	6,092	1.8
9.6 Package holidays	13.50	335	1,110	4.5

Source: Family Spending 2005/6—A report on the Expenditure and Food Survey http://www.statistics.gov.uk/download/theme_social/Family_Spending_2005-06/Familyspending2005-06.pdf.

Table 3.6. Museum statistics for Europe 2003

	Number	# visits	% free	Income	Entry fees	Staff	Participation
Finland	201	91	37	19.6	8.7	1,590	37
France	2,729	111					23
Germany	384	121	47	81.0			33
Italy		52				1,735	28
Latvia		62				223	59
Luxemburg	26	43	24	6.0			32
Netherlands	541	130	30	414.4	56.9	8,935	32
Norway	146	183	46	236.9	18.9		45
Portugal	218	59				2,648	16
Romania	519	7					
Slovak Republic	102	72	23	17.1	2.1	2,292	
Spain	878	106	56			10,951	22
Sweden	184	185	43	327.6	30.7		52
UK	1,102	127		491.0		16,777	42

Key: Number (of museums opened at least 200 days a year), #visits (visits per 1,000 inhabitants), %free (percentage of free admissions of total visits), income and entry fees (millions euro), and participation (percentage of population of 14 years and older who have visited a museum in 1994. #visits for Germany is excluding free entries and for the UK is based on visits to 1,182 out of 1,850 responding museums.

Source: Van der Ploeg (2006).

number of bars purchased. In the case of heritage services, we have to identify a similar measure. This is found in the *intensity* of use, a commonly used indicator being the number of visits paid to view treasures of the past. Here we can penetrate a little further into the murky world of cultural statistics, as Table 3.6 indicates.

The results are intriguing rather than useful. The data are not comprehensive enough nor sufficiently reliable—far less strictly comparable—to allow us to begin looking for generalizations which would make us all, including museum and heritage directors, better informed. For example, is there any close relationship between the incidence of charging for services, for example by a payment for entry into a building offering heritage services, and the number of visits? More comprehensive data, including some qualitative ones, covering a number of years would be needed to try to assess the existence of any sound correlation. Further analysis might examine the relationship, if there is any, between income level and attendance, and comparisons between the time trend of visits between the various countries. And so the list could be extended, but far beyond the weight which our slender data can bear.

It will clearly take time to persuade those concerned with heritage policy that their decisions might depend on assessments of its results as depicted in data, but there are some indications of a somewhat sluggish movement in this direction. One example is found in Table 3.7 which illustrates the intensity of use of cultural services, including museums, in different countries. Again, such data gives rise to questions which can only be answered by more comprehensive figures, notably in order to check whether policies directed to increasing participation are actually working as indicated by the time trend. (Peacock had some difficulty in getting the Arts Council of Great Britain (of which he was a member) to supply information about participation rates in the performing arts. The usual reasons offered by officials were about cost and the unreliability of results, but what was probably in their minds was a fear that the data would not confirm that policies claimed to increase participation were actually working.)

The importance of institutional structure

We treat heritage provision as a 'market', but one where demand is expressed not only through direct payment for services but through

the political process, and where the volume and structure of supply has to be related to demand forces. This extended view of the function of a market forms the basis Chapter 4, where we show how it influences how we think about analysing the motivation of those who participate in its workings. However, we must be careful not to offer a distorted picture of reality. It is the very nature of preserving the past that it cannot be re-created but only revealed, although this does not prevent enterprising rogues from inventing history.

The process of revealing the past requires a particular expertise, as does advice on how it is to be preserved. Even those sceptical of relying on interested parties to provide the necessary information to enable them to fulfil their role as custodians of our heritage have to come to accept that they must trust expert judgement. That there is justification for this, not only on pragmatic but also on philosophical grounds is argued in Chapter 2. Our present concern with 'facing the facts' requires something to be said in advance about *the relative roles of the public and private sectors* as providers of heritage services; this will act as a guide to the data which are designed to illustrate the influential importance of both.

It should be noted that the principal, but not exclusive, role of deciding what should be preserved and of taking responsibility for the task of preservation is generally assigned to the state. Intervention in the heritage 'market' can no longer be represented by expenditure data, although, as we shall see, some data are available in reasonably

Table 3.7. Cultural participation in eight European countries

	Historical monument	Museums or galleries	Concert	Public library	Theatre	Ballet or opera
Netherlands	71	62	56	51	58	26
Belgium	54	42	40	37	33	17
France	54	43	35	33	23	19
Denmark	76	65	58	68	40	27
Finland	63	51	51	72	48	23
Italy	49	34	31	29	26	20
Spain	50	38	34	29	25	12
UK	61	49	40	53	41	20

Source: The Eurostat News Release (2007).
Key: Percentages of population that visited a historical monument, museums or galleries, a public library and have been to the theatre, to a concert, to the ballet or opera.

malleable form (see Chapter 8). In fact, a major form of intervention is in the form of *regulation*, principally in the identification of buildings of historic importance, their grading in terms of significance, and the formulation, sometimes by both central and local government, of rules governing permitted methods of preservation and restoration, including the extent to which buildings simply become monuments, may continue to be used as residences, or be converted into business centres. The reliance of governments on expert advice from art historians, architects, planning experts, and so on must lead them to be arbiters of taste. This must constrain the choices of the individuals who favour heritage in principle but are not as a matter of course consulted on the decision making in practice. As shown later (see Chapter 8), deriving information to fit with our statistical formula from official sources is difficult, despite the fact that the economic impact of regulation can be considerable.

At the same time, one would like to have illustrated the dimensions of government participation and control on a comparative basis by reference to the relative growth in public and private *ownership of* the sources of supply of heritage services and for a number of countries. This would be an ambitious undertaking at the best of times, and might, at a rough guess, take about five years of digging; the data immediately available is meagre to say the least. What we are able to present are two tables for a particular point in time, one for Italy and one for the UK (Tables 3.8 and 3.9), which present what we believe is a useful indication of the kind of questions that not only inquisitive academics but also policy makers might wish to ask about heritage provision. First of all, once again, further questions arise because of the differences in the composition of supply between Italy and the UK, as far as the role of the public sector is concerned—the latter mainly relying on independent museums while the opposite holds for Italy. At the same time, a similar pattern is revealed when the role of local authorities is taken into account, since in both countries, notwithstanding the major difference, there seems to be evidence of a tendency towards devolution (see Chapter 8). Moreover, it is another example of an intriguing list which might lead one to speculate why certain kinds of museum are concentrated in central or local government hands and others in the hands of the church, universities, or other parts of the private sector.

But speculation cannot lead to proper analysis without further probing into the content of each category of activity and how it varies

Table 3.8. Italian museums and similar institutions by ownership and type of collection

				By Ownership			
	State-owned museums	University-owned museums	Regional-owned museums	Other local-owned museums	Other public-owned museums	Private-owned Museums	Total
N.	492	221	86	1.695	150	1.146	3.790
%	13,0	5,8	2,3	44,7	4,0	30,2	100,0

			By type of collection			
	Art and archaeology museums	History museums	Science, natural history and technology museums	Ethnology and anthropology museums	Other museums (Specialized, Regional, General museums)	Total
N.	1.915	306	537	250	782	3.790
%	50,5	8,1	14,2	6,6	20,6	100,0

Source: European Group on Museum Statistics (EGMUS), 'A Guide to European Museum Statistics', Berlin 2004 (http://www.mdc.hr/ UserFiles/File/Guide-to-European-Museum.pdf, 2, April2007).

Table 3.9. Number of UK museum sites in the Registration Scheme by ownership, 2003

Government agency	34
Independent	730
Local authority	691
National	52
National Trust	156
Armed services	100
University	87
Total	1,850

Source: European Group on Museum Statistics (EGMUS), 'A Guide to European Museum Statistics', Berlin 2004 (http://www.mdc.hr/ UserFiles/File/Guide-to-European-Museum.pdf, 2 April 2007.

through time. However, such an investigation is unlikely to produce relevant information, and is comparable with the results of similar analysis carried out in the private sector. In fact, when dealing with private supply, changes in the structure of that supply (i.e. births, deaths, mergers) offer an indicator of the vitality of the economic sector under scrutiny. It can be easily forecast that no measure as such would apply to the heritage sector, since it is almost impossible to find evidence of institutions which are shut down because of a lack of visitors and are, therefore, not financially sustainable. As a consequence, at the 'macro' level, the aggregate supply will increase through time or, at least, not decrease, regardless of whether or not these optimistic figures are representative of the 'health' of the sector.

Finally, for a better understanding of the different roles played by public, private, and non-profit actors, information would be needed on private sector support and the various forms it can assume. No systematic sources of information which offer reliable and comparable figures across countries are available and, interestingly enough, this is the area where major differences are known to occur across countries.

Some politics of statistical presentation: a parable

All the above caveats, doubts, and reservations are boring but important: imagine now that you have to overcome them in order to satisfy the curiosity of some enthusiastic young Minister of Culture who wants to impress his Cabinet colleagues with an understanding of his department's knowledge and his own grasp of detail. 'Lead on the

statisticians, please, and provide me with suitable information on the demand for heritage services covering the last twenty years so that I can find out what happened under previous regimes and, hopefully, show how badly heritage was treated by previous governments of a different political complexion!' The task is not easy, especially if we recall the aphorism that politicians use statistics the way drunks use lampposts: for support rather than illumination.

You would be able to devise a format for the statistical series, something like the one shown in Table 3.10.

Your experience suggests that you present him only with this general information and see what he makes of it, knowing that Ministers soon discover that they are inundated with information from all sides and can only absorb a limited amount of it, given the pressures of their job. But you are ready with subsidiary tables in case he has got some more questions up his sleeve. So it is useful to offer comparative figures from other countries (e.g. if you are a member of the EU) and further breakdowns of the general statistical series to show how heritage demand compares with demand for other forms of cultural activities.

Your Minister gets unhealthily interested in heritage problems—perhaps because his constituency prides itself on being an area of great historical interest to tourists. He is also reminded of this by the *cognoscenti* in the world of the arts, whose livelihood and professional standing depend on architectural design or who are in the forefront of intellectual discussion of the cultural value of paintings and sculpture best able to enhance our national prestige. He notices that when he has time to read Annual Reports of heritage providers, their managements give particular prominence to the growth in 'inputs' as a measure of

Table 3.10. Demand for heritage services 1985–2000

	1985	1990	1995	etc.
Paying for heritage				
(i) Admission charges				
(ii) Subscription payments				
(iii) Private donations				
(iv) Government grants				
Volume of services provided				
(i) Number of visitors to Sites				
(ii) Number of visits				

progress. Indeed, the Minister's own department may embody volume indicators, such as the growth in the number of historic sites under the charge of the relevant provider or the growth in buildings listed for conservation, in the 'performance indicators' used to assess the efficiency of the division or agency responsible for the conduct of heritage policies. It is very much in the interest of managements to concentrate the attention of politicians on the indicators of 'progress', which are more under their control than the number of visitors to historic sites, etc. who can find alternative uses of their leisure time. Notwithstanding the professional politics of statistical preferences, the information on inputs is of considerable importance within the general context of arts policies, where comparisons with other cultural services are of public interest. The relevant data can be gathered as shown in Table 3.11.

Your Minister attends an EU conference on 'the creative impetus and cultural interchange in a world of globalization' (or a similar grandiose theme) and discovers that his confrères are just as committed to a policy designed to improve 'inclusivity' in the arts. But they have a statistical base for analysis which he has not thought about: the participation rate in cultural activities by different social and economic groups which purports to show their relative popularity. 'So, back to work, please, and prepare me suitable tables which, it is to be hoped, demonstrate that we emulate our EU partners in the progressive nature of our policies.' This may very well be an area that officials have thought a lot about, including the problems associated with official surveys of participation, but are all too aware of the difficulties, not to speak of the expense, of carrying them out (see Chapter 4). Moreover, this is another source of possible enquiry into

Table 3.11. Growth of heritage inputs

	1985	1990	1995	etc.
Inputs				
Number of heritage sites				
Value of preservation and restoration expenditures				
Labour input				
(i) Wages and salaries				
(ii) Volume				
a. Full-time				
b. Part-time				
Number of listed buildings				

Table 3.12. Level of participation in cultural activities

Activity	Percentage of adults visiting by year			
	1985	1990	1995	etc.
Historical site visit				
Libraries				
Museums and galleries				
Arts events (theatre, opera, ballet, concerts)				

the efficiency of managers that they feel they can well do without (one of us remembers how difficult it was to push the Arts Council of Great Britain some years ago into devoting resources to this form of analysis). Apart from the Minister's particular interests, such information must achieve some resonance with those with a reasonable claim to comment and criticize official policies (including the present authors), particularly if governments desire and commit themselves to improving access to cultural events. Table 3.12 is a 'mock-up' of the kind of information which enables the Minister to look his counterparts in the EU in the face.

Obviously, such a table is a strong candidate for decomposition, for policies to promote cultural activities through the encouragement of government presuppose further detailed information about participation, past and present (a good example being offered by 'Taking Part' the annual national survey commissioned by the Department of Culture, Media and Sport). To take heritage alone, it is necessary to know the frequency of visits, the relative popularity of historical sites by region and type of site (e.g. castles, historic homes, churches, battlegrounds, etc.), by social and economic groupings, by age, and so on. The incentive to seek such information may extend to private providers who rely on direct payments by visitors and subscribers.

The cold douche of reality

Of course, the 'Parable' above is something of a fantasy. The poor statisticians and the attendant economist waiting for them to adapt their data to fit with the informational requirements of the tables would be in a quandary, for the data may simply not be available in most countries, even those with a particular interest in the development of heritage policies. This is a reflection on the refusal of governments at all

levels and their advisers to recognize its relevance, possibly because cultural policies, in the narrow sense of expenditure on the arts, while of growing importance in general policy discussions—for reasons already adumbrated—is miniscule alongside the voracious demands for the public expenditure required to fulfil social policies, such as health and education, not to speak of defence and law and order.

An interesting sidelight on this problem is provided by Rick van der Ploeg, a very well-known economist who was also for three years (1999–2002) State Secretary for Education, Culture and the Sciences of the Netherlands. It clearly shocked him to find that, as he has put it, '(no) good comparable data on sizes of cultural sectors for the countries of Europe exist. Still, local and national governments of Europe spend substantial resources on culture and cultural sectors contribute significantly to employment and national income' (van-der Ploeg 2006, p. 1184). His article is itself an interesting exercise on how to manufacture 'bricks without straw', through various acts of statistical manipulation, so that a reasonable attempt can be made to reach conclusions about the thrust of official policies.

So far as heritage is concerned, we fared no better. The raw data may exist although buried in a myriad of official reports, particularly those which represent a legal requirement for institutions wishing to produce intelligible annual accounts (see Chapter 4 for examples). The situation is changing in Italy and especially in the UK now that official interest extends to using an economic defence to justify heritage as an important contributor to 'invisible income from abroad' resulting from tourism. However, we are in a similar position to van der Ploeg and the data above are marked by the pronounced lack of detail necessary to analyse the links between policy aspirations and the actual outcome of chosen policies expressed in quantitative form. Like him we have used a certain amount of *legerdemain* to press the data into a form in which a coherent story can be told about the nature of heritage activity.

Looking ahead

So far we have stuck fairly closely to the statistical path that is prescribed by the way that economists look at the presentation of cultural data, particularly in the heritage field (further examples are to be found in the Further reading at the end of the chapter). But one of the reasons for writing this book is to emphasize that cultural policies are not

developed in democratic societies by the issue of decrees by all-powerful Ministries of Culture, but are a matter of negotiation between policy makers, public officials, providers of cultural services, and, last but not least, the general public who finance all their activities.

The economic analysis of heritage institutions must therefore consider the financial relations between these various 'stakeholders' involved in the provision of services which slake the thirst of a large proportion of the adult population for information and interpretation of their past. These relations are expressed in quantitative form in the accounts of heritage institutions and reflect their behaviour. Economists are associated with attempts to generalize about the economizing behaviour of firms and households which, when aggregated, provide the material on which generalizations about economic development are made. This material is essential in the formulation of government policies, including the determination of limits to government intervention. It is an error to suppose that, as most heritage institutions are not profit-making concerns and are not financed principally by contributions paid directly to them by those who wish to benefit from their services, it is beyond the scope and the understanding of economists to apply similar methods of analysis to study their behaviour. It follows that any attempt to quantify the effect of such behaviour also requires a particular statistical framework, labelled 'social accounting', to express the interaction between the stakeholders, even if the collation of data may be as difficult as in the conventional use of it just described. But that merits separate treatment, which is the subject of Chapter 4.

Appendix: The preparation of descriptive statistics

1. The collection of data on cultural activities for the purpose of making international comparisons is of fairly recent origin. While independent investigators may have attempted to adapt national statistics for this purpose, it is clearly more convenient if the task is taken over by some international body with a remit from member countries. Not surprisingly, UNESCO took an interest in undertaking this role in 1972 and was followed by the EU, and the obvious experience and skills of OECD in the collation of national economic statistics has resulted in considerable efforts to build on earlier attempts. Additionally, other international organizations have been interested in cross-border studies of cultural activities, a notable example being the World

International Property Organization. The various tables in this chapter which cover cultural activities as a whole, while separately identifying, so far as that is possible, heritage provision, are derived from three main sources:

(a) OECD, 'International Measurement of the Economic and Social Importance of Culture';
(b) EU Commission, 'The Economy of Culture in Europe';
(c) Council of Europe/Ericarts, 'Compendium of Cultural Policies and Trends in Europe'.

In some cases, as in France and the UK, the individual countries have assembled comparative international data through their Ministries of Culture. See, for example, Andy Feist *et al.*, 'International Data on Public Spending on the Arts in Eleven Countries' and French Ministry of Culture DEP, 'Definition and production of harmonized Statistics on Culture in Europe'. This latter report, however, is more than a study since it represents the first chapter of the Eurostat project 'Implementation of the EU methodology for statistics on cultural employment', on which Table 3.2 is based. In both these sources, it is carefully explained that there are gaps in the information provided and that some of the statistics may be unreliable. A more specialized but valuable source of data which aids the understanding of the economic activities of museums is to be found in the European Group on Museum Statistics (EGMUS) 'A Guide to European Museum Statistics'.

There are clearly major difficulties in arriving at uniform definitions of culture and for the heritage component in making international comparisons, particularly one which is recognizable as a contribution to economic analysis in which the relation between supply and demand can be expressed. The UNESCO framework did include Cultural Heritage as a separate category amongst the ten categories identified, but adopted a very wide definition of culture in which cultural activities such as Sports and Games were unlikely to be competing substitutes with heritage services. Latterly, recognition of the so-called 'economic' contribution of culture has been dominated by the concept of 'creative industries' (see Chapter 2 for a critique of this concept) which takes us even further away from an attempt to produce data for economic analysis. A particular interest of the EU has been the preparation of statistics which demonstrate the relative importance of cultural services by reference to employment. Here the above difficulties

are compounded by the problem of homogeneity, particularly in the heritage sector, because of the incidence of part-time and voluntary employment. Employment is also a sensitive subject in EU cooperation on economic policy, principally in cultural activities where employment prospects are uncertain. The possibility that cultural activities, including employment in museums and galleries and built heritage, are dependent on government grants, must stimulate the interest of employers in seeking some protection for employees through government action and therefore in being included under the statistical umbrella of culture.

2. The reader will have noticed that the main tables record comparative data mainly for a single year, and not always for the same year for each country. This severely limits the economic information that one hopes to derive from international comparisons. It is difficult enough to offer firm definitions of cultural activities and to identify heritage services within them, but unless one has data on a series of years, statistical analysis cannot reveal anything useful about some important economic relationships, for example that between growth in particular services, growth in personal expenditure, and the changing pattern of cultural provisions between the public and private sectors which can affect changes in relative prices, depending on the relative importance of various sources of income. The one exception that we are able to provide is Table 3.3 compiled from OECD sources (OECD, 'Factbook', 2006), but in that case the data refer only to household expenditure and it has not been possible to single out heritage provision from the broad category of 'recreation and culture' as recorded in that table.

3. Economic analysis is bound to pay particular attention to identifying the division of heritage provision between the public and the private sector, particularly, as Chapters 4 and 5 should make clear, how this division of responsibility represents different ways of making provision, determined in large measure by who 'holds the purse strings' and what effect this has on the choice of policy objectives. One might imagine that the government accounting system would automatically reveal data on the flows of income and expenditure of museums and galleries and heritage services provided within the orbit of the state and, with growing state support to the private sector, would do likewise in producing comparable data from private beneficiaries (which would have to be submitted in order to arrive at the

form and amount of such support). Unfortunately, this is not the case. Even if the political and administrative objections to revealing the outcome of such data provision could be overcome, there are both methodological and practical problems encountered. For example, one can enter into endless argument about how to assign providers or services to the public or private sector. The division itself does not necessarily guide one as to the degree of influence on the private as well as the public sector occasioned by such controls as regulation of conservation. A further example is provided by the lack of incentive for ministries of culture to collect data on the relative size of the private sector when their policy remit is largely confined to the oversight of the public institutions, including those assigned some degree of independence in their mode of operation, as instanced in the British case with so-called Non-Departmental Public Bodies (NDPBs), notably museums. This extra statistical burden would require some official definition of 'private' heritage provision and the possible clamour for recognition by all manner of folk and other museums and with it privileges for favourable tax treatment and other indirect ways in which government support can be obtained. However, a description of different institutional provisions for each EU country can be found in the national country profiles in the Council of Europe/Ericarts publication (2007).

Finally, one should notice that much attention has been paid to the collection and interpretation of national statistics in the case of the two countries—Italy and the UK—which provide the bulk of our illustrations. For instance, Tables 3.8 and 3.9 provide data on the relative roles of the public and private sectors and can be representative of the insights deriving from the comparison of these two countries. Further information can be found for specific fields of analysis, for instance a very detailed work undertaken in Italy refers to the sectoral employment in heritage provision and ample evidence is contained in a Report of the Associazione Italiana di Economia della Cultura ('Rapporto sull'-economia della Cultura') which also provides a dynamic perspective of the evolution of the cultural field in Italy in the period 1990–2000, paying attention to the economic issues discussed above. A similar attempt to marry the data collection on the characteristics of the built heritage with the requirements of economic analysis is now being carefully examined by English Heritage, which is a good example of an NDPB, and therefore a government agency, but one which is partly

financed by charges for admission to historical sites and buildings. One reason for this is the growing interest in methods of appraisal of the value of heritage put forward by economists and which are examined in Chapter 7. From such a point of view, detailed information on the main features of the supply and demand of heritage is provided by English Heritage in the Report 'Heritage counts. The State of England Historic Environment'. As far as museums and galleries are concerned, a rich and stimulating source of data and information on some economic and social aspects is offered by the Travers' report on museums and galleries in Britain, commissioned by the Museums, Libraries and Archives Council (MLA) and the National Museums Directors' Conference (NMDC).'

4. Finally, it is worth mentioning that almost all the statistical references quoted in this Appendix, which have provided the basis for the analysis developed in the chapter, have been found surfing the internet, as can be easily seen by the references to websites. This is an example of how technology might be helpful in overcoming asymmetries in information (see also Chapter 9), as well as in fostering international exchange of information and how its potentialities are largely unexploited because of the lack of suitable inputs, that is reliable information. At the same time, this kind of information, when compared with the information available in the more traditional printed official reports, is likely to be subject to greater obsolescence, the reason being that when websites are updated, the existing files and documents are sometimes substituted by new ones. Therefore, a reference to the date of consultation is invaluable, otherwise tracing back to the source of reference might be very difficult.

Moreover, if data available on the internet are not of good quality—partly because their distribution and use is much easier than it was in the past and, therefore, the data are open to everybody—it reinforces the phenomenon outlined more than thirty years ago, by public policy analyst Max Singer in his article 'The vitality of mythical number' (1971): once a statistic is produced (regardless of whether it is correct) and circulates, it is quoted, becomes 'autonomous' and officially enters the debate. Although Singer's original field of investigation was crime and drug addiction, the idea deserves attention and the previous discussion on cultural/creative industries might offer an interesting area for assessing its validity.

Further reading

Alongside recording the statistical sources listed in the Appendix, the reader may find it useful to consult the following works which cover the main methodological problems which are encountered in preparing statistical series. There may be no lack of ingredients in the form of raw data, but assembling them to represent an acceptable 'dish' is hard and grubby work! (the analogy with 'cooking' is well established in the statistical world where it may be difficult to penetrate the mysteries of how the final results were achieved!). The approach to data collection and presentation may be of interest as contained in Alan Peacock's 'Public Financing of the Arts in England'.

Moreover, the issue that data are not relevant per se but in the light of their use for cultural policy and the implications in an international perspective are carefully investigated by Mark Schuster in a paper entitled 'Informing Cultural Policy. Data, Statistics, and Meaning'. International Symposium on Cultural Statistics *"Statistics in the Wake of Challenges Posed by Cultural Diversity in a Globalization Context"*, organized by UNESCO and Institute for Statistics Observatoire de la culture et des communications du Québec Montréal in 2002. This issue will be explored further in Chapter 8 where attention will be devoted to public intervention.

The difficulties of gathering suitable data and information as tools for policies are stressed by Rick van der Ploeg in 'The Making of Cultural Policy: A European Perspective'. (van der Ploeg is an economist who held the post of State Secretary for Education, Culture and the Sciences in the Netherlands (1999–2002).)

The most extensive survey and commentary on the methodology of data collection for the conduct of cultural policy is provided in: Christopher Madden's paper 'Indicators of Arts and Cultural Policy: A Global Perspective'. This article is particularly useful for its criticisms of current practice basing them on the quotation that heads it from Albert Einstein: 'Not everything that can be counted counts, and not everything that counts can be counted.'

The question as to what constitutes a 'creative industry' has become a central issue in deciding on the priorities of data collection that define the remit of cultural services supported by the government, including the use of copyright protection. How this impinges on heritage policies is far from clear, but clarification of the issues is clearly set out in Ruth Towse's Inaugural Lecture as Professor of the

Economics of Creative Industries at Erasmus University, Rotterdam. She has played a key role in the development of cultural economics, including heritage policy, which has also been a special interest of hers, and, as the title of her lecture indicates, she has much of interest to say on cultural economics in general: Ruth Towse, 'Copyright and Creativity: Cultural Economics for the Twenty-first Century'.

References

Associazione Italiana di Economia della Cultura. 2006. 'Rapporto sull'economia della Cultura'. Associazione Italiana di Economia della Cultura.

Council of Europe/Ericarts. 2007. 'Compendium of Cultural Policies and Trends in Europe', 8th edn (http://www.culturalpolicies.net, accessed 2 April 2007).

Department of Culture, Media and Sport. 2007. 'Taking Part: The National Survey of Culture, Leisure and Sport. Annual Report 2005/2006' (http://www.culture. gov.uk/Reference_library/rands/taking_part_survey/, accessed 14 January 2008).

English Heritage. 2006. 'Heritage Counts. The State of England Historic Environment' (http://www.english-heritage.org.uk/hc2006/upload/pdf/HC_2006_ NATIONAL_20061114094800.pdf, accessed 2 April 2007).

EU Commission. 2006. 'The Economy of Culture in Europe' (http://ec.europa.eu/culture/eac/sources_info/studies/economy_en.html, accessed 2 April 2007).

European Group on Museum Statistics (EGMUS). 2004. 'A Guide to European Museum Statistics', Berlin (http://www.mdc.hr/UserFiles/File/Guide-to-European-Museum.pdf, accessed 2 April 2007).

Eurostat New Release. 2007. 'Cultural statistics. The cultural economy and cultural activities in the EU27', n.146 (*http://epp.eurostat.ec.europa.eu/pls/portal/docs/PAGE/PGP_PRD_CAT_PREREL/PGE_CAT_PREREL_YEAR_2007/PGE_CAT_ PREREL_YEAR_2007_MONTH_10/3-29102007-EN-AP.PDF*, accessed 14 January 2008).

Feist, A., R. Fisher, C. Gordon, C. Morgan and J. O'Brien. 1998. *International Data on Public Spending on the Arts in Eleven Countries*, Arts Council of England, Research Report no. 13.

French Ministry of Culture DEP. 2004. 'Definition and Production of Harmonized Statistics on Culture in Europe', Batch 1: Cultural Employment (http://www.culturestatistics.net/cultureemploymentfinalreport.pdf, accessed 16 February 2007).

Madden, Christopher. 2005. 'Indicators of Arts and Cultural Policy: A Global Perspective', *Cultural Trends*, 14(3) September, pp. 217–47.

OECD. 2006. 'Factbook' (http://oberon.sourceoecd.org/v1=23729348/c1=15/nw=1/rpsv/fact2006/10-02-02.htm, accessed 2 April 2007).

OECD. 2006. 'International Measurement of the Economic and Social Importance of Culture' (http://www.oecd.org/dataoecd/26/51/37257281.pdf, accessed 2 April 2007).

Peacock, Alan. 2003. 'Public Financing of the Arts in England', in David Miles, Gareth Myles, and Ian Preston (eds), *The Economics of Public Spending*, Oxford: Oxford University Press, pp. 341–72.

Schuster, Mark. 2002. 'Informing Cultural Policy. Data, Statistics, and Meaning', in Proceedings of the International Symposium on Cultural Statistics *Statistics in the Wake of Challenges Posed by Cultural Diversity in a Globalization Context*, organized by UNESCO and Institute for Statistics Observatoire de la culture et des communications du Québec Montréal, available at http://www.colloque2002symposium.gouv.qc.ca/h4v_page_accueil_an.htm, accessed 2 April 2007.

Singer, Max. 1971. 'The Vitality of Mythical Number', *The Public Interest*, 23, Spring, pp. 3–9.

Travers, Tony. 2006. 'Museums and galleries in Britain. Economic, social and creative impacts', Report commissioned by the Museums, Libraries and Archives Council (MLA) and the National Museums Directors' Conference (NMDC) (http://www.mla.gov.uk/resources/assets//M/museums_galleries_in_britain_10528.pdf, accessed 14 January 2008).

Towse, Ruth. 2006. 'Copyright and Creativity: Cultural Economics for the Twenty-first Century', inaugural Lecture as Professor of the Economics of Creative Industries at Erasmus University, Rotterdam, 30 May, Rotterdam: The Faculty of History and the Arts, Erasmus University.

van der Ploeg, Rick. 2006. 'The Making of Cultural Policy: A European Perspective', in Victor Ginsburgh and David Throsby (eds), *Handbook of the Economics of Art and Culture*, Amsterdam: North Holland, ch. 34.

4

Heritage institutions and the economy

Introduction[1]

In the famous Brera Altarpiece, *Virgin and Child with Saints*, painted by the renowned Piero della Francesca (1410/20–92), one of his pupils, later a close friend, is the model for St Peter Martyr. His name was Luca Pacioli (*c.*1445–1515), a Franciscan monk who was also to become a friend and associate of Leonardo da Vinci. He is an important figure in intellectual history as a mathematician and particularly for providing the first written account of double-entry bookkeeping. It has been said that 'treatises on double-entry bookkeeping must rank among the dullest reading known to man', but the same author adds a clue to our interest in Pacioli, 'it is arguable that the glamorous world of the Renaissance was founded on this unglamorous skill' (see E. R. Chamberlain 1982, quoted in Yamey 1989 pp. 31–5).

Pacioli provided two important instruments for Renaissance artists. As a mathematician, his treatises were meant to offer practical guidance in drawing skills needed to depict proportionality and solidity in paintings and sculpture, and artists as famous as Leonardo and Albrecht Durer consulted him on the geometry of design. As a pioneer of accounting, he contributed to the business training of artists whose patrons expected to be satisfied that they had obtained value for money for their commissions. The economic history of the Renaissance indicates that artists developed their accounting and mathematical skills as an integral part of their secondary education and not as a kind

[1] (The introduction is based on chapter 8 of Basil Yamey's delightful scholarly work *Accounting and Art* (1989).

of optional and unfamiliar extra which could be dismissed as an unnecessary distraction from the search for the Holy Grail of artistic inspiration.

We shall not go so far as to employ some modern version of Pacioli's system of double-entry bookkeeping, although there is a trace of this in the very simple accounting that may be used to explain the structure of the heritage 'industry'. This 'petite histoire' has been presented to the reader to show that it is a mistake not only to assume that those whose works are considered to be an integral part of our heritage divorced themselves from the real world, but also that accounting is somehow simply a vulgar intrusion into the discussion of heritage provision. It can help to bring the subject to life, as we endeavour to demonstrate.

The importance of accounts

To achieve proper understanding of the economics of heritage, one must begin by identifying the various 'actors' in the process of providing the required services, for example access to historic buildings, display of historical artefacts either on site or in museum and gallery collections, and the generation of knowledge which enables the public to understand, appreciate, and criticize the services provided. The economist—obsessed by numbers, so it seems—sees this process as best explained in the form of the financial transactions which link 'consumers' with 'producers'. This requires the drawing up of some accounting system.

Long before the economists poked their noses into our subject, artists and later private and public galleries and later still museums, kept accounts because they needed the information that they provided—as anyone who keeps a note of their income and expenditure in a petty cash-book must know. Accounts have always been a useful source of knowledge for organizations which have to justify that what they are spending is in line with agreed decisions and to prove that no one is stealing the funds. If a business or an individual files an application for bankruptcy, those who have to approve the application will go straight to the accounts to find out the extent of the liabilities of the applicant. The public interest is clearly involved if fraud accompanies bankruptcy, so that accounting information must accord with professional standards which have been approved by law, and it may also be used for other situations which might reveal what is regarded as unacceptable personal, corporate, or government behaviour.

An economist interested in the behaviour of, say, public or private galleries and museums open to the public can learn a good deal from their published accounts. As we shall see later, this is only true up to a point, but the fact remains that anyone concerned with arts management is well advised to know how accounts are drawn up and how the information that they may have to provide as managers is embodied in the accounting system. We believe that something more is required of them, namely that this process helps them to appreciate why the economist will need more information than the accounts provide in order to conduct a proper analysis of the motivation of management, leading to some speculations about how this will affect the conduct of government policy. Heritage institutions differ in their managerial organization from country to country and accordingly the degree of discretion that the management has over major policy decisions. The greater the degree of discretion of the individual firm producing heritage services the greater the necessity to examine its accounts to understand the 'production process'. Even when private or quasi-public institutions receive conditional and substantial financial support from central or local government, they will normally be required to produce accounts in accordance with recognized accounting standards. We show how the degree of public intervention has a marked effect on how accounting information is produced and interpreted (see the next section and Chapter 8). It enables one to identify considerable differences between the economic organization of the UK system of heritage provision and that of Italy, the latter being subject to much more centralized government control than the former.

Information requirements

Perhaps the best way of explaining what we want to gather by way of information about any individual producer of heritage services—here we shall concentrate initially on museums and galleries (hereinafter MGs)—is to consider what an economist would require to know in order to make an appraisal of their activities.

The first question that the economist will put to the managers of an MG will be: *what are your objectives?* It is not a question which would detain him too long, given the cost in time and resources available for such an investigation in the case of private businesses. Of course, the question needs further elucidation, otherwise a manager of a business

may concentrate on what he knows best, namely the types of things or services produced and the resources in terms of labour and raw materials and capital costs required to produce them, taking the economist, with great pride, round the production plant to impress him—and it can be impressive—with the ingenuity and skill of the workforce. But in the end it will have to be admitted that the production process is a means to an end, and the end is that of maximizing the difference between the costs of production and the revenue received over some specified period of time in the interest of the owners of the business—who may be a single individual, a set of partners, a workers' cooperative, or a corporate body which issues shares in the company. Today, the manager of the business will no doubt stress that reaching this single objective is constrained by other objectives to reflect the business's own perception of 'fair dealing' with customers or employees and the present-day emphasis on corporate responsibilities which society may consider requires government intervention. Still, as economists asked to help in official inquiries into restrictive practices know well, the calculation of rates of profit is considered vital information in attempts to establish whether these practices reflect attempts to reduce competition.

The director of an MG will understandably seize the opportunity to highlight the differences between private enterprise and the provision of heritage services, particularly one directing a public institution whose trustees (directors) are appointed by the public sector. Overcoming some emotional resistance (for talking about the 'output' of an MG seems to some directors of our acquaintance as inappropriate as to talk of the relation between religious observance and the individual's prospects for redemption) the director may be prepared to offer a taxonomy of activities. He will want to distinguish between outputs in the form of a display of artefacts and associated explanations of their significance, the maintenance and preservation of such artefacts, and the access afforded to archival material such as undisplayed art works, prints and drawings, and rare historical works. Correspondingly, such services require estimates of the inputs of labour as the need for professional curatorial and research staff, guides, attendants, and marketing and security personnel. This makes MGs highly labour intensive so that labour costs emerge as a major item of expenditure, although their relative importance seems likely to fall as capital expenditure increases with the use of modern presentational devices in exhibitions.

Nowadays, given the very considerable degree to which central and regional governments fund heritage provision, it must be possible to develop the accounting information so that it indicates the links between the input of resources and the output of services and what governments will be expected to provide by way of funding to meet the agreed objectives of the grant-receiving heritage providers in the future. The governmental authorities, after all, may have many claims for funding and inevitably have to make judgements and awkward decisions about the relative merits of heritage against other claims. We shall consider the limitations of accounting information at a later stage. Here we need to emphasize that the accounts form, as it were, the skeleton of the activities of an MG, displaying the grubby business of what the governmental authorities will provide by way of funding and what the MG is expected to raise by its own efforts and how the money will be spent. This calls for a continuous set of accounts stretching back in time, in order to reveal a trend in the relation between inputs and outputs, and forward in time to provide estimates for agreed future government commitments. In other words the accounts become more than a mere statement of probity and economy but an integral part of an agreed business plan. A necessary condition, of course, is that producers are separate entities from government. If this is not the case, as it appears to be in Italy, there are no separate accounts and not even a business plan.

So the second question put by the economists is: *can you produce the accounting information which illustrates both past decisions and present intentions?* Fortunately, for the economist at least, with pressure from governments to produce data on how funding is spent and what MGs wish to claim in the future, there appears recently to have been a marked improvement in the quality of information relating to financial transactions in major Western countries. Again, when producers are not separate entities from government, it is useless to look for detailed and sound information on financial flows, since these transactions are not related to specific responsibilities and, therefore, cannot be used for evaluating producers' accountability. Let us follow the economist in the quest to become informed of how the differences between the motivation of the managers of MGs and private profit-making concerns and the constraints under which they operate affect the interpretation of the accounting information. This is done in two stages, first by presenting a stylized and simplified accounting scheme, and then illustrating this with the use of an actual set of

accounts taken from a well-known provider of heritage services. It should be clear from the above discussion that we are well aware that the 'value' of heritage services is widely perceived as having to include any positive externalities which provide general benefits over and above those received by those visiting MGs, and which are not reflected in the accounts.

Consider Table 4.1 and the notes attached to it. The Revenue and Expenditure Account is a formalization of what you may keep by way of personal accounts, even if using only a simple cash-book costing less than 1 euro. In the case of a business enterprise, the most important item on the left hand side is likely to be Item $x(1)$, money received in a given period for supplying goods and services. If holding substantial cash balances with a bank, then it may also receive some current income from interest payments (Item $x(2)$) although if an enterprise is in debt to a banks to help finance their working capital, this Item will be negative or, alternatively, offset by outgoing interest payments (Item $y(4)$), so that Item $x(2)$—Item $y(4)$ becomes a negative amount. Grants or subsidies from government may be received but can be assumed to be relatively unimportant (Items $x(3)$). However the maintenance of plant and machinery and new investment expenditure may make it necessary to call upon reserves or to borrow, shown here in Item $x(4)$ as transfers from the enterprise's reserves.

It is true that there are heritage services that are privately owned and which may seek to earn a profit from the sale of such services or at least to avoid losses, in which case Item $x(1)$ is of particular importance to them. However, a considerable proportion of MGs are largely funded by local or central governments, which makes Item $x(3)$ of prime importance. Managers will have their attention concentrated on the ongoing relationship with the officials, or, put in what would be regarded as the vulgar language of the business school, on marketing their product to the government as its customer, rather than on selling it directly to individuals. It is also the case that the relative importance of different sources of income of MGs and other heritage providing bodies will change over time as a result of changing government policies reflecting different political perceptions of their relations with the public sector. In recent years, for example, one has seen a considerable growth in income earned from in-house shops selling such items as books on art, reproductions of pictures and postcards, and even handkerchiefs embroidered with representations of some artefact with iconic significance. In the extreme case of MGs which

Table 4.1. Highly simplified accounts for business enterprise

A. Revenue and expenditure account

	+			−	
Revenue from sales		x(1)	Cost of sales		y(1)
Other income		x(2)	Taxation		y(2)
Subsidies and capital			Gross capital formation		y(3)
Grants		x(3)	Dividend and interest payments		y(4)
Transfers from reserves		x(4)	Current surplus		y(5)

B. Balance sheet (Statement of assets and liabilities)

	+			−	
Value of fixed assets		X(1)	Current liabilities		Y(1)
Value of financial assets		X(2)	Non-current liabilities		Y(2)
Value of stocks		X(3)			
Accounts receivable		X(4)	Shareholders claim on equity		Y(3)

Notes:

x(2) – the main example is likely to be interest on bank deposits but in more complicated business relationships can include interest on loans to other firms or dividends from shareholdings in them.

x(3) – this items is included, not because it is likely to be a substantial source of income of firms but to facilitate comparison with MGs commonly in receipt of considerable public funding.

x(4) – new investment, maintenance and depreciation of the capital stock could in principle be financed out of current income but a normal and major source of financing will be from accumulated surpluses or from loan finance.

y(1) – cost of sales will include direct costs that vary with the volume of sales but also attributable administrative and related expenses such as advertising.

y(2) – could include profits, taxation and taxes on sales.

y(3) – includes both expenditure on new investment e.g. on plant and equipment, and on maintenance and depreciation of the capital stock.

y(4) – principal items would include interest payments on borrowing and the dividends of shareholders.

y(5) – represents receipts minus payments—the item might be negative—transferable to the balance sheet as an increase in assets.

X(1) – the valuation of fixed assets such as property, plant and equipment assumed to have a market value.

X(2) – includes financial assets e.g. in stocks and shares (cf. y(4)) and cash. In drawing up these accounts it would simplify their interpretation if we regarded y(5) as an addition to the stock of cash.

X(3) – estimated value of stocks of both finished goods and those in the course of manufacture.

X(4) – will probably largely consist of outstanding debts for goods sold but not so far paid for on the date of the valuation of the business.

Y(1) – includes accounts due for settlement currently, include tax obligations payments of suppliers of raw materials and professional services such as accounting and sales promotion.

Y(2) – liabilities already incurred but due for future settlement, such as long-term debt, deferred tax payments.

Y(3) – the claims of shareholders *for* any increase in value of business, represented by the value of assets *minus* the value of liabilities.

are incorporated within government, being similar to government departments, Item x(3) is not very relevant since resources are not formally transferred to the producer but remain within the government budget. Indeed, governments may regard grants in part as an incentive device for encouraging MGs to increase in-house sales so that the size of x(2) and x(3) become interdependent.

There is less need at this stage to dwell on the current expenditure items which display the costs of offering heritage services, with the strong claim of labour costs made necessary by curatorial, research, and educational responsibilities, except to say that these data by themselves give only a rough indication of the quantitative relation between the various 'outputs' of MGs and the 'input' effort required to produce them (devising suitable measurement systems, as we shall see later, is a growth industry made necessary by what managers may regard as the inquisitorial features of government probing into their activities). However, this helps to highlight another important difference with private enterprise. The latter, particularly if operating in competition with others, will know that there is a close relationship between what it can pay its owners and the size of any difference between costs and revenue. This must mean that cost control is an important feature of its managerial activities, as well as to the marketing and pricing of its goods and/or services. Such activities have become more familiar to MG directors than hitherto, particularly when subsidies or grants from government are under scrutiny by ministries of finance with many competing claims for funding. This brings with it reluctant acceptance of cooperation with their 'financiers' in identifying suitable indicators of 'progress', while understandably privately deploring the incursion of business buzzwords into the terminology of discussion about their mission to preserve 'Hochkultur'. Again, such a concern is closely related with a situation in which a budget—including all the items listed in Table 4.1—is assigned to the MG directors and they are responsible for all the main decisions concerning the management and accountable for the results obtained. Most of the UK national museums, to some degree, fit this picture, but their Italian counterparts lack this degree of financial responsibility, which means that several strategic decisions, notably those regarding hiring of personnel, are not within their control.

The third question put by the economist arises from the second: *do the parallels with private enterprises with respect to the interpretation of*

the accounts extend to the valuation of the enterprise? The 'below the line' items in the highly simplified accounts represent the valuation of the assets and liabilities of the enterprise at the end of the period covered by the flows of income and expenditure above the line. A more elaborate presentation would show the changes between the end of one period and the beginning of the next. The main 'creditors' are those with shares in the enterprise and the value of these shares will fluctuate with the value of the business which comes down to its 'Net Worth' (Item Y(3)). This item is of particular interest to financial institutions advising clients on which shares to buy or sell, assuming the shares of the enterprise are available to the public through the stock market. How assets such as plant and machinery and buildings, as well as stocks of goods for sale and intangible assets such as the goodwill generated by the business with clients are valued, is a matter of perpetual discussion and argument, depending in the end on some estimate of market values, that is what the assets would fetch in the relevant market. This explains why when a business is sold as a going concern, there is much argument about its price and a necessary but not a sufficient condition for its sale will be full information about the valuation of assets, offering accountants a potentially lucrative source of income. The valuation has to take account of the risk that in certifying that a capital valuation is a 'true and fair view' they are relying on intelligent guesswork. A glance at the footnotes tucked at the back of company accounts reveal that auditors will frequently require that assets are valued at their cost price, which at least provides a known figure but, in an age of inflation and also rapid technical changes, a figure which may prove to be wrong when it comes to their actual sale. No wonder that the takeover of a business by another company, where buying out the shareholders is reflected in vast sums in euros, can lead to even highly respected firms of accountants with international reputations finding themselves having to defend their integrity in the law courts, as may happen if their clients have deliberately given them misleading information about their financial dealings. In short, understanding the balance sheet is a fundamental piece of knowledge for the senior management of any company, particularly managers responsible to many owners who, as shareholders, can sell or buy their claim to a company's assets in international share markets and base their decisions on their appraisal of the company's success of failure as revealed in its contents.

If the current income and expenditure accounts of MGs now have to be understood, albeit with reluctance, by MG directors and their senior staff, the parallel does not extend to the 'balance sheet' or at least to the items to which attention has been directed in the case of private businesses. There can be no excuse today for senior management of MGs if they are not able to conduct a discussion with their 'sponsors', such as government departments or large foundations or personal donors in which the financial implications of their plans and their fulfilment are evident. But there appears to be no compelling reason why the balance sheet should concern them, as those with a legitimate interest in their activities are far from likely to claim that the progress in the net wealth of an MG has any policy significance.

There also appear to be good technical reasons why MG directors should not have to extend their mindsets to include a knowledge of the accounting conventions for preparing a capital account. It is true that a large part of their activity, as we have seen, is in the display of an existing stock of artefacts for examination by researchers, with the acquisitions and disposals of stock not having a major effect on its composition, even in the relatively long run (after all, it is the very essence of heritage policy to preserve artefacts).

This being the case, it is not part of the job of staff to buy and sell pictures and other artefacts in order to maximize the income of the MG. Therefore, there is little point in seeking a 'true and fair value' of the stock by reference to the art or antique markets. The very idea of placing a monetary value on, say, a genuine Botticelli, is repugnant to the votaries of art treasures, who would regard its value as 'beyond price' without being too specific about what that means, although it may imply that it cannot be sold under any circumstances. There is also the practical consideration that in many MGs the stock is an accumulation of gifts that have been given on condition that they will never be disposed of by sale.

Nevertheless, there are items on the capital account which, if they do not directly concern the day-to-day workings of an MG, must have numbers attached to them in order to be able to review their efficient use. In the case of state-owned MGs, the land and buildings are likely to be part of the state patrimony and their use and disposal will not be decided by the MGs' management. A value must be attached to them, if only for insurance purposes and an estimation of the cost of their upkeep, even if it is unlikely that their use will be altered without consultation with MG managements.

As so often happens when economists probe into the reasons for accounting practices, rather fundamental issues keep popping up, and heritage preservation through the custodianship of artefacts is no exception. It is a matter of fact that, for practical reasons, museums and galleries cannot display the characteristics of magpies and simply go on adding to their stock in the expectation that all constraints on space will be removed by their paymasters; and this applies even when top management claims that its aim extends to being able to expose to the public the major developments in the history of art throughout the globe and to preserve major examples for posterity. Short of risking public disapproval when it is discovered that the problem may be at least shelved by consigning the less favoured artefacts to the basement to gather dust and risk decay, then the issue is bound to be raised about the *relative* value of items of stock. Such a valuation, however rough and ready, must alter the 'league table' of the estimated importance of the artefacts to the extent that the objectives of the MG change and perceptions of which artefacts best fulfil these objectives change. Even if the objectives do not change, their fulfilment does not necessarily imply that they will be best achieved by an unchanged portfolio of artefacts. Views on the relative significance of what should be preserved to represent past periods of a nation's history are bound to change, notably when what is momentarily contemporary history moves back in time. In short, alterations to the portfolios of historical artefacts held by MGs, both public and private, require managers to be informed about the nature of arts markets and therefore to understand the process of buying and selling. It follows that if what is called 'de-accessioning' takes place, the conventions governing what is included in the Capital Account and the valuation of assets can markedly change. Furthermore, the responsibilities of managers is extended, particularly if they are allowed to devote the proceeds of sale to the purchase of other artefacts, and the way their responsibilities are exercised come much more under public scrutiny when they are identified as major players in the art and antique markets. However, 'de-accessioning' and when and how it should be undertaken and by whom raises major policy issues which are considered later (see Chapter 5). Here we are only concerned to point to the ways in which MGs, often considered as the modern equivalent of holy temples in which articles of iconic significance are guarded by an exclusive priesthood, take on a different identity when the various 'markets' in which they operate are exposed to view.

The fourth question raised by the economist is: *what information do the accounts provide on the 'links' with other providers of heritage services established with those with whom it has to negotiate to exercise its claim on resources?* It is possible to assign in a rough-and-ready way from whom income is derived and who receives out-payments for services rendered to the MG, but the creation of a flow of funds system requires a clear identification of who is negotiating with whom and the magnitude of the funds which pass between the various decision makers in the process of funding heritage. The fact that this requirement is important for economic analysis is no reason why one should criticize those who have to prepare and use the accounts. It requires separate justification and this is examined in the next stage of our investigation.

The big picture

Imagine a government that decides that it must clarify its views on the scope of its responsibilities for the promotion of interest in and provision of heritage services and decides to review how these services are currently provided. The person or body commissioned to undertake the review would have to draw up an agenda. Here is what would be included by an economist.

1. *Definition of heritage services.* This is as difficult to decide, and probably more difficult, than the definition of any major industry or service. The narrower the definition—such as the identification of institutions within the public sector or financed by the public authorities—the easier it may be to determine the economic and financial structure of the service, for information may be found (or usually is 'buried') in the public accounts. However, in a country such as the UK the very services provided by public institutions and private institutions financed by government can also be partly provided by private owners of properties of historical significance with whom the public authorities must reach agreement as to the extent to which the preservation of their estates and buildings is a matter of public concern. But the wider the definition, the more difficult it may be to collect the data which would help one to determine the relative significance of the private sector. Not surprisingly, perhaps, the breadth of the definition has a political significance if it is relevant to the question of whether or not there

is funding available from the government for 'recognized' MGs which perform tasks in accordance with government policy.

2. *A typology of MGs and related heritage providers.* Bearing in mind that the economist hopes to contribute to the understanding of heritage provision by the study of the motivation of providers and how it affects their decisions about the allocation of the resources and the range of service that they offer, a typology is suggested by which providers are classified with regard to their *ownership* and their *welfare function* (i.e. their objectives and their relative importance). This separation is somewhat artificial for the very reason that a service being provided by public authorities is likely to be assigned a particular welfare function, which precludes giving primacy to the provision of income to shareholders. Nor need it necessarily be assumed that private ownership takes a form where the prime motive is to maximize profits. The classic example of this is The National Trust in the UK (see Chapter 3).

3. *A transactions matrix.* It is important to remember that all payments to support heritage provision eventually emanate from *individuals*, whatever the legal position which may assign personality to firms through giving them corporate status. For example, a distinction is sometimes made in government budget statements between taxes paid by individual taxpayers and by corporations. It is true that the classification of taxes is often based on 'who' pays the tax and individuals and corporations can be separately responsible in law for payment. The initial impact is reflected in the personal and corporate accounts as a deduction. However, the question as to who has to adjust their behaviour to take account of the tax payment requires an answer in which individuals have to be identified. Thus the management of a corporation have to decide whether a tax obligation requires a reduction in profits or in dividend and debt payments, or in deductions from wages and salaries, or some combination of these items, all of which affect the fortunes of individuals.

As well as defining heritage services and classifying them with reference to the motivational character of those who directly finance them, we have to complete the matrix of transactions by identifying the *flow of funds* from those willing or compelled to supply funding to those receiving it (see Figure 4.1 later in the chapter). The prime reason for this is that, in

practice, the introduction of public funding produces major complications in the flow system.

If heritage services were purchased by persons, individually or members of some society or consortium, then the relations between buyers and sellers would be the simple one of direct payment, for example by entrance fees to MGs or to historic buildings or private donations. There would be no intermediaries unless individuals made donations to private foundations which specialize in giving grants to MGs, for example in the UK, The National Arts Collection Fund.

In practice, a substantial part of the funding of MGs, as we have seen, comes from the public authorities, both central and local, who raise the money from the private sector, which means, as we have argued, the use of taxes—which are eventually borne by individuals (we neglect an important feature of heritage financing, the flow of income received from abroad through overseas visitors, etc.).

When the process of government is introduced, the suppliers of funding, the taxpayers, are no longer in direct contact with the recipients. Their prime role in the process is confined to electing the governments who choose to spend money on heritage services provided by public or private institutions; but private persons may be members of the management of those arms of government responsible for the allocation of funding, such as the Trustees of the various British National Galleries, although not chosen by election.

The process takes its form from the passage of funding through the stages which intervene between the public and the eventual users and one may distinguish between: *Suppliers*—the taxpayers where, despite our previous argument, it is convenient to separate firm and households. *Allocators*—the central and local governments who have the overall responsibility for arts policies. *Spenders*—the agencies of government responsible for the distribution of grants to particular suppliers, which may range from individual government departments through autonomous government appointed councils or commissions to private sector bodies working under contract. *Users*—the heritage service providers, such as MGs, churches, public and private management of man-made heritage.

The 'big picture' cannot be completed without the inclusion of the flow of funds within the private sector, where direct payments are made by the public to private institutions offering heritage services. When this is done, one can draw up the Transactions Matrix for Heritage Services and attempt the further tasks of 'filling the boxes'

with the appropriate numbers. In this way one obtains an under-
standing of 'where the money comes from and where it goes' and
thus try to find an answer to such questions as what is the relative
importance of different sectors in financing heritage services and
what is the relative importance, at least in financial terms, of each
heritage service sector. This matter is pursued further in the final
section of this chapter.

The implications for analysis of heritage decision making

One has always to bear in mind that the purpose of the institutional
analysis using economics concepts is to throw light on the decision
making process. Before considering this matter further, one must be
aware that the flow of funds system, while an essential part of the
analysis, does not offer a complete picture of this process, particularly
in relation to the links between the public authorities and heritage
institutions. The public authorities have other methods for influen-
cing the behaviour of organizations other than by direct funding.

The first method is through the fiscal system. This can be done
directly by taxes on expenditure, usually by some forms of tax con-
cessions or exemptions. MGs and suppliers of heritage services fre-
quently claim that public funding is offset by having to buy material
inputs, such as equipment, which are taxed, and exercise their rhet-
orical skills by complaining of 'taxes on culture', just as nineteenth-
century authors used to refer to 'taxes on knowledge' if taxes were
payable on books. This method can also be conducted indirectly by
exempting from income tax donations out of income given by private
individuals to non profit-making cultural services (see Chapter 8).

The imperfect nature of financial flows as an indicator of the influ-
ence of government on heritage is clearly demonstrated by an im-
portant regulatory tool, namely the official listing of buildings
according to their 'importance' as historical artefacts. In high-income
countries in which heritage preservation has become a major element
in environmental policies, the employment prospects of art histor-
ians, archeologists, and stone masons have been markedly improved
by the perceived need for ensuring that not only artefacts in the public
domain but also those privately owned are preserved or restored as a
long-term cultural investment. Regulatory techniques vary—these
will be examined in Chapter 8.

Of course, we are putting the 'cart before the horse' in describing these various control devices, for so far no principles governing the size and structure of regulation have been offered to the reader, nor any notion of how such principles may be derived. However, the reader may be better prepared to understand their derivation if he or she is already familiar with the links between those who would claim to have a say in devising these principles—notably those who have to bear the costs of preserving the past—or have a stake in how they are to be applied.

The big picture, therefore, and the extra 'brushwork' in order to make the picture a more accurate reflection of the realities of heritage funding, offers an important insight into the instruments of participation in the political process and the economy that MGs may wish to exploit, depending on the relative importance of their sources of finance. If MGs, and heritage institutions generally, were solely dependent on income derived from the sale of their services to private individuals, their efforts at protecting and increasing the size of their income would be concentrated on maintaining private demand, with a direct financial relationship with 'customers'. Additionally, some effort might be devoted to raising money through charitable contributions, notably in cases where there was a self-imposed obligation not to charge for such services, an important example being churches. There could also be an incentive to try to control prices by limiting competition with rival concerns, if they exist, through professional associations. Thus in the UK, where there is a large sector of private museums, usually of a specialized nature, they may combine through a body such as the Museums Association to look after their collective interests in various matters, for example the tax treatment of charitable contributions and of their purchases. One must also bear in mind that private museums may not wish to restrict themselves to independent sources of finance, but seek some public funding, provided that their directors can maintain control of their policies. So bargaining skills may not be directed solely towards private 'targets'. The difference with large regional or national museums may therefore be one of degree rather than of kind, but there can nevertheless be no doubt that the bargaining scenario in which they operate must be more complex.

Considering the links depicted, national museums will need to negotiate with the relevant government department or agency about its main source of income. These negotiations may be protracted

because they will involve agreement about the conditions which govern the award of funding, including nowadays the specification of targets translatable, if possible, into indicators of performance (see Chapter 9). Like businesses, they will be required to negotiate over rates of pay and conditions of work for all grades of employees, although they may be able to claim, if the staff are public employees, that they are relieved of responsibility for negotiation (however, they are likely to be consulted by government about the job specifications of staff). Heritage policies are likely to require that senior management become fully familiar with the acquisition and disposal of historical artefacts, both nationally and internationally, because of the impact of the international markets for such artefacts on the power of national museums to influence their prices, both directly through possible purchases and indirectly through government regulation of disposals and sales. Reliance on alternative sources of income to government funding involve negotiations with potential donors of artefacts or money. Such negotiations will have to pay particular attention to any conditions attached to the receipt of this income.

The above description of the relationship between MGs and, more generally, public producers of heritage services and the world outside the museum or gallery (government, donors, customers, etc.) refers to a modern arena in which producers enjoy autonomy and, therefore, accountability to a certain extent. A somehow different picture arises when, as was said before, public producers are civil servants and experts at the same time, operating within government, since incentives differ and bargaining takes place in accordance with bureaucratic rules, as explained later in Chapter 8.

Two particular trends have increased the degree of involvement of major MGs in negotiations with outside funding sources, sources which until only recently hardly existed. The first is the elaborate system of lending of pictures and moveable artefacts to support special exhibitions, often arranged in conjunction with some major cultural event such as an international festival. There is a strong incentive to cooperate in such exhibitions because of their prestige value to both lenders and borrowers, but this activity calls for special skills in negotiating the terms of the 'bargain'. The second trend is the growing involvement of international agencies such as UNESCO and the World Bank and specialist non-governmental organizations, notably those concerned with environmental questions. They are particularly active in promoting the interests of developing countries where archaeologists

and historians have discovered or re-discovered artefacts which attract international interest. Such agency involvement includes consideration of the extent to which earlier explorers had contracted sales with indigenous inhabitants on what appear today to be on the most advantageous terms. This new dimension to the issues concerning the preservation of the past must engage our interest at a later stage. It requires little imagination to envisage the extent to which professional involvement in advising international agencies and servicing their committees has impinged on national museums and galleries, not the least the incentive given to their senior management to pay particular attention to the influence of these agencies on MGs' position in the world as ambassadors of their national culture.

What can an economist make of a change in the function and scope of MGs and other providers of heritage services which has, within living memory, turned them from being primarily repositories of valuable objects (allowed and even expected to be no more than these) into major sources of expertise on the philosophy and practice of heritage provision? This chapter has provided one justification, namely a different perspective on the 'heritage biz' through a description couched in terms of the economic relationship between those who supply heritage services and those who demand them or are meant to benefit from them. But the economists can and do go a stage further: by identifying more precisely the preferences of those who provide these services and trace how these are manifested in the allocation of resources that result. Only in this way can economists fulfil a remit to explain whether the actions of providers conform with the objectives, and therefore the wishes, of those who provide the resources.

A simplified system of accounting for the heritage sector

The emphasis in this chapter has been on the use of accounting not only as a tool to inform the heritage entity (museum, gallery, or guardian of immoveable archaeological treasures) about its financial situation, but also to present that information in a form which, with other information sources, will allow a judgement to be made about whether its funding provisions are being properly and efficiently used.

Not surprisingly, as MGs have assumed an expanded role in providing heritage services—both as result of the public's growing interest in the past and the acceptance of a more extensive role of the state in

encouraging such interest—attention to the presentation of accounting information has changed, now requiring more detail and a greater emphasis on financial trends. It even extends to expressing future plans in the form of detailed budget estimates which employ the accounting structure as a planning instrument.

The accounting system shown in Table 4.2 is a simplified version of that which is now to be found in annual reports of MGs and similar organizations. The rationale of the design to the accounts is explained and an actual example is given in summary form. This should enable the reader, it is hoped, to understand the text of those rather formidable appendices found in official reports in which the accounting detail is concealed, even if it does not tempt the reader to develop an enthusiasm for close examination of such detail. However, there is a more important immediate purpose of the system. Relatively few MGs and similar bodies are run on commercial lines. However,

Table 4.2. Income and expenditure account and balance sheet for Historic Scotland (HS) (year ended 31 March 2005) (all entries in £mn)

Income and expenditure account

+		−	
IP Income from properties		CE Current expenditure	
(i) Charge for admission	13.4	(i) Staff costs	13.4
(ii) Sales of good and services	8.8	(ii) Other costs	16.9
		(iii) Grants for historic buildings	13.4
		(iv) Depreciation and maintenance	6.9
OD Operating deficit	36.4		
TOTAL	58.6		58.6

Balance sheet

FA Fixed assets	22.6	CR Creditors	10.2
CA Current assets			
(i) Stock valuation	1.7		
(ii) Sums owing by debtors	1.4	FOD = OD Finance of operating deficit	36.4
(iv) Cash in hand	4.9		
EC Grant from Scottish Executive	36.6	B Balance (FA+CA−CR)	20.4
TOTAL	67.0		67.0

Notes: There are some minor differences in definition from the published accounts and figures may differ slightly from those in the relevant tables through rounding.

Source: Based on Historic Scotland Annual Accounts, 2004–2005.

accounts drawn up and classified in much the same way as for commercial organizations must be provided as a check on their efficiency.

We take as our example the Summary Accounts of Historic Scotland. Historic Scotland is an Agency responsible to the Scottish Executive, the administrative organ of the devolved Scottish Parliament. Its activities are presented in financial form in Table 4.2.

It incurs expenditure (E) in order to administer the buildings which it operates and maintains for the benefit of the public (i), (ii), and (iii) and awards grants to support historic buildings owned by private persons and foundations which are open to the public (iv). It has to raise a proportion of its income from Admission Charges to the public (IP(i)) and Sales of Goods and Services (such as brochures, souvenirs, etc.) (IP(ii)) and the remainder of its current expenditure is an operating deficit (OD) which is covered from funding agreed with the Scottish Executive and a charge against the latter's budget. A simple calculation indicates that in the accounting year 2004/5, this operating deficit was £36.4 million. There we might simply leave the matter, and regard the deficit as the symbol of Historic Scotland's financial relations with the government who have agreed to pick up the tab, were it not that the published accounts include a Balance Sheet as at 31 March 2005, which has some features which bear a superficial resemblance to that of a commercial concern. As this is a requirement laid down by the auditing authorities, some explanation of its contents is called for and there is at least a presumption that the public and, more particularly those concerned with heritage policy and its implementation, are expected to understand what the figures represent.

We recall that the supposed purpose of a Balance Sheet in a commercial concern is to reveal how efficiently it is being run, which implies to its owners (i.e. shareholders) that the 'bottom line' should record whether or not their net wealth has increased, diminished, or remained as it is. If we look at Table 4.2, there is an item in the bottom right hand corner of the Balance Sheet which records that the end of the financial year 2004/5 saw an increase in the reserves (R) of over £20 million. This figure represents the difference between the increase in the value of the total assets *less* current liabilities. How is this figure arrived at?

Some of the items are easy to understand. There will be Current Assets which record the outstanding liabilities of those who owe Historic Scotland (HS) money (CA(ii)) and Stocks of saleable goods which will eventually be sold must have a value attached to them

(CA(i)), plus there will be a Cash 'float' kept (CA(iii)). Correspondingly, Current Liabilities (CL) will largely consist of amounts due for payment to creditors of HS. HS will also 'bank' during the year the amount needed to cover its current Deficit but this will be immediately offset on the liabilities side by the need to meet HS's current expenditure commitments (Finance of Operating Deficit (FOD) = OD). This brings us to the last unexplained item, namely the Fixed Assets (FA).

It is here that we come across one of the fundamental problems about the valuation process in heritage provision. In common with other heritage authorities, HS is responsible for the operation and maintenance of a variegated set of assets, in its case about 300 monuments. A large proportion of them (in HS's case the majority) may be described, in HS's words as 'non-operational heritage assets', that is, they are removed from the standard valuation process in terms of money because they are assumed to be 'beyond price', it being claimed that they will not in any circumstances be put up for sale. HS is therefore enjoined to record a value only for those buildings used for business purposes, such as visitor facilities, maintenance depots, and occupied accommodation.

This value (FA) is reflected in the Balance Sheet and is given as £22.6 million. In HS's case, the list of non-operational heritage assets is an interesting one. It is divided into three main groups:

1. *Crown Properties*, which includes such famous buildings as Edinburgh Castle, Stirling Castle, Dunblane Cathedral, and Glasgow Cathedral.
2. *Crown Moveable Properties* such as the Honours of Scotland (including the Crown Jewels), paintings, and other artefacts.
3. *Historical Sites*, notably Holyrood Abbey, Linlithgow Palace, St Andrews Cathedral and Castle, and Arbroath Abbey.

It does *not* follow that the residual balance (B) is a 'performance indicator' for HS, similar to Y(3) in Table 4.1 (the Increase in Shareholder Wealth). The vital question of the efficient operation of artefacts designed to preserve the past is dealt with in detail in Chapter 9.

We now turn to the 'big picture' once again. Above we have outlined how a flow of funds system may be built up as a way of illustrating the network of transactions which surround the provision of services designed to preserve the past. In Figure 4.1 we now offer an amplification of the system in a diagrammatic form, following the distinctions

already made between *Suppliers* of Finance, *Allocators* of Finance, *Spenders*, and *Users*. Such a diagram cannot be presented in a completely generalized form applicable to all economies, however similar the economies are in other respects. For example, as we argue below, there are distinct differences between Italy and the UK in regards to the methods of funding and their relative importance. Furthermore, as we have particularly emphasized, government regulation directed at influencing the private sector to preserve and restore historically important properties plays a major role in heritage policy, and the costs of regulation cannot be identified and expressed in the transactions depicted in a flow of funds system.

The flow of funds in Figure 4.1 would be recognizable to those familiar with the UK system of finance. Two particular features deserve comment as a supplement to our previous discussion. In recent years, the National Lottery has played an increasing role in finance *current* expenditure and directly supporting cultural ventures, including heritage, although originally it was permitted only to finance capital expenditure. Current lottery funding is largely channelled through quasi-governmental organizations as a supplement to their grant income. In accordance with recent practice, we have labelled such quangos (QUANGOs) as Non-Departmental Public Bodies (NDPBs) who have been allowed considerable independence in their use of both governmental and lottery funding.

Figure 4.1, although originally designed by ATP to represent the UK system, being very general, offers room for describing the various institutional and organizational arrangements which can be implemented in different countries. Looking at the Italian case, for instance, the distinction between *spenders* and *users* does not hold to the same extent as in the UK and the unification of these two types of decision maker would offer a more realistic approximation of the Italian situation as far as the public producers of heritage services are concerned. More precisely, as already stated, state museums, galleries, libraries, archives, public buildings, and archaeological sites can hardly be distinguished from central government as far as their accounting is concerned. Indeed, notable exceptions exist, for example the management of the archaeological site of Pompei or that of the Uffizi in Florence, just to quote the most relevant ones, and there is an increasing awareness of the need to autonomy in the management of MGs (Ministerial guidelines in this direction were

issued in 2001 but without being fully implemented by the time of writing). Moreover, reality is more diverse when regional and local institutions are taken into account because of the impact of decentralization. Another reason for suggesting the unification of spenders and users is that in Italy NDPBs are almost non-existent (see further in Chapter 8).

One is apt to find oneself in a minor political minefield even in presenting financial information in this way. For example, it may be objected that the system is incomplete. It does not depict how Users allocate their funding so as to identify the structure of their costs, that is to say, we should extent the right hand part of the diagram. It portrays nothing of the employment structure offering speculation on the relative importance of different factors of production. Likewise, where do Households and Firms acquire their income to pay for cultural services? In other words one should extend the left hand part of the diagram. The enlargements and refinements are potentially endless. Elaboration would not alter the 'core' message, namely that government can play a major role in influencing the size and pattern of expenditure on cultural services in general and on heritage services in particular through its power to tax, to borrow, to spend, and to lend.

The identification of a flow-of-funds system leads naturally to the question, where are the numbers? Should one not attach to each flow a money value so that one can compare the relative importance of flows at each stage of the financing process? That is surely useful information, and, if one were really ambitious, as suggested in Chapter 2, one would provide the data on a year-by-year basis in order to illustrate the changing pattern of finance. ATP, together with Christine Godfrey, suggested this as long ago as the early 1970s, but the UK Central Statistical Office clearly regarded the scheme as having a low priority in their long list of proposals for improvement in UK official statistics. It is easy to understand their point of view and why nothing has been done in the last three decades. It is reasonable to suppose that the return on the statistical resources involved would not be very high, whatever the logic behind the scheme. ATP made an attempt to 'fill in the boxes' in the early 1990s and, with some difficulty, produced the information, but only for the transactions between Spenders and Users, shown in Table 4.3, and only for England. It is far from complete, notably in the data provided on the activities of private foundations. It was beyond our capacity to attempt to bring the table

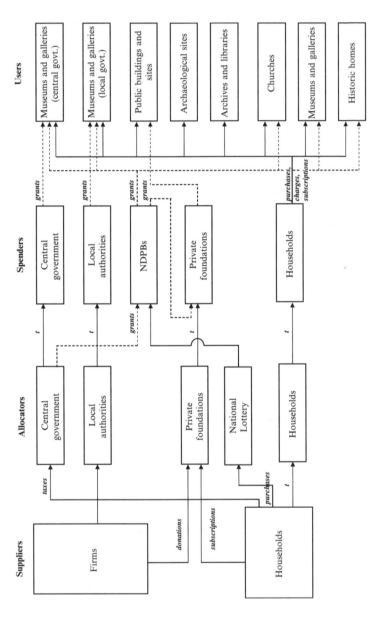

Fig. 4.1 Transaction matrix for heritage services

Note: t denotes transfers.

Source: A development of ATP's presentation in Peacock (1994).

Table 4.3. Sources and uses of heritage funding: England, 1993–4 (in £million)

Sources	Central government	Local government	NDPBs	House holds	Private foundations	Total	% of total
Grants	201	142	105	—	(37)	485	73
Charges	—	—	—		—		
Subscriptions	—	—	—	179	—	179	27
Sales	—	—	—	—	—		
Total sources	**201**	**142**	**105**	**179**	**(37)**	**664**	**100**
Uses							
Museums galleries (Central government)	189	—	—	73	(30)	292	44
Museums galleries (Local government)	—	?		?	—	110	17
English Heritage	—	32	105	15	(7)	159	24
Museums/ galleries (Private sector)	12	?	—	8	—	20	3
Historic homes (Private sector)	—	—	—	83	—	83	12
Total uses (£m)	**201**	**142**	**105**	**179**	**(37)**	**664**	**100**
% of total	**30**	**21**	**16**	**27**	**6**	**100**	

Notes: — = figures are not known but amounts probably negligible

() = figures are estimates only

? = figures are not known and magnitude of amounts cannot be estimated

Source: See Peacock, 'The Economist and Heritage Policy: A Review of the Issues', in *Does the Past have a Future*, Readings 47, Institute of Economic Affairs, London, p. 10 fn. 10.

up-to-date! Nevertheless, the table may fulfil our pedagogic purpose of unravelling the complicated relationships that are felt necessary to implement heritage policy.

Table 4.3 will give a broad idea of the relative importance in financial terms of the various 'players' in the public sector as both suppliers and users of funds. We hope that it affords a better understanding to the reader of the nature and importance of the structure of funding. It should be noticed that it employs a simple form of double-entry bookkeeping, a small tribute to its inventor, Pacioli, the good friend

of the creator of works regarded as of signal importance in international heritage, Piero della Francesca.

Further reading

A suitable starting point for supplementing our text is to become familiar with the tasks of the public authorities from the point of view of the officials responsible for carrying them out. Recommended are the reports of English Heritage (www.english-heritage.org.uk) and Historic Scotland (www.historic-scotland.gov.uk), both of them government agencies which are well geared to answer questions raised by Parliaments and the public about the scope of their tasks and methods of fulfilling them. They naturally concentrate on their successes but at least indicate the difficulties that they encounter. Both reports are beautifully illustrated: 'Heritage Counts: The State of England's Historic Environment', 2006 (www.heritagecounts.org.uk). 'Historic Scotland: Annual Review 2004–05', Laid before the Scottish Parliament, October 2005, ISBN 1-904966-17-9. (These reports cover built heritage, so that they must be supplemented by similar accounts describing the operations of museums and galleries as custodians of moveable artefacts such as pictures and sculpture.)

Particularly recommended is K. Thomson's book *Treasures on Earth. Museum Collections and Paradoxes*. Written by a distinguished museum director, this book offers splendid insights into the responsibilities and dilemmas of his calling. It is also highly relevant to the discussion in Chapter 5.

Finally, we should draw attention to the detailed comparison between heritage provision in Sicily and in Scotland which, in the case of the latter country, required a close examination of the administrative structure of Historic Scotland. This is to be found in a Ph.D. dissertation by Anna Mignosa, 'To Preserve or not to Preserve?'. Apart from providing a useful survey of the cultural economics relevant to heritage practices and policies, Mignosa recognizes the importance of identifying the decision making 'network' made necessary by the influence of the public authorities on heritage provision. The dissertation also includes a very useful bibliography that forms a good starting point for anyone embarking on a study of the economics of preserving the past and wishing to trawl through the ever increasing 'shoal' of (mainly) academic literature now available (for further references, see Chapter 6).

References

English Heritage. 2006. 'Heritage Counts: The State of England's Historic Environment' (www.english-heritage.org.uk).

Historic Scotland. 2005. 'Historic Scotland: Annual Review 2004–05', laid before the Scottish Parliament, October (www.historic-scotland.gov.uk).

Mignosa, Anna. 2005. 'To Preserve or not to Preserve?', Unpublished Ph.D. Dissertation, Faculty of History and the Arts, Erasmus University, Rotterdam.

Thomson, K. 2002. *Treasures on Earth. Museum Collections and Paradoxes*, London: Faber & Faber.

Yamey, Basil. 1989. *Accounting and Art*, New Haven, CT: Yale University Press.

5

Some economics of museums and galleries

Introduction

The previous chapter indicated the way in which the economist would approach the question of extracting and classifying data about MGs and heritage institutions to throw light on their activities. It was shown how this would require an analysis and presentation of their accounts which highlighted the decisions of such bodies and how these depended on their links with those who supply them with funds—both private individuals, in the form of charges and donations, and public bodies, in the form of grants.

Economists go further than build a taxonomy of the financial links between MGs, etc. and other economic entities. Although such information can enlighten both the individual heritage suppliers and policy makers, something more is required if this information is to form the basis of policy decisions by government and how far they will achieve their desired end of influencing the behaviour of the providers of heritage services by such instruments as grants and subsidies, tax concessions, and regulation. The 'anatomy' of the flow of funds system must be the precursor of its 'physiology', and this requires knowledge of how the various parts of the system behave in relation to one another. Economists try to develop models of behaviour which may help in the design of such measures and what they can tell us about reactions to their impact.

Economists can claim some success in predicting how businesses will behave in the light of expected changes in their economic environment, including changes wrought by governments. Of course,

economic forecasts are beset with uncertainties and are often no more than general impressions of likely changes. The respectable reason for their survival is that they appear to those who commission them that they provide a better foundation for decisions depending on their results than pure guesswork.

Of course, the use of economic analysis in order to throw light on the behaviour of MG directors and other providers of heritage services is of a different order. We are no longer concerned with trends in the movements in aggregate of well-established indicators of economic conditions, such as incomes, employment, and expenditure, but with the behavioural characteristics of those who manage the resources of a relatively small sector of the economy, albeit one whose perceived significance from the point of view of the government and the electorate is probably much greater than its economic indicators would suggest. It is, then, not sensible to rely on the kind of broad generalizations which are possible in considering behaviour in the aggregate where the 'law of large numbers' prevails.

This difference in scale points towards particular difficulties in analysing MGs and other providers of heritage services. It is not always easy to build a model which can comprehend the objectives of individual commercial concerns, although making profits for the owners comparable to those which they would earn from alternative investment opportunities serves as a useful approximation and is a common starting point in studies designed to measure the degree of monopoly in particular lines of business and which concern governments anxious to promote competition. Moreover, while what appears as 'profit' in their accounts may be arrived at after intense negotiations with both auditors and tax officials, at least it is expressible in measurable quantities. In competitive situations, satisfying shareholders requires managers to keep a close watch on costs and on sales opportunities, and in the longer run, to seek 'process' and 'product' innovations which will reduce the former and increase the latter (sometimes, they seem to be more concerned with their share of the market as a kind of symbol of their virility, but keeping shareholders happy must require particular and continuous attention to the rate of profit).

Not surprisingly, as goods and services, including cultural goods of all kinds and labour services, are exchanged for money, economists have concentrated empirical studies on market relationships where decisions are given quantitative expression. Accordingly, economists, not anxious to find themselves in the murky waters of measurement of cultural

output, they have worked largely on the fringes of the 'heritage-biz' by considering what they can reveal about the operation of the art market, particularly the sale of paintings and sculpture, where data on prices are available going back hundreds of years. Conclusions may be drawn about whether art is 'good investment' in the sense that pictures act as an alternative to investing in house property, land, and financial assets, etc. Analogously, attention has been paid to the analysis of the private demand for heritage services, as expressed by visits. The empirical results seems to suggest that demand is price inelastic and income elastic, the latter effect, however, being somehow ambiguous because of the opposite effect generated by the opportunity cost of time, which increases with income. At the same time because of the peculiar features of cultural consumption, stressed in Chapter 3, individual preferences, as determined by past experiences, are usually found to have a relevant effect in determining private demand alongside many other factors referring to the type of museum, the quality of collections, the type of additional services, etc. (for further analysis see the references provided in the Reading List).

However, as we continually emphasize, the demand for heritage services cannot be fully expressed through commercial relationships, which offers reasons, already outlined, for public intervention, including public financing. In receiving public funding, often the main source of income of MGs, the 'buyers' become the agents of taxpayers and have to devise some means for specifying the nature of the 'return' they expect from funding the providers, other than commercial success, and, by implication, how the level of that return varies with the amount of the funding budgeted for the purpose.

The form of incentives, such as grants and tax concessions, and constraints, including regulations and other restrictions on the activities of managers of MGs, will vary in their effects, and a good deal of attention has been paid in economic analysis of the effects of such measures, but usually assuming that managers are passive reactors to their imposition. This may be a useful first approximation, particularly in comparing alternative incentives and constraints with a view to minimizing the cost to the taxpayer in order to achieve some given change in the amount and composition of heritage 'output'. However, as we have continually emphasized, defining the public interest in terms of cultural goods and services makes it difficult to lay down precise targets which can be translated into a 'job specification' for managers, something that is made all the more complex because of the wide acceptance of the

influential role of the producers of culture themselves in deciding what is 'good' for those who are expected to benefit from their services.

A clear example is offered by the simple fact that it is difficult to define what a museum is. The issue is interesting not merely as a matter of definition but because it may be used as a 'barrier to entry' by peer group committees in vetting applications for public funds. The International Council for Museums (ICOM) provides an influential benchmark in any discussion of about 'what is a museum'. According to ICOM 'A museum is a non-profit-making, permanent institution in the service of society and of its development, and open to the public, which acquires, conserves, researches, communicates and exhibits, for purposes of study, education and enjoyment, material evidence of people and their environment'.

In line with the experts' approach, such a definition tends to narrow the set of eligible institutions to those which combine all the above mentioned activities. In fact, to what extent the readers will find evidence of such a definition in their experience as visitors is an open question since in many cases the composition of the objectives and activities varies greatly. The authors can offer many examples. For instance, according to the Accreditation Scheme for Museums in the United Kingdom, 'Museums enable people to explore collections for inspiration, learning and enjoyment. They are institutions that collect, safeguard and make accessible artefacts and specimens, which they hold in trust for society.'

On the other hand, according to the new Italian Code for heritage, issued in 2004, Italy still retains a Napoleonic approach mainly aimed at the conservation of collections. 'Museum is a permanent institution which acquires, conserves, orders and exhibits cultural artefacts for purposes of education and study.'

And anybody could easily check for such diversity, by exploring the websites of comparable British and Italian museums institutions.

The degree of latitude afforded to MG managers in defining the nature of their services, together with their bargaining relationship with the providers of their funding offer a challenge to the economist interested in generalizing about their motivation and how this is reflected in the services for which they are responsible. The problems are compounded by the very considerable variety in the size and structure of the institutions providing such services from private concerns, which can be non-profit-making charities or profit-making enterprises and which range from large complexes of preserved and

restored buildings coupled with archaeological sites of international eminence to small galleries and museums run by 'one man and a boy' celebrating the history of one village or district. Moreover, a peculiar kind of museum is given by the personal collections, usually put together by wealthy people, with the advice of experts, and sometimes located in dedicated spaces within a museum or constituting a museum themselves, when located within original premises.

Again, the composition of supply, especially as far as ownership is concerned, reflects the differences in the public decision-making model prevailing in each country. Age is also relevant if we consider the widespread phenomenon of new museums entering the scene at a very rapid rate: whether such a phenomenon is a signal of vitality of the cultural sector, of its capability to meet increasing demands, is hard to say, the answer depending on the institutional context in which the phenomenon takes place—whether public, private, or non-profit institutions are involved.

Indeed, there is a variety of MGs: art, archaeology, history, natural science and natural history, science and technology, ethnography and anthropology are the most common, but there are also many museums specialized in such a wide range of specific subjects that they cannot be included in one category. This appears to be the largest category according to the recorded statistics. The less specialized is their mission the higher is the degree of substitution with other forms of entertainment, a classical example being the science and technology museums, which provide interactive experiences, facing the competition of other leisure activities rather than archaeological museums.

In the economists' jargon, MGs are multi-product producers and it is in the interest of the economists to understand how the combination of the output is determined and to what extent it reflects MG managers' own priorities or is demand-oriented. The features, such as size, content, location, are inevitably important elements in shaping the output as well as the professional features of the MGs' staff and the institutional environment in which MGs operate, as we are going to examine.

Modelling museum behaviour

The reader will probably be familiar, perhaps without realizing it, with methods used in the social sciences, including economics, to confirm hypotheses about 'economic' behaviour, if only from being

confronted with the frequently issued questionnaires which drop through the letter box or now appear on e-mail. It seems a positive advantage for the investigator to be able to 'converse' in this way with their subject matter, compared to scientific investigation of, say, animal behaviour where there is a language barrier, although in the latter case, there are possible compensatory advantages if animals can be studied under controlled conditions, as in experimental laboratory work.

Here we pursue another approach which endeavours to avoid the difficulties associated with direct enquiry from respondents by method more akin to detective work than to an interrogation of 'suspects'. It is known in the technical jargon as the 'revealed preference' method. At least, nowadays when MGs are financed to a considerable extent by public funding, the managers have to be accountable to those in charge of such funding—the public officials and ultimately their political 'masters', where the latter may in turn be accountable to the national or regional electorate through legislatures who require information checked by the auditing authorities. The result is the emergence of statements about the professed particular aims of MGs, their methods of fulfilling them, and, as we have seen in Chapter 4, financial data in accord with accounting and audit principles used in government funding. Such an approach is not always fully applicable: as already stressed in Chapter 4, the managerial independence of MGs might be very limited or even non-existent as is the case for most of the Italian state MGs which are directly managed by the Ministry of Culture (through its local administrative branch) with even basic choices, such as admission ticket prices and opening hours centrally decided and revenues from ticket sales or from ancillary services being part of government revenues and not always accruing directly to individual museums. In such a situation, MGs' accountability is clearly reduced, although changes are on the way, as is demonstrated by the financial and managerial autonomy granted to state museums of 'exceptional value' (Florence, Naples, Rome, and Venice).

There are, however, two difficulties about reliance on public documents of the kind described. If prepared and issued by the particular institution responsible for a heritage service, such as an Annual Report, they invariably (and understandably) concentrate on producing a litany of successes and play down, if they mention at all, any failures in achieving objectives. If they are overviewed by some government

funding body, they may be required by law to provide certain kinds of information, for example referring to their financial situation and agreed indicators of their performance (see Chapter 9). Important limitations to publicizing particular activities of beneficiaries from public funding include, *inter alia*, accusations of unwarranted interference and the extra cost on both sides of a detailed monitoring process.

The second difficulty is how 'success' is to be defined. The tasks of MGs are both difficult to specify and to quantify and, although they may be required to publish Mission Statements which define such tasks, often in considerable detail, these do not offer a clear indication of what actions these entail in order to fulfil them. Their identification varies according to the skills and competence of the experts involved. In the case of MGs, there is a strong tradition of assigning these tasks to those who have technical expertise as art historians, archaeologists, etc., sometimes with restricted views concerning the choice of artefacts of national or regional significance and the understanding of the issues involved in their conservation. Therefore, the more this is the case, the more the managers are trusted to act in the public or general interest. It is not surprising, therefore, to find that the published documents on their activities may emphasize that their 'output' is not definable in quantitative terms and that those who enjoy their services will best be guided by their professional reputation.

It is this discretionary element (and its consequences) which interests economists, particularly as it is a characteristic of other organizations in which the discipline of the competitive market is absent, and profit is no longer the principal spur to action in deciding how resources are to be employed. In the economic analysis of bureaucracy, for example, a model of behaviour assumes that bureaucrats have no profit-making opportunities which are related to their input of effort—corruption is ruled out—and that their principal optimizing strategy is to try to raise their real income in other ways, for example, by 'empire building' which increases their personal prestige or, if such an opportunity is ruled out, by increasing their consumption of leisure at the cost of effort. The general result of such models is to show the extent to which inefficiency—in the form of costs incurred over and above those necessary to perform the required services—is endemic. Naturally, such a result, varying with the behavioural assumptions made, does not appeal to its subject matter, and

we should not expect things to be any different if similar ones are made in the case of heritage provision.

The pioneer in the application of 'revealed preference' analysis to the motivation of MGs managers is the well known Swiss economist, Bruno Frey (see the Further reading at the end of this chapter). It will be clear from his writings that this approach assumes a quite extensive knowledge of the workings of MGs, but the really interesting issue is how this is brought to bear on the question of motivation. He fastens on one important characteristic, revealed in published information, which offers a marked contrast to what happens in the pursuit of private business.

An ordinary business sells as much of its product(s) as is compatible with its profit target (cf. above) which has a marked effect on the amount on its stock-in-trade. The amount and the composition of the stock will depend on the demand for the products or services, and in any case the business may be physically transforming the products before sale. In the course of time, not only will the stock vary in size but its existing composition may change as a result of modifications in the stock made necessary by changes in taste, with the fashion industry being a striking example. An example more in line with an interest in heritage, is provided by art dealers: only in the case of prints may the stock turnover be characterized by repeat orders for the same product; the stock of original paintings for sale will be altered in line with changes in tastes for the arts of different periods and for different schools. The important point is that the stock is held in order to ensure that output requirements can be met, but, as holding it involves costs which are likely to vary with the size of stock, managers of private businesses must have an incentive to minimize such costs by acquiring expertise in forecasting the relation between stocks and output.

Commonly, MGs recognized as being approved agents of the public interest, and financed and/or owned by the public authorities, have holdings of historical artefacts that are static in the short run, and additional stock will be limited in the longer run by the rate of purchase out of income and the incidence of offers of acceptable gifts. These additions will be a small proportion of the total stock in the case of long-established MGs. The alteration in the composition of the stock, for whatever reason, as a result of accretion will be a slow process. However, at some stage, unless the composition and size is to be altered by a disposal of part of their 'portfolio of assets',

accretion puts pressure on galleries to increase the availability of space involving capital costs or rental payments. Not surprisingly, given the competition for arts funding generally, and the tendency to relate display space to demand for exhibitions of the permanent collection, net accretion of historical artefacts can produce the awkward situation where the proportion of stock on public display diminishes through time. The example which appears to have stimulated Frey and his collaborators to look more closely at the welfare function of MG managers was that of the famous Prado museum in Madrid where a few years ago it was alleged that only about 10 per cent of its available stock of paintings was on display at any time.

An obvious solution seemed to be presented by giving MG managers the freedom to alter the amount and composition of their stock by sale, including 'barter' with other holders of heritage artefacts, and to use the proceeds from sales to purchase artefacts that would enhance the appeal of their collection to those that they identified as their 'customers'. For example, this could give them the flexibility to purchase items which closed 'gaps' in their collections. Why, therefore, is this not a widespread practice which attracts the enthusiasm and tests the skill of managers? Before answering this question directly, one should be aware of the constraints affecting the degree of discretion which MG managers may have in deciding on the size and composition of their stock of artefacts. Frequently, MG collections of artefacts consist to a major extent of gifts which have been made over many years. The condition of acceptance not infrequently requires that the individual items and the whole gifted collection should not be sold and also that it is expected that it will be available on display to the public. Again, the nature of the employment contract for MG directors may restrict their power to buy and sell artefacts because any decision taken, primarily in the case of well-known items such as Renaissance paintings, may raise political issues. A case in point is when, as in the UK, an important painting in a private collection is offered for sale to a public gallery in exchange for some relief in inheritance tax payments and where agreement on the price clearly concerns the tax authorities, and it must be agreed by the Government that the painting is, in some sense, of 'national importance'. In some countries the law specifically prohibits de-accessioning. Take the Italian case. The fact that public collections are state property prevents independent action by museum directors.

However, the impression must not be conveyed that managers of MGs feel that these constraints are necessarily onerous and more of their time should be spent on seeking for their modification to allow more freedom of manoeuvre in the handling of their stock. On the contrary, there are several reasons for believing the opposite. As MGs do not operate as profit-making concerns, the managers have no means for deriving any personal financial benefits from adjusting the portfolio of assets. Moreover, their actions would be more open to scrutiny if they engaged in commercial transactions and deflect judgement away from consideration of their professional reputation and skills. To concentrate assessment of performance on increasing the opportunities to improve and expand the stock on display would be to neglect their duty as custodians of research archives and the husbanding of artefacts which are too valuable or too fragile to be displayed, or which are of interests only to scholars.

These actions denote that the consequence of the lack of dependence of MGs on direct payment such as charges for viewing and for use of research material must be that their managers have considerable opportunities for discretionary behaviour. The important policy concern here is whether, with public funding, the managers have an incentive to use this discretion to promote the 'public interest'. There is clear evidence that in the case of national museums it is accepted that a necessary condition for the senior staff is that they are respected by their professional peers. That being the case, maximizing their reputation with their peers becomes an overriding objective and that does not depend on arranging the stock of artefacts so that they receive maximum exposure and conform to the wishes of the ordinary public as MG visitors, but on the perceptions of professional experts in the creative arts in the aesthetic value of the collection and the mutual benefits derived from the undisplayed stock made primarily for research purposes to kindred spirits.

There is nothing unusual about the influence of discretionary action amongst professional occupations. Academic economists are paid to teach but are also expected to publish research which conforms to the standards set by their own profession and from which they derive not only its acclaim but evidence for career advancement, and fringe benefits regarded as complementary to their reputation such as subsidized attendance at international conferences, study leave, and time off for consulting and for advising governments. Much the same applies in MGs. However, one gains the impression

that their directors have much more direct influence than academics over the terms and conditions of their employment because their field of expertise can have a particular aura which overawes their paymasters and the Trustees or governing body set up to regulate their activities. Collectively, directors of MGs, united in a common discipline (such as art history and appreciation or archaeology) if divided in their aesthetic tastes, can offer an articulate and persuasive voice in cultural matters, which impresses their governmental masters and influences their own job specification and that of their professional staff.

This generalized account of the motivation of MG directors, the constraints under which they operate and their behavioural reactions is not an implicit criticism of their optimizing activities. Even if the viewing public have little direct influence on these activities, there is likely to be a solid core of enthusiasts who wish to learn how to appreciate artefacts and who depend for their instruction on contributions to the literature on arts written by gallery curators. Such votaries of heritage artefacts are understandably impressed by what they read and likely to accept the argument that the public interest is best served by the artistic judgements of MG professional staff and therefore the choices the latter make in preserving the national heritage. They will also appreciate that the custodial role of MGs extends to considering the interests of future generations and not simply the passing fashions in artistic and historical interests of today's public. Thus, on the normally rare occasions when decisions on the financial future of cultural institutions such as MGs may crucially depend on public attitudes, their directors may have 'built-in' support already available.

Whatever skills MG directors and their senior staff may possess in identifying artefacts of historical importance and in knowing the appropriate techniques for their preservation and display, having to work with limited budgets and therefore having to choose between alternative additions to the stock of artefacts must display their *personal* preferences. This must be the case because there is no scientific way of ranking their choices. Choices are value judgements but in the case of historical artefacts, it must be said, they are informed ones based on what the famous art historian, Ernst Gombrich, labelled 'collateral information', which only experts are able to supply in respect of the provenance of works of art. Of course, a consensual view amongst MG directors in the ranking of artefacts may carry

weight with public authorities and the informed public. Their judgements on such policy matters as serving preservation orders on historic buildings and on the exporting of works of art must command great respect, but such a view must remain subjective.

It would be wrong to give the impression that MG and built heritage managements can ignore the pressures on them to consider the development of their activities so that they are consonant with the interests of the general public as the latter perceived them. There is a natural extension of their skills in the development of educational programmes and a wide conspectus of publications from large expensive tomes to 'give-away' fly leaves that adorn the display units of the art shops now attached to their premises. (The subject of cultural heritage has the great advantage that the display of its services can be so vividly presented in visual form.)

More questionable, perhaps, is how far management perspectives are prepared to take into account the further requirements of organizational skills which more attention to overall economic issues must demand. Pressure from the public financing authorities has been recognized in the rather clever device of 'inventing' a science of Museology, by which senior management have formulated precepts of 'good governance' that it is hoped will convince their paymasters that they are the principal source of knowledge on the expertise required to run their affairs, a strategy not unknown in the university world. Such defensive tactics are consolidated in the ICOM Handbook on *Running a Museum: A Practical Handbook*, which commands wide acceptance internationally (see the Further reading at end of this chapter). However, how far do principles of museology, either conceived in the narrow sense of how to acquire, display, and conserve historical artefacts or the wider one that includes marketing and financial control, assume practical significance? That will crucially depend on the extent to which these principles become reflected in the conditions attached by the public financing authorities to the provision of funding.

However, our present concern is how far economic theory produces insights into managerial behaviour; Museology is clearly an attempt to codify rules of governance designed to offer a guarantee of responsible behaviour so that senior management of MGs financed largely by taxation can avoid attempts to expand government intervention in their affairs. The economics of any bargaining relationship is explored further in Chapter 9.

The relevance of economic analysis

A common misinterpretation of the model of 'maximizing' the welfare of the decision maker, subject to the constraint of limited resources, lies in the charge that economists overemphasize human selfishness and offer a cynical interpretation of human action. This may appear to be confirmed by the examination of the behaviour of those in charge of heritage services. It goes further in appearing to deny that removing the prime objective of maximizing the income of shareholders by the creation of non-profit suppliers of services, that is an institutional change, will create a consideration for others. The desire to serve the community at large is then epitomized in willingness to work in a non-profit-making organization in which monetary incentives, such as bonuses tied to profit performance, are absent. The conclusion to be drawn appears to be that the economist's model of human behaviour cannot and should not be applied to non-commercial concerns.

Our analysis is designed to show that the model, shorn of attaching exclusive attention to profit making as the main impetus for managerial action, can easily be adapted to the analysis of the motivation of managers of non-profit making organizations in general, including public authorities, and MGs in particular. No more is claimed for it than its interpretative quality, but this is important when one examines the relationship between MGs and their methods of finance, particularly in the terms and conditions negotiated with public authorities concerning grants and loans which, in the case of national MGs, extends to agreement over indicators of performance, the terms of reference of their directors and the regulation of their actions. We hope to substantiate this claim in later discussion of heritage policies.

There is a wider question raised by the view that an institutional change, in this case assigning the main task of implementing heritage policies to non-profit making, principally publicly provided concerns, will alter the moral climate and, in so doing, better achieve the requirements of the public interest in extending appreciation of culture. It cannot be satisfactorily discussed, far less answered, without a full analysis of what constitutes moral behaviour, not a subject to be embarked upon in this context. However, it is important to raise it because it is often taken for granted in discussion of cultural issues that the 'higher values' involved in the provision, understanding, and

appreciation of artistic treasures, in contrast with popular taste, by themselves improve the moral standing in the community of their *aficionados*.

The reader should know that this view is highly contested, and not only by economists, as will be apparent later. The economist's approach is quite straightforward. In the market-place, exchange takes the form of buying and selling, and contracts are made which are agreed between persons who never meet and which are subject to the uncertainties arising from taking time to fulfil. A necessary condition for such a system to work is honesty and trust between buyers and sellers, with the incentive to behave morally reinforced by competition. That is not to say that the rules are not broken or that entrepreneurs will not try individually or collectively to reduce the impact of competition by some form of monopolistic action. But similarly, whatever view is taken of the aspirations of the directors of MGs and their staff, the degree of discretion afforded by a system where their 'productivity' is defined by themselves and not by the direct sale of their services can offer a temptation to rationalize their own choices of the stock and composition of the artefacts under their charge by claiming that the end result is a display which is fully compatible with the public interest. The important constraint on this temptation is peer group assessment of their achievement. In both systems, in other words, one need not equate selfish behaviour with self-interest. Once again, the question is how far the resultant 'product' conforms with acceptable criteria of what is the public interest, stressing once again that this is one that we must not ignore.

Finally, one must bear in mind that, just as in commercial life, the economic climate is always changing and constraints on entrepreneurial action are constantly altering, such as changes in buyers' tastes, and the same is true in the MG world.

A prime influence on the changing pattern of public demand is technology. We offer, as an example, its impact on the educative function of MGs. Within living memory, the authors can recall the days when MGs as public institutions exuded an atmosphere of sepulchral calm with a few reverential visitors tiptoeing through the display rooms. Nowadays the concepts of education and enjoyment have entered most museums, without distinction of size or content. The extent to which these activities are implemented depends on the priorities assigned by the directors, consistent with the existing set of incentives. Apart from the more conventional educational means,

such as guided tours and audio guides, museums are increasingly using computers, with specially designed software so that visitors can learn, usually interactively, about the museum services available. Additionally, special education spaces are supplied with information and material to allow for various degree of analysis of the topics related to the content of the museum. A caveat is often put forward, suggesting the risk that computer-based information and learning systems, while improving the educational function of the museum, may distract attention from the displays and original objects themselves. It goes without saying that the same educational opportunities can be offered through the internet to 'virtual' visitors; indeed, web sites can be a powerful means to increase and qualify the demand of the MGs services and, more in general, to improve the level of information and education and, eventually, to enlarge the demand to other cultural attractions; in other words, the concept of 'experience good' (see Chapter 2) may acquire a further dimension.

Moreover, governments concerned about international competition in cultural services attach the condition to the ever-increasing demands for funding from MGs of becoming more conscious of their role in meeting the demands of cultural tourism. The response of major MGs has been remarkable, although special circumstances seem to have favoured particular ways of doing so. The demand for their services seems to have been led by the tastes of professional and other highly paid groups who have already invested in cultural experiences or who have an incentive to do so. MGs managements have been particularly clever in satisfying this demand and in ways which are consonant with the objective of retaining their status in their peer group. This has been achieved by temporary 'blockbuster' exhibitions, perhaps drawing on the latest research on the work of an already popular artist (but one approved by the art establishment) and which is made palatable by fascinating brochures and coffee table books and a whole range of souvenirs that mark out a visit to such an exhibition as a special occasion. The organization of such exhibitions generate close cooperation in which 'peer to peer' relations have been fundamental to their success, leading to active lending policies between major MGs, not only within but outside national boundaries. No money changes hands in the 'market' for lending and borrowing, but an informal barter system has developed between directors of MGs willing and able to lend major works of art, but only to a select group with close professional relationships based on

personal prestige and mutual respect. The inclusive character of this arrangement has an interesting economic effect. It can operate as a high barrier to entry, making it very difficult for 'interlopers' to demonstrate how they might challenge accepted opinion on museological practice. This leaves the incumbents free to use temporary exhibitions as a means for introducing attendees to their permanent collections and possibly interest them in other artistic treasures of the past linked to their exhibitions.

In addition, joint supply is increasingly practised in the sense that different cultural institutions enforce their own 'market share' cooperating with others offering similar but complementary services. In Italy, for example, a large selection of 'cultural circuits' designed to increase the number of visitors are available in Rome, Florence, Naples, and Venice—to mention only the most famous producing very good results, almost doubling the number of visitors between 2000 and 2005.

Although key players in the cult of cultural tourism, MGs are only part of the complicated pattern of services available promoting cultural heritage and specifically designed for different tastes. The following is a familiar scenario. Cultural tours have become increasingly attractive to well-off, busy, and educated people for whom time has a high price and who therefore find it worthwhile to pay agents to offer well-organized visits to historical sites and similar attractions, relieving them of the time and effort of obtaining information about the cultural gems to be enjoyed. Even the sailing time between major ports during a Mediterranean cruise may be taken up with background lectures on the art treasures in easy reach of, say, Barcelona, Palermo, Venice, Livorno (for Pisa and Florence), Tunisia, and Athens. Public MGs will be expected to be open at convenient hours and not proscribed by national and local holidays and Saints' days, to provide knowledgeable guide books and a panoply of literature and souvenirs for sale. As tourists invest in knowledge of artistic matters, they may wish to find a time-saving way of recollecting what they have learnt, for example DVDs which present informed accounts of what they have seen. The growing use of web sites as a source of information has encouraged MGs to increase their accessibility by reducing the time costs of search for information about suitable accommodation and transport. A potent symbol of the way in which national and regional MGs are no long simply part of the passing show of available experiences but the focal point of the tourist experience is the care and attention now paid to the design of new MGs. They are no longer simply repositories of works of art but works of art in

their own right and designed to take their place through time as part of the architectural heritage. Bilbao springs to mind, and, by contrast, the new Lowry complex designed to improve the built environment of the old industrial town of Salford, England.

The mention of the built environment is a reminder that the contents of MGs do not by any means exhaust the items which constitute heritage. On the contrary, the preservation and restoration of the cultural environment in the form of the vast variety of buildings of all kinds, from castles to cottages, is what for many ordinary people is covered by the term 'heritage' rather than their contents now on display in MGs, to which must be added sites of historical interest, notably battlefields. This is our next concern and we hope to demonstrate that economics, as the science of choice, has a good deal to say about the methods used to organize its provision.

Further reading

The application of formal economic analysis to the examination of what makes non-profit making organizations tick is of recent vintage and presenting it in digestible form for those unused to mathematical presentation offers the risks of being misunderstood, particularly by the subject matter—museum and gallery directors and managements. This is vividly illustrated by the experience of ATP who (with Christine Godfrey) wrote one of the first attempts to explain the economics approach: 'The Economics of Museums and Galleries', *Lloyds Bank Review* (1974) particularly the section on The Museum/Gallery as a 'Firm' (Reproduced in Towse 1997).

A prominent gallery director attacked this article, claiming that it was the blueprint for the introduction of charging in British MGs by the Thatcher Government! ATP makes no claim to have such direct influence on Government arts policies! Cannon-Brookes (1996), however, does mount a vigorous defence of the right of the gallery director to resist any attempt by governments to introduce political criteria in the choice of MG contents.

As already suggested in the text, the *locus classicus* of economic modelling of MGs' management behaviour is found in the work of Bruno Frey (2003, Part II).

Economists interested in a more formal approach can follow up Frey's analysis in his comprehensive study with Stefan Meier (2006).

An imaginative, amusing, and penetrating essay is written by William Grampp, a pioneer in the field of Cultural Economics, and a major authority on the economic organization of museums and galleries. It not only raises all the main questions that concern the economist about organization, but also offers a very useful introduction to the further study of the motivation of museum directors and its importance in devising cultural policy. (See Grampp (1996)).

Some kind of *rapprochement* between the economist and the directors of MGs is suggested by the approach used to the study of the planning problems facing the distinguished curator the Oxford University Natural History Museum, Dr Kenneth Thomson in his *Treasures on Earth: Museum Collections and Paradoxes*. For example, he is prepared to consider the possibility that museums could dispose of their collections through 'de-accessioning'. Once considered a forbidden topic and an idea contrary to the Code of Ethics of the Museums Association of Great Britain, it has become a subject of public debate in the UK centred in a report sponsored by the National Museum Directors Conference in 2003, *Too Much Stuff: Disposal from Museums* (2003). The Report was prepared by a working group chaired by Mark Jones, Director of the Victoria & Albert Museum, London.

A wide overview of the evolution of the operation of a museum, is offered by ICOM, 'Running a Museum: A Practical Handbook', which offers the contributions of several experts to relevant aspects, ranging from general issues such as Code ethics to very specific ones such as museum security.

References

Cannon-Brookes, P. 1996. 'Cultural Economic Analysis of Art Museums: A British Curator's Viewpoint', in V. Ginsburgh and P. M. Menger (eds), *The Economics of the Arts: Selected Essays*, Amsterdam: North Holland, Elsevier.

Frey, Bruno. 2003. *Arts and Economics*, 2nd edn, New York: Springer Verlag.

Frey, Bruno. 2006. 'The Economics of Museums', in Victor Ginsburgh and David Throsby (eds), *Handbook of the Economics of Art and Culture*, Amsterdam: North Holland.

Grampp, William. 1996. 'A Colloquy about Art Museums: Economics Engages Museology', in V. A. Ginsburgh and P. M. Menger (eds), *The Economics of the Arts: Selected Essays*, Amsterdam: North Holland, Elsevier.

International Council for Museums (ICOM) n.d. 'Running a Museum: A Practical Handbook', http://unesdoc.unesco.org/images/0014/001410/141067e.pdf

Jones, Mark (chair). 2003. *Too Much Stuff: Disposal from Museums*, Report prepared by a working group chaired by the Director of the Victoria & Albert Museum for the National Museum Directors Conference London.

Peacock, Alan and Christine Godfrey. 1974. 'The Economics of Museums and Galleries', *Lloyds Bank Review* January, Reproduced in R. Towse (ed) 1997. *Cultural Economics: The Arts, Heritage and the Media Industries*, Cheltenham: Edward Elgar, 364–75.

Thomson, K. 2002. *Treasures on Earth. Museum Collections and Paradoxes*, London: Faber & Faber.

6

The built heritage

Introduction

Our description of the organization of heritage provision and the analysis of the 'objective function' of those who manage heritage services has been applied to the cases of museums and galleries which house moveable artefacts such as paintings and sculpture and to the built heritage. We believe it to be substantially true in respect of cultural organizations which are not run for profit. It has been convenient to concentrate primarily on museums' and galleries' managements. However, there are features in the presentation of the built heritage as a service to the public that pose particular problems of interpretation and which call for more extended analysis.

No international association nor professional body has attempted to produce a definition of 'built heritage' and demanded its acceptance, as in the case of MGs (see Chapter 5). Later we shall show that it would be difficult and possibly misleading to do so for the term covers a heterogeneous set of artefacts whose composition and size varies between countries.

These features are closely associated with the history of heritage provision. Museums and galleries may proliferate as a result of private as well as public initiative, particularly in response to interest in the industrial past. How our forebears lived and worked stimulates contemporary curiosity and helps to establish private, non-profit making museums specializing in a particular trade or craft with which our ancestors were associated. They house collections of artefacts which may be of interest in themselves or because they hold together a narrative of the evolution of a particular occupation or trade or even the history of a family. Location may not be a crucial factor in displaying these collections to best advantage.

The built heritage is another matter. The separate location of buildings of historical significance which excite the interest of the public as well as that of the historian, archaeologist, and architect is a common phenomenon. The location itself may add to that significance, as realized by those interested in castles, forts, and battlegrounds as historical landmarks. One recalls that reverence for the past is not new: it was associated from an early time with the pilgrimages to holy shrines and these still retain their significance today, for example Mecca and Jerusalem. However, in periods of rapid economic and social change, especially with the growth of industrialization in Western countries, while the location cannot alter, the perception of the value of the built heritage may markedly change. This is particularly true when what was once a building, clearly distinct and separate from others, ceases to serve its original function as a residence or a place of worship and becomes juxtaposed to others created in a different style and more closely related to the social and economic activities of a predominantly built environment and meeting the needs of an urban working population. This is because the architect's and designer's skills have now, more than ever before, to take account of the reconciliation between the different and often conflicting aims of urban planning which, with the concomitant growth in democratic local as well as national government, require a political solution. The perceptions of the value of the built heritage changes in the light of planning requirements, not simply because of the extension of political participation to those supposedly devoid of the aesthetic sensibilities of acknowledged pundits in artistic matters, but even within professions with a long history of precedence in the dispensing of aesthetic judgement.

It would take us too far away from the theme of this book to offer a disquisition on the 'battle' between the European modernist architects and the 'conservationists' which has now reached the stage of a possibly uneasy truce between the contending parties. Put very baldly indeed, many of the influential members of the former 'school' still believe that urban planning must not only entail some overall uniformity of design to which older buildings cannot be made to conform but that concessions to individualism of taste are counter to the creation of a cohesive society. There are still vestiges of the belief of the older town planners, such as Geddes, Mumford, and their disciples, that comprehensive planning was an aid to improving the moral welfare of society. This is not a view which receives great support from the social history of European countries, in which

town planning has permeated the provision of workers' dwellings in large complexes, even if these have been centred in pleasant rural areas and provided with recreational space and facilities. This in itself has allowed more prominence to be given to the views of those architects and historians who have attracted growing interest from the public by tracing the importance of our links with the past through preserving the built heritage of our forbears.

The inevitable conflict of values goes much further than the confines of the architectural profession. Thus historians may claim that the satisfaction derived from knowing our social and economic origins does not necessarily presuppose that important historical events take place in buildings of architectural significance (ATP recalls his amazement at the idea that the markedly undistinguished Nissen huts—used as a base camp for housing naval personnel on the Orcadian island of Hoy—ought to be preserved as a necessary reminder of the historical importance of Scapa Flow as a naval base!). The technical advances in archaeological discovery have markedly increased the number of locations of settlements and their contents, offering new perspectives on the social, military, and economic history of our ancestors. If such discoveries coincide with the sites chosen for or even occupied by present-day shops, offices, and homes, by what principles can one decide whether archaeologists and historians should have any influence over how such sites should be developed? (The reader who wishes to ponder on our interpretation is referred to the discussion of our sources, given, as usual, at the end of the chapter.)

We may need to be reminded of this background information at a later stages of our analysis. Our own perception of the significance of heritage as an important element in the 'objective function' of individuals, acting alone or in collaboration with others, must raise the prior matter of the opportunity cost of investing in resources with the intention of benefiting ourselves and, as part of our choice patterns, future generations. If we rely on the expertise of those whom we employ privately or through our contribution to the public purse to offer advice and guidance on what it is in our own interests to enjoy, then the conflict of interest between those who claim that their 'cultural values' should have pre-eminence becomes at least a source of confusion in our minds. To anticipate our later discussion (Chapter 8), it is our contention that removing this confusion entails looking for sensible ways in which the 'consumer of heritage' can become more closely involved in the choice process.

The economic characteristics of the built heritage

Heritage can be considered as a capital asset with some cultural economists, notably a well-known Australian economist, David Throsby who used the term *cultural capital* to reflect the value attached to this type of asset. This approach combines different dimensions. On one hand, there is a physical dimension which requires resources to maintain heritage in good shape and to prevent deterioration; on the other hand, heritage provides a flow of services to be enjoyed as a consumer good (for instance when a monument requires to be visited) or as an input for production purposes (for instance, an ancient Roman or Greek theatre used for performances). It may be regarded as a valuable asset not related to the use of the monument but only to its existence in the present as well as in the future.

These two dimensions, however, are not independent of each other because the possibility of producing a flow of benefits is strictly related to the state of the physical asset and, of course, such a state depends, amongst other things, on the uses to which it is put and the rate of its depreciation. Indeed, an extreme and paradoxical case might be put forward if the role of new technologies is taken into account. Thus if 'virtual' visits (e.g. using videos, DVDs, etc.) can be considered as substitutes for actual ones, the concern for physical deterioration might lose part of its relevance. The benefits stemming from heritage could be enjoyed through 'virtual' visits, offering a cultural experience which can be replicated through time, with heritage having a static role, being described at a given point in time, the only difference among different cultural experiences through time depending on the consumers' capability of appreciation and not on the changes in the heritage features. Indeed, 'virtual' visits might provide more complete and satisfactory cultural experiences than actual ones because of the almost endless opportunities offered by technology to a very wide range of customers.

Several implications derive from the application of technology. Heritage might deteriorate through time but it could still be 'virtually' visited as it was, regardless of whether further decay has arisen through time, because its image has been stored, enriched by the provision of full in-depth information. Provided that no value is attached to the material existence of the artefact *per se* and to

the possibility of transmitting it, physically, to future generations, technology could be seen as offering an extreme solution to the conservation problems. There would be no reason for investing resources in conserving an artefact, since it is already preserved in the collective cultural memory.

There are clearly definite limits to such a provocative extreme view. First of all, the assumptions themselves are questionable: the argument, indeed, relies on the very weak hypothesis that 'virtual' and real visits are substitutes and that the existence of heritage entities does not offer private and social benefits. Technology favours the dissemination of knowledge and is therefore likely to increase the demand for heritage. The more appealing the 'virtual' visit and the more the knowledge and appreciation of the artefacts presented, the more likely it is that there will be a desire to experience a 'real' visit, particularly if the interests of future generations are being taken into account (how an evaluation of such demand can be attempted, is explored in Chapter 7). Such an argument has to take into account the rapid evolution of technology which may render the stock of such information rapidly out-of-date.

There is one use of technology that has excited much interest. It concerns the case where providing access to some important archaeological site would involve costs in the form of the denial of other community benefits. The classic case is the Mayan archaeological site of Calakmul in Mexico which UNESCO declared as a World Heritage site in 2002. The site is in the depths of the tropical forest and archaeology. This presents a dilemma because it is claimed that the full manifestation of its well-preserved artefacts require them to remain in a forest setting, but the density of the forest makes it inaccessible to visitors. One proposal for resolving this dilemma is to employ modern technological devices, notably 3D models, which offer a 'virtual' visit, coloured by suitable text about its origins and historical importance.

A catalogue of devices for virtual display may appeal to those who are concerned about any imbalance in the availability of heritage information to the public. The lack of representation of some artefacts of historical significance may be corrected by such devices that are specifically directed to promoting demand for 'neglected' items. (However, to avoid any 'imbalance' between description and analysis in our own exposition, the reader specifically interested in 'virtualization' is recommend to consult our Further reading list at the end of this chapter.)

This description of possible uses of virtualization techniques gives rise to some general questions. 'Virtuality' is not unanimously accepted by heritage experts as a tool for the promotion of archaeological sites or historical artefacts generally. The most general objection raises the rather fundamental issue that arises at all stages of our own analysis—who is meant to benefit from preservation? As we have observed, there is strong professional support for the proposition that cultural heritage has a value that is entirely independent of any value that arises from public's interest and support because of the enjoyment that they derive from it. Mass communication methods of the kind described downgrade the 'high' character of heritage and risk transforming sites into some vulgar form of theme park. Our own position has been clearly indicated. It supports technology as a useful tool that improves public understanding and interest in supporting cultural heritage initiatives and in so doing is a complement as much as a substitute for promoting the aims of professional experts.

This last point needs further elaboration. We have been emphasizing the educational benefits that hopefully encourage the public who are asked to contribute to the expenses of maintaining and developing historical sites and buildings. In other words, our emphasis has been more on complementarity between visiting cultural heritage examples and presenting or recalling their benefits by visual presentation, thereby making a case for virtuality to be taken into account in their public finance.

On the other hand, it should not be disregarded that overall, the impact of technology on the demand for heritage is likely to vary according to the function which is assigned to technology, that is whether it is a tool (for communication, research, education, etc.) or whether it is considered valuable per se, as most specialists of Information and Communication Technologies (ICT) applied to heritage would probably prefer, as would be the case if the innovative sophisticated technological content of graphic applications is considered independently of the marginal contribution to the appreciation of heritage. (One of us attending a conference on heritage and virtual reality was amazed to discover how much attention was devoted to enhancing the capabilities of avatars as virtual guides, namely in making them moving their mouths in line with the language spoken, while explaining heritage to visitors. This gave rise to the thought that this way of bringing the past 'alive' perhaps had a high opportunity cost, alongside alternative ways in which the same financial

resources might have been used for the benefit of the customers.) In practice, technological innovations of the kind described offer at least a limited opportunity for potential customers to find out whether they wish to add cultural heritage to the list of their leisure pursuits as an alternative to having to be taxed for something they might not come to enjoy. This is because technological products, such as books, photography, videos, etc. are divisible items of expenditure. It is easy to understand why cultural heritage producers, understandably anxious both to maintain public support and to emphasize their efficiency to their government paymasters (and generally against the public having to pay directly to their professional services) have no hesitation in selling these products themselves or offering franchises to outside contractors in exchange for a fee or a share in profits.

Preservation and adaptation

The concept of heritage stock bears some similarities to that of *natural capital*. Heritage goods as well as natural resources are inherited and, once destroyed, cannot be recreated. As explained in Chapter 2, the present generation, usually through their political representatives, have to decide on heritage provision in respect of investment and on the invigilation of its use. As with natural capital, one encounters a *sustainability* problem and even a *diversity* problem, reflecting concern for the pattern of heritage.

Heritage is therefore closely identified with the activity of *conservation*, which is widely accepted as the responsibility of government. The extent and form of government action must be open to question, as our economic analysis has already indicated. Certainly advocates of public support usually introduce some economic rationale, but economics is far from being the only progenitor of public action. Many disciplines ranging from urban planning to architecture, archaeology, and social sciences claim a share in such support. Conservation itself is a concept which offers a variety of possible meanings: recalling the World Bank definition, conservation 'encompasses all aspects of protecting a site or remains so as to retain its cultural significance. It includes maintenance and may, depending on the importance of the cultural artefact and related circumstances, involve preservation, restoration, reconstruction, or adaptation, or any combination of these'. In other words, a historic building can be *preserved*, in the sense that

115

no uses are allowed, or it can be *adapted*, that is modified, for compatible uses under the assumption that it does not substantially detract from its perceived cultural significance and this may be essential if a site is to be economically viable. *Preservation* is used as an example of intervention which does not normally allow for compatible uses although these can be economically relevant. So even amongst professional cadres there can be considerable debate about the 'philosophy' of intervention which makes heritage choices a matter of controversy within their ranks. The choice between *preservation* and *adaptation* affects the benefits that conservation can yield and, therefore, complicates the definition of sustainability. Using our previous example, the preservation of an ancient Greek or Roman amphitheatre in its original state with the prevention of compatible uses, such as performances which can be economically viable, implies a trade-off between the forgone benefits—financial as well as economic—and the guarantee that its aesthetic qualities are not adversely affected. The same questions can be considered in a wider perspective more directly open to everyday attention. To what extent should the area surrounding an archaeological site be denied to economic development which might be perceived as negatively affecting the quality of the site itself? To what extent should the construction of a major road be diverted to protect heritage? How are such trade-off questions to be resolved and who is going to resolve them?

Although the political planning process may permit a role for voters to comment on measures designed to protect heritage artefacts, recognized experts in heritage matters are bound to have a predominant influence on this process, having an informational advantage denied to both citizens and political representatives without professional knowledge and with many other areas of government to preoccupy them. However, political pressure may be exerted by taxpayers called upon to finance heritage and make their representatives aware of the need to seek evidence of the degree of support, and whether it accords with the evaluations of heritage professionals with a vested, if legitimate, interest in expanding preservation programmes (we consider the economist's approach to measuring consumer evaluation in Chapter 7, and how conflicting interests in government decisions are addressed in practice in Chapter 8).

The economic issues raised by heritage must vary according to its specific features. First of all, different *physical features* (church,

monument, building, archaeological site, etc.) impinge upon the bundle of services which stem from them and, therefore, on the degree of 'publicness' or 'privateness' (see Chapter 2). The consumption of a public good such as the façade of a monument is non-rival and non-excludable. The visit to an archaeological site, though excludable, offers benefits which are non-rival, unless congestion occurs and, as a consequence, a risk of degradation when over-crowded—Venice or the Tower of Pisa offering good examples.

Moreover, *location* of built heritage, whether as part of the urban environment or whether located outside cities, affects the range of benefits and costs deriving from their use and, therefore, any economic evaluation and also the extent and form of public intervention.

A good example is offered by the conservation of historic centres. In this case, the concept of heritage refers not only to each single building but also to the historic set as such, made by several buildings and public spaces considered altogether. Many interested parties can be involved and, therefore, high transaction costs are implied by any attempt to reach agreement by voluntary action, since free riding is likely to arise. In such cases public intervention is usually needed to overcome these problems, but whether it will be regarded as satisfactory will depend on the choices about conservation adopted. Apart from the issues related to the physical dimension, those connected with *quality* should also be analysed. Not all old buildings or sites will deserve to be considered 'heritage' when the perception of what is 'heritage' does not depend on individual demand but on the evaluation of experts hired by the government. However, as we have seen, what constitutes heritage is not an objective fact but rather a social and cultural construct that is likely to change through time. The stock of 'heritage' building and sites tends to increase because recent buildings are included to represent the national heritage for future generations and the concept of heritage is enlarged to cover new typologies of building and sites, notably those with an industrial and commercial content. The *listing* of heritage artefacts is a regulatory solution used by most countries, and one which we shall examine in Chapter 8.

Further, even those buildings and sites which are included in the stock of heritage differ in relative importance. They can be located along a broad spectrum with two extreme cases being world renowned heritage and regional or local heritage which is known only within limited boundaries, with many intermediate cases.

The main economic difference between the two is that the former can be remarkable enough to have no physical substitutes nationwide, or even worldwide, while the latter may be easily replicated and experts will find that its inclusion in the list is questionable. Of course, the degree of substitution in the economic sense of the extent of competition between artefacts cannot be established *a priori*. Clearly, very different issues arise as far as the demand for, and the design of, public policies are concerned (see Chapter 8).

Different microeconomic and macroeconomic issues are involved. From the *microeconomic* point of view, interesting issues arise if the recording of the stock affects private decisions through alteration of property rights. This is the area where experts' discretion about the scope and the extent of conservation is more likely to prevail since their intervention is not likely to attract the public scrutiny that obtains in cases of 'superstar' heritage. But important issues of principle arise when public intervention affects the market price of listed buildings (see Chapter 8).

From the perspective of macroeconomics the role of heritage, and, indeed, cultural activities supported by government in general, become increasingly associated with economic development. Heritage is regarded as an important attraction to overseas visitors and therefore to tourism. The nature of this link between heritage and tourism becomes a source of much interest to those who no longer see economics as a threat to the aspiration of enthusiasts for preserving the past but as a possible means of buttressing the case for support for preservation of historical artefacts. A huge literature has been produced on the impact of heritage as an *input* in the process of stimulating economic growth, rather than as a final *output* for individuals to enjoy. These impact studies, as they are called, commonly suggest expenditure on heritage conservation results in an increase in the attraction of these artefacts, thus encouraging and financing visits to them, and also attendant positive employment effects on the provision of related services such as transport and accommodation. Consequently those who manage heritage buildings and sites, as well as those managing ancillary industries and services, claim that such studies offer 'scientific' proof that their activities should have public support and that the economic return from such support will provide benefits, including extra revenue, which exceeds their costs. However, impact studies rarely include any reference to the opportunity costs of public funding. Account has to be taken of the fact that

resources diverted to heritage support involve the denial of such support to alternative investments which may be at least as effective even if confined to an increasing demand for tourism.

However, apart from shortcomings in the measurement of impact, such a perspective only focuses upon the effects of the (private/public) spending decisions, without examining the process behind, and its effects on, the decision itself. Heritage, before being an input for economic and social development, is an output of a public policy, and its role as an input is strongly affected by how public policy is conducted. Therefore, when dealing with economic and social growth, using heritage as a strategic input, the sustainability of the public policy process is relevant, too. The stock of heritage is decided by rules based on the informal value judgements of professionals and is not pre-determined by the public authorities. If the size of the stock is huge relative to GDP, a *sustainability* issue arises. Public finance may not be enough to sustain preservation levels decided by professional rules, which had the opposite effect to that desired. Such an effect is likely to be intensified if government measures discourage the profitability of private investments in heritage (see Chapter 8).

The above issues also have an *international* dimension. For instance, 'superstar' heritage raises an international demand for preservation, in its broadest sense, which cannot be satisfied when heritage is located in poor countries, where the sustainability problem is demonstrably more severe than in rich countries. A good example of the kind of issues involved is provided by the Wal-Mart case in Mexico, where the construction of a shopping centre was authorized close to a very important archaeological area. The consensus of local people favoured the initiative whereas there was worldwide criticism of it expressed by intellectual public opinion.

Despite the interest in the above mentioned issues, overall academic concentration on the economic analysis of the built heritage appears to be less than on the activities of museums and galleries, not to speak of the performing arts. Several reasons can be put forward for this state of affairs. Scholars interested in international comparisons face major difficulties because available information is strongly affected by the national institutional context more than in other cultural sector fields. This is principally the case because regulation plays a crucial role in shaping the features of this specific cultural sector (see Chapter 8) and familiar difficulties of measurement characterize regulation activities.

As well as conceptual difficulties, major practical ones arise in collecting and processing data. As Chapter 3 indicates, empirical data concerning built heritage (e.g. market prices of historic buildings, private sponsorship of restoration, public subsidies to private owners, etc.) are usually poor, highly heterogeneous, and dependent on different sources. Qualitative information, although necessary to assess the performance in this sector, are even more difficult: for instance, the above discussion about conservation raises the issue of the strength of regulation which is an elusive concept if one aims to measure it. In measuring the performance of museums and galleries, several types of performance indicators can be listed, although none are wholly satisfactory as we shall demonstrate, however useful for the information they reveal. Such an exercise would be more difficult in the case of heritage institutions, especially if attention is concentrated on conservation activity. Perhaps this is because of the close contact of the public with the final product. Different benefits are produced, they are more easily identifiable, and most of them are direct benefits which can be priced. Such a situation does not occur in the built heritage case where prices play a minor role and other forms of evaluation are needed (see Chapter 7).

Further reading

The reader unused to the way that economists approach the study of the arts and culture may be surprised that we have so far reduced the history of the growth in interest in heritage to a few paragraphs in Chapter 1, and to a few scattered references in later chapters. However, to be absolutely sure that the reader does not regard this presentation as some sort of a takeover bid by economists in historical analysis, we mention three works that are important contributions to the understanding of the principles and practice that have evolved in reconciling the demand for buildings designed for current use with the desire to preserve the built heritage.

A superb introduction to the dilemma of reconciliation of past, present, and future use of buildings is found in Patrick Nuttgens's work *Understanding Modern Architecture*, particularly chapter 12. He explains why there was a strong reaction in the 1950s against the mass building of homes for workers and huge new office buildings as these were based on planning principles which took little account of

the tastes and preferences of the occupants. Of course, that is well known, but the subtle twist in his exposition is to demonstrate that preservation of the past was not simply a reflection of the revival of some form of collective nostalgia but had two practical purposes. The first was to find ways of adapting buildings of architectural merit for present uses without compromising their historical significance. The second was to derive inspiration from architectural styles of the past, more perhaps from the recent than the far past, in the construction of new buildings. The book, being replete with illustrations of the process of conservation and adaptation of buildings covering several different countries and styles, shows how widespread the 'conservation movement' has spread its influence.

Secondly, there is Jukka Jokilehto's book, *A History of Architectural Conservation*. This has become a standard work on how reverence for the past has been translated into the conservation and restoration of buildings and artefacts. It reminds us that the issues of what to preserve and restore go back in the Western World as far as Roman times. The historical thread is firmly tied by the study of the persistent attempts to define what is 'good practice' and how this affected the choice of items to be preserved and restored through the ages. The task became increasingly difficult when religious observance ceased to be the major determinant of the relative importance of heritage items. It seems presumptuous for an economist to do other than admire the depth of scholarship of such a work, but there are two things that will strike him or her. The first is the firm indication that the final judgement on what is 'good practice', in the sense of what *should be* preserved or restored, should rest with those charged with the task of preservation and/or restoration. The second is the absence of any discussion of the 'opportunity cost' problem, confirming that those who have to bear the cost of the work undertaken in the name of good professional practice are assigned no status in the decisions required to implement it.

Thirdly, Bernard Feilden's book, *Conservation of Historic Buildings*, has been described as the *locus classicus* of the subject but despite its length and compendiousness, it is immensely readable. Sir Bernard Feilden had a lifetime of experience in devising the principles and practice of conservation. Part III of this work offers the authoritative statement on the task of the conservation architect. Confidently stated value judgements on that task also require that full recognition is given to the cooperative nature of conservation involving craftsmen and clients as well as principals. Economics is allowed to slip in

through recognition that the best projects embody careful *cost control* and due regard to the possibilities that conservation offers for further household or commercial occupation of any habitable premises. One of Fielden's last major tasks was the restoration of York Minster, the largest ecclesiastical edifice in Northern Europe, which offers a wonderful illustration of the application of principles and the evolution of practice affected by rapid technical progress in construction work. A delightful twist to the narrative is the Appendix reproducing William Morris's Manifesto on the conservation versus restoration debate—see further reference to it in our final chapter, Chapter 10.

The observant reader will have noticed that the statistical series in Chapter 2 places more emphasis on method than content. To illustrate how difficult it would be to produce a long series of data, following the criteria elaborated in that chapter, consider the investigation undertaken by the well-known economic historian, Guido Guerzoni, of the development of cultural heritage policies in Italy: see Guido Guerzoni, 'Cultural Heritage and Preservation Policies: Notes on the History of the Italian Case' (1997).

Despite the inevitable difficulties of quantifying statements about the relationship between the growth of regulation for the sale of historical artefacts and the extent to which policy objectives related to preservation were attained, the author shows consummate skill in the use of trade statistics to reinforce his main conclusions. These deal with the extent to which the regulation of cultural heritage was able to adapt to the cultural and economic forces which made it difficult to ensure that public authorities' objectives were reached. This should warn the reader not to expect that government regulation is a simple and easy instrument to employ in trying to steer the market in heritage goods—see, further, Chapter 8.

The Guerzoni article covers the long period, for which the data we seek do not exist. With a shorter period, what may be lost in historical perspective may be compensated by more comprehensive data. Francoise Benhamou, a major authority on both the economics and historiography of heritage, presents a graphic picture of the evolution of heritage policies in France; see her chapter 'The Evolution of Heritage Policies', in Peacock (1998). She also suggests an agenda for the discussion of the policy problems that governments make for themselves by extending through time the definition of heritage, a subject that reappears in our own Chapter 8.

The reader who might wish to know more about the Calakmul case, as an example of the controversial issues as well as of the potentialities of ITC in the heritage field might find a very interesting and illuminating source in F. Niccolucci, 'Virtual Museums and Archaeology: An International Perspective'.

References

Benhamou, Francoise. 1998. 'The Evolution of Heritage Policies', in Alan Peacock (ed), *Does the Past Have a Future?*, London: Institute of Economic Affairs, pp. 75–95.

Feilden, Bernard. 2003. *Conservation of Historic Buildings*, 3rd edn, Oxford: Architectural Press, Elsevier.

Guerzoni, Guido. 1997. 'Cultural Heritage and Preservation Policies: Notes on the History of the Italian Case', in Michael Hutter and Ilde Rizzo (eds), *Economic Perspectives on Cultural Heritage*, Basingstoke, UK: Macmillan Press, pp. 107–32.

Jokilehto, Jukka. 1999. *A History of Architectural Conservation*, Oxford: Butterworth/Heinemann.

Niccolucci, F. 2007. 'Virtual Museums and Archaeology: An International Perspective', *Archeologia e calcolatori*, 17, 15–30.

Nuttgens, Patrick. 1988. *Understanding Modern Architecture*, London: Unwin, Hyman.

7

Evaluating the demand for heritage

Introduction

Not all the benefits stemming from heritage are marketable or depend on the direct consumption of heritage. Economic literature refers to them as *non-use* values. Non-use values are usually sub-divided into *existence* value (individuals derive satisfaction from the very existence of a given item of cultural heritage, even though they may not consume the services of the item directly themselves); *option* value (individuals want to maintain the possibility that they might consume the asset's services at some time in the future) and *bequest* value (the desire to bequeath heritage to future generations). The evaluation of demand is important at national as well as at international level, the latter not being satisfied in poor countries, if the financing of preservation depends only on the national decision making process. Account must be taken of these non-use values in cost–benefit analysis (see Chapter 9), being of particular importance in uses where there can be no expression of choice through market relations.

The search for methods to evaluate the non-market demand for heritage rests on the need for collecting information on *consumers' preferences* to orientate public policies to their satisfaction rather than to be driven by *suppliers' preferences*. The case for this approach has already been made in Chapter 6. Whether the commonly adopted methods offer satisfactory solutions to such an issue is another question, and an open one. In what follows, the different approaches will be briefly reviewed and compared with the opportunities offered by 'political' solutions.

Contingent valuation

We have already given an account of one approach to examining economic behaviour not reflected in measurable form—the *revealed preference* approach to identifying the objective function of (MG) senior management. This method reappears in many studies where consumer pricing is not or cannot be used to elicit preferences and demand for heritage services is no exception. In this case, something close to pricing can be achieved by reviewing the costs incurred by the beneficiaries in viewing historical sites, notable travel and related costs, a method developed out of environmental examples such as visits to national parks in the USA.

A complementary approach relies on information supplied by the (potential) beneficiaries—by asking them what is their willingness to pay (WTP) for the benefits received or the amount of compensation they would accept (willingness to accept—WTA) if the benefit were denied them, caused, perhaps, by the destruction or neglect of a well known historic artefact—this is known as the *contingent valuation* (CV) approach. A further development designed to offer some recognition of the opportunity cost problem is *conjoint cost analysis* (CCA) in which those asked to take part in a survey of their attitudes to heritage are offered two or more alternatives with stated attributes which the respondent, faced with a budget constraint, has to 'trade off' against each other.

There are further variations covered in the burgeoning literature on what is now known as 'experimental economics', but here we only wish to convey how far economics has penetrated into this unusual area of analysis including the difficulties encountered. This is enough to explain why heritage authorities, increasingly subjected to the pressure exercised by disparate professional and pressure groups, are becoming aware that economic analysis offers a useful counterbalance to their special pleading.

Here, attention will be focused upon the issues raised by stated preference methods, with special emphasis on CV, although reference will also be made to CCA studies. Actually, CCA might be considered as an evolution of CV because it produces more information, but it is costly since it usually needs a larger sample and more sophisticated statistical techniques. CV is the most widely used in arriving at a monetary value to a programme for the preservation and restoration

of specific urban buildings with historic and cultural significance, such as churches and monuments. CCA is usually considered preferable in evaluating changes in policies or programmes.

The popularity of the CV method is displayed in the theoretical, well-established methodological and empirical research undertaken in the environmental field. It is enough to look at the articles in specialized journals in environmental economics, such as the *Journal of Environmental Economics and Management* or *Land Economics*, to see how widespread is the use of this valuation technique. Moreover, in the environmental field CV plays a relevant practical role, as it was expressly advocated in a regulation issued by the US Department of Interior in 1986 as a valuation technique to be used by Government to sue those responsible for natural resources damage. The most well-known application was in the valuation of damages to natural resources from oil spills, a famous case being the *Exxon Valdez* oil spill in Alaska in 1989, which led the US National Oceanic and Atmospheric Administration (NOAA) in 1993 to the appointment of a distinguished panel of social scientists, with two Nobel Laureate economists, who had to critically evaluate the validity of CV measures of non-use value. The panel provided thoughtful and stringent guidelines for the construction of a CV survey and for its administration and analysis which, although very often quoted, are rarely put into practice.

CV is also becoming popular among cultural economists; according to a recent and extensive review of the bibliography on CV consisting of almost 140 papers, more than 40 per cent of the reviewed papers have been published since 2000. This increasing attention ranges from broadcasting to performing arts, covering a tangible as well an intangible heritage. From this perspective, it is worth mentioning the extensive and thorough survey of valuation studies, mainly CV studies, on historical sites and buildings and archaeological sites provided by a Report commissioned by English Heritage (in partnership with the Heritage Lottery Fund and the Department for Culture, Media and Sport and the Department for Transport) to review economic valuation studies concerned with the built historic environment. Scholars have paid attention to various types of historical assets, ranging from single and identifiable historical assets such as cathedrals, castles, towers, and single historical buildings to groups of historic buildings, including monasteries, a medieval city, and groups of built heritage within cities and towns. Many studies also refer to archaeological sites

of various kinds as well as to single ancient monuments while relatively little attention is devoted to recent heritage. Moreover, these studies offer a broad geographical perspective, ranging from Europe, UK, and Italy being most represented, to North America, with single studies also in Latin America and North Africa. Specialized journals such as the *Journal of Cultural Economics* take full account of such a tendency. But why so many CV papers? A cynic might claim that the decreasing marginal costs in extending the same technique, albeit with slight refinements, to different case studies has a positive effect on the productivity of researchers involved. A more charitable suggestion might be that the extensive application of CV to culture recognizes that the risk of paternalism can be reduced if it is taken into account in policy design. A special issue of the *Journal of Cultural Economics* in 2003 was devoted to 'Contingent Valuation in Cultural Economics', but it will be noted that the editor, in his introduction, remarked: 'To date, many of the CVM (Contingent Valuation Method) studies in the cultural field have been hypothetical, conducted by economists who are perhaps more interested in their analytical techniques than in informing actual policy debates. Few seem to have been commissioned by actual clients who have decisions to make.'

This statement leads us straight to the 'core' issue: what is CV for? The name of the method refers to the fact that the values stated by respondents are contingent upon the market scenario presented to them by the survey. Is CV able to offer reliable estimates for non-use values? Is it able to provide a consistent framework to overcome the boundaries of the specific case studies examined so that results can be generalized and transferred? Is it advisable to use CV results to draw out the policy supposedly to help the decision maker in allocating the resources and/or devising, pricing policies? An exhaustive survey of the above issues and of the related extensive literature would not fulfil the purpose of this volume, but we can highlight some of the major problems which are likely to be encountered.

An example

Let us start by offering one example drawn from the above-mentioned literature for a better understanding of the theoretical and practical issues which are behind the use of such a technique. We have chosen to report on the results of a study carried on by Cuccia and Signorello

in 2001 (and published in 2002) on Noto, a small town in south-east Sicily rich in churches, monasteries, and noble palaces in Baroque style. Furthermore, an interesting feature of this case study is that just after the analysis was carried on, in 2002, Noto (together with seven other towns Caltagirone, Militello val di Catania, Catania, Modica, Palazzolo, Ragusa, and Scicli) was included in the Unesco World Heritage List because they were all rebuilt after 1693 on or beside towns existing at the time of the earthquake which took place in that year. The reason behind the listing is that 'they represent a considerable collective undertaking, successfully carried out at a high level of architectural and artistic achievement. Keeping within the late Baroque style of the day, they also depict distinctive innovations in town planning and urban building'.

Noto exhibits some interesting features from the point of view of CV analysis being located on a hill six kilometers from the coast, it is a city where tourists mainly go to visit its cultural heritage and, therefore, is a place where the estimation of WTP is not biased by the presence of other attractions. Moreover, historical buildings are concentrated mainly in two streets, once representing the centre of daily life and nowadays restricted to pedestrians. Such a physical location of heritage makes it at least reasonably realistic to hypothesize that a charge could be made for access to the most significant part of the historical pedestrian area.

The study is designed 'to estimate the demand curve and consumer surplus accruing to the visitors of Noto' and 'to convert user's willingness to pay to revenue-capture potential'. In other words, the study seeks to elicit respondents' WTP for a hypothetical entrance fee for adult tourists to the historic area to be devoted to the maintenance and conservation of the historic buildings.

To fulfil this objective, a CV survey is used, based on face-to-face interviews with a random sample of 560 Italian and foreign tourists visiting Noto during spring 2000. Tourists were interviewed after the visit, at the main entrance of the city, and in hotels; after being informed about the aims of the survey. The interview was conducted using a questionnaire comprising three sections. In the first section questions about the nationality of the respondents were asked while the third section contained questions to identify their socio-economic profile. The second section contained all the questions relating to the WTP. The first question was:

The entrance to Noto's historical centre is presently free. Let us assume that, as already happens in many other arts cities, each adult tourist is required to pay an entrance ticket to visit the historical centre of Noto and this revenue would go towards covering the maintenance and conservation cost of the cultural assets. Let us assume that the price of the entrance ticket is... lire. If this were to be the case would you be willing to pay... lire for the entrance ticket to visit the historical centre of Noto? (before answering, please take into account what you have already spent to visit Noto. We emphasize that the payment of the ticket would only allow entrance to the historical centre. All other services, such as tourist guides and so on would not be included).

A vector of seven prices was used for the first question (2,000, 3,000, 5,000, 6,000, 8,000, 10,000, and 15,000 Lire). After the first answer, a second similar follow-up question was asked, the only difference being a larger amount (3,000, 5,000, 6,000, 8,000, 10,000, 15,000, and 20,000 Lire)—if the response was 'yes'—or a lesser amount (1,000, 2,000, 3,000, 5,000, 6,000, 8,000, and 10,000 Lire)—if the answer was 'no'—(using the so-called double-bounded format, discussed below). Moreover, all respondents, regardless of their first answer, were asked a third open-ended (see below) question to specify the maximum amount they would pay for gaining access to the city. This open-ended format was meant to reveal respondents with no positive valuation or with unrealistic biased values.

Leaving aside the econometric technicalities of the analysis, let us offer a short comment of the results. The survey revealed that 16 per cent of respondents exhibited a zero WTP for the entrance fee, their main reasons being that pricing for accessing the historical centre is unfair (46.7 per cent) and that funds for restoration projects of cultural heritage must come from general taxation or by the owners of the private historical buildings (41 per cent). Interestingly enough, 5.6 per cent answered that, rather than paying, they would go elsewhere, suggesting that there is a certain degree of substitutability among the towns.

The mean WTP for the whole sample for access to the historic centre was estimated at 11,500 Lire. It is interesting to outline that there were no major differences between foreign and Italian tourists: the authors suggest that this is a counterintuitive result, since Italians are usually considered unwilling to contribute to public goods. However another possible explanation might be that such a WTP does not capture the

non-use values related to restoration, since these are likely to be higher for Italians than for foreign visitors. As expected, WTP increases with education while age, membership of a cultural heritage organization, and gender do not seem to significantly affect the WTP.

Finally, the WTP results were used to construct a demand curve and the entrance fee which would maximize revenue was estimated to be 10,000 Lire.

Practical and theoretical issues

The above case study offers an example of how it is possible to evaluate the WTP for heritage and it appears that there exist among the respondents some support for fees for visits to the historical centre of the Sicilian city of Noto. Of course, the above mentioned study, as any other, is the result of methodological as well as practical choices which are not straightforward. In what follows, the practical and theoretical issues underlying CV analysis and the related choices will be sketched to see what is behind the scene off-stage.

CV is a survey approach to valuation; the researcher is asked to collect his/her own primary data and this calls for the need of a consistent survey design process. The solution offered to practical problems is important because poor surveys lead to poor estimates of value. If the results of CV studies have to be used in policy decision making, the definition of a common design of the questionnaire, fulfilling stringent requirements, is advisable. Because of financial constraints and feasibility problems, researchers often fail to fulfil some of the suggested requirements. Fortunately, proponents of CV are generally well aware of such problems. Further analyses have been conducted to show how the WTP estimates are affected by the features of the survey design and administration as well as by the heritage entity under consideration. A few examples offer an indication of the major issues at stake:

1. Different methods of survey administration can be employed (mail, telephone, face-to-face); the use of face-to-face is recommended. There is evidence that the WTP estimates tend to be higher in face-to-face surveys, perhaps because of a selection bias. The more important the heritage entity being evaluated, the more likely it is that a costly method will be used.

2. The selection of a representative sample is a crucial step to obtain results which can be generalized. Depending on the nature of the entity ('superstar' or minor item) a geographical partition has to be made, for example people who visit the site, people who live close to the site, people who live elsewhere and may never intend to visit the site. Sometimes, resources constraints lead to samples which can hardly be considered significant, with the further problem of facing a low response rate. Existing studies suggest that larger sample sizes seem to be associated with smaller WTP values.

3. The composition of the sample, in terms of different income groups, is important; CV is likely to carry a 'distributional bias' in favour of the wealthier groups of society, since WTP for heritage services increases with income increases. For this reason, in some surveys carried out by international investors in developing countries, medium- as well as high-income groups have been interviewed.

4. In the design of the questionnaire structure, the valuation section, the 'core' of the questionnaire, is combined with others describing the project as well as collecting information on the respondent. A short and simple description of the scenario is needed to make the respondent aware of the valuation problem. This is recognized as a recurrent problem since in many studies there is a poor or ambiguous definition of the object of valuation which undermines the reliability of estimates. At the same time, a section devoted to investigate the characteristics of the respondent is usually adopted to understand how preferences may be influenced by their socio-economic characteristics and to offer information for the design of policies.

5. The choice of the method of elicitation is more controversial. There is a wide spectrum of possible types of questions, ranging from *open-ended* ('What is the most you would be willing to pay for...?') to *closed-ended* ('If the cost to your household was 10 euros would you vote "yes" in a referendum?'), with intermediate solutions to mitigate the shortcomings of the two extremes (e.g. the *payment card format* that lists different money values to reduce the dispersion of the answers in the open-ended format or the *double-bounded format* that uses a follow-up question to narrow the interval generated by the single binary choice question). In practice, most studies are based on the *closed-ended* format, because it is considered more reliable and easier to handle.

6. Respondents are usually made aware of the proposed method of payment, that is how the payment would be collected and how it can be implemented. Examples of payment methods include: tax increases, user fees, voluntary contributions. The more realistic and credible the payment method is, the more reliable the estimates of value are likely to be. A closely related issue is that the policy implementation rule must be enforceable, otherwise the contingent valuation question will not retain its validity. In other words, surveys should be designed so that respondents should be able to understand what, exactly, they are asked to pay for and how.

Controversial issues in valuation

Apart from the shortcomings revealed by the way surveys are specifically designed, there are many controversial issues raised in the literature with respect to CV in general, and when specifically applied to culture.

First of all, since the questions asked are hypothetical, the risk of strategic behaviour should not be undervalued; being asked for a hypothetical payment, respondents might fail to consider all the relevant consequences of a change in the provision of a public good as well as the effects of their own budget constraints.

Even if the estimates derived by CV can be aggregated across consumers to obtain a 'price', the measure of the value of the good may not necessarily be a sound estimate of its value. It has been argued that individual WTP might not necessarily offer a complete account of the non-use value of a cultural good for those categories of value which cannot be expressed in terms of WTP. For instance, an individual might enjoy the feeling of common identity with those living in the same community derived from a common heritage, but it is clearly difficult to express such a value in money terms, since it cannot be exchanged with other goods.

Secondly, major difficulties arise in connection with the fact that the value of culture may be perceived as being not only for single individuals but for society as a whole, examples being, say, a piece of famous music, or symbolic sites, the value of which cannot, even in principle, be sensibly derived from aggregated WTP estimates provided by individuals, and, indeed, they cannot be plausibly represented in financial terms, no matter how they might be assessed.

On the other hand, CV results might tend to overestimate WTP for a single good since respondents' answers might also include the satisfaction they derive from cultural heritage, as is demonstrated by the fact that in some cases the WTP for one specific good, for example a monument, is found to be similar to the WTP for more goods, perhaps two or more monuments. The hypothetical character of the CV might explain such a bias, which is likely to be lower in the studies on multiple goods.

Moreover, there is no reason to think that contingent values express only preferences, as is shown, for instance, by the fact that cultural preservation often elicits opposing views, since it might affect alternative uses of the land for economic purposes. The presence of negative WTP values needs to be addressed when the survey is designed and when the econometric analysis is carried out.

Thirdly, respondents might also be affected by what has been defined as the 'framing' effect, arising when people are asked their WTP or, alternatively, their WTA. One should rationally expect that the two are similar while, indeed, the values for the latter are usually bigger. The reason can be found in what is known as the endowment effect and, for this reason, WTP estimates are usually preferred.

Fourthly, some problems, of estimation cannot be anticipated. For example, it has proved difficult to construct plausible contingent markets because it is difficult to apply the concept of marginal changes to goods such as heritage—for instance, restoration is an 'all or nothing' choice—and at the same time, it is extremely difficult to treat abstract cultural goods as commodities.

The above caveats suggest that one should avoid the generalization of the results of a specific study. The analysis of the CV surveys, however, offers some interesting indications of individual motivations and preferences for heritage. The hypothesis of 'free riding' does not seem to get strong support from the surveys since WTP may be positive for pure public goods such as the restoration of exteriors of ecclesiastical buildings, a well known example being Lincoln Cathedral. As it was pointed out before, support for fees has also been found for visits to the historical centre of the Sicilian city Noto. Quality seems to matter. A study for Paestum, famous for its Roman remains, using the CCA approach, shows that the most preferred services are those improving the accessibility and the understanding of the site as well as the educational services, while little interest is shown in the 'entertainment' dimension (performances,

café). Moreover, some CV surveys seem to indicate that voluntary contributions might have a role in cultural policies. For instance, this seems to be the case when studies were made of the access value of Durham Cathedral and the Naples museums. Do people care about heritage? According to the results of most CV studies, the answer seems to be 'yes'.

However, it is difficult to compare and therefore to aggregate the findings obtained from different studies, because of the different formats used for the elicitation of questions and the chosen instrument of payment. More generally, attention has been paid in the literature as well as in operational studies on the issue of 'value transfer'—that is to say the use of the results such as the WTP deriving from some studies to value similar assets. The Further readings section offers references for these studies. Here, it is enough to indicate that the 'value transfer' is closely related to the degree of substitutability of different assets; the lower this degree, the more unlikely is the fulfilment of the requirements for 'value transfer'. Apart from the heritage characteristics (uniqueness, aesthetic quality, state of conservation), other criteria have been put forward as conditions for the reliability of transferring WTP; in such a perspective, reference is usually made to the demographic characteristics of the area where assets are located, to the definition of property rights, to the similarities in the action to be valued (restoration or enhancement of the asset). In other words, the 'value transfer' seems to be quite difficult to undertake. Of course, this leads to stress that even more doubts arise when the transfer is pursued across countries.

The use of the referendum has been proposed as an alternative to CV, since it allows for the direct expression of individual preferences; according to its supporters, a referendum is preferable because it combines evaluation and decision making and also avoids the implementation problems typical of WTP studies. However, referenda and CV surveys have different aims and they can hardly be considered as alternative tools. Referenda are mainly aimed at overcoming the biases of the political decision making process where specific issues are involved, although the power of the agenda setter should not be undervalued. In contrast, CV aims are wider since it offers more information about the consumer surplus of different classes of respondents which can be helpful for designing public policies. Moreover, the widespread feasibility problems of referenda should not be forgotten.

However, the case for relying on expert judgement as a satisfactory alternative to CV is not thereby established. The risks related to a supply-oriented approach have been extensively outlined (see Chapter 2). Indeed, these risks are one of the major reasons why valuation methods, such as CV, are called for. Experts can play a crucial role in determining the costs of restoration but their informal value judgements cannot take exclusive precedence in deciding what restoration is worth to the community.

Even if no firm conclusions can be reached, it is reasonable to forecast that, notwithstanding its weaknesses, CV will continue to be used, unless an alternative better method can be devised. The awareness of its weaknesses, however, induces caution in the use of the results, as its own promoters are aware. At least, those in charge of heritage provision may come to regard it as a 'regrettable necessity'.

Further reading

Our suggestions for further reading are mainly oriented to papers, books, and reports analysing the methodological as well as the practical issues related to demand valuation, with special attention to CV, and offering an overview of the existing literature. No specific reference will be made to the several papers offering specific a case study because the list would be very long, the only exception being the paper by T. Cuccia and G. Signorello, 'A Contingent Valuation Study of Willingness to Pay for Heritage Visits: Case Study of Noto', presenting the case study of Noto which is analysed in the chapter.

A very extensive and useful overview of the methodological and practical issues involved by the valuation, with special attention to the 'value transfer' is the Report commissioned by English Heritage, the Heritage Lottery Fund, the Department for Culture, Media and Sport and the Department for Transport, Eftec, *Valuation of the Historic Environment—the scope for using results of valuation studies in the appraisal and assessment of heritage-related projects and programmes*. The Annex offers a survey of the existing studies with a very broad perspective both as far as the geographical dimension (from Europe to North America, with single studies also in Latin America and North Africa) and the content (from cathedrals, castles, towers to groups of historic buildings as well as archaeological sites).

From a different perspective, a survey is offered by D. Noonan in an article entitled 'Contingent Valuation and Cultural Resources: A Meta-Analytic Review of the Literature'. This article, in fact, examines the results of 65 studies (classified by year, country, and topic) and provides a meta-analysis to assess whether the findings are consistent with expectations, whether they vary because of methodological differences and whether information bias can be considered a significant problem in the CV studies.

Twelve interesting case studies—mainly based on CV although not exclusively, from eight different countries and ranging from single monuments such as castles, cathedrals, and monasteries to an historic quarter—are presented in a book edited by S. Navrud and R. C. Ready, *Valuing Cultural Heritage. Applying Environmental Valuation Techniques to Historic Buildings, Monuments and Artefacts*, which offers also a good introduction to the theory of economic valuation.

References

Cuccia, T. and G. Signorello. 2002. 'A Contingent Valuation Study of Willingness to Pay for Heritage Visits: Case Study of Noto', in I. Rizzo and R. Towse (eds), *The Economics of Heritage. A Study in the Political Economy of Culture in Sicily*, Cheltenham: Edward Elgar.

English Heritage, Heritage Lottery Fund, Department for Culture, Media and Sport and Department for Transport, Eftec. 2005. *Valuation of the Historic Environment—the scope for using results of valuation studies in the appraisal and assessment of heritage-related projects and programmes*, London: English Heritage.

Noonan, D. 2003. 'Contingent Valuation and Cultural Resources: A Meta-Analytic Review of the Literature', *Journal of Cultural Economics*, 27, pp. 159–76.

Navrud, S. and R. C. Ready (eds). 2002. *Valuing Cultural Heritage. Applying Environmental Valuation Techniques to Historic Buildings, Monuments and Artefacts*, Cheltenham: Edward Elgar.

8

The practice of public intervention

Our procedure

In theory, government may approach the cultural sector, adopting one of three different stances: avoid any intervention, leaving the market free; improve the functioning of the market; support heritage, it being considered a merit good (see above, Chapter 2). In practice, the first approach is rarely adopted and, in fact, in all the industrialized countries the public sector plays an important role in cultural heritage conservation, even if considerable quantitative and qualitative differences are found between different countries. The second approach derives its rationale from the welfare economics principles put forward in Chapter 2 and provides the most widely used framework for studying heritage public policies. The third approach is controversial since it shows a 'paternalistic' philosophy which can be criticized on the grounds of the consumer sovereignty principle: the argument is that cultural heritage deserves support simply because of the superiority of its inherent value which can be properly judged only by experts, regardless of individual preferences. Entering such a theoretical debate is outside the scope of this book and in what follows attention will be concentrated on the role of the public sector to correct the market. Within this perspective, some questions need to be addressed: What are the tools of government intervention? What are the most widespread institutional arrangements? What is the relationship between the public sector and the private sector? These questions will be analysed bearing in mind the policy implications stemming from the design of public intervention.

Looking specifically at the heritage field, there are several ways to classify government policy instruments. Some scholars tend to list

them looking at the public attitude they represent, ranging from direct public involvement to the issue of guidelines. Here, we lay more stress on the economic nature of each instrument, in accordance with the conventional approach in the public economics literature, which identifies expenditure, taxation, and regulation as the major instruments of government.

When such a classification is applied to the cultural heritage field, different patterns emerge. Governments can adopt *direct* or *indirect* intervention and can use instruments with a *monetary* or *non-monetary* content. *Public spending* and *tax-expenditures* are, respectively, the direct and indirect monetary tools while *regulation* is the non-monetary one, usually adopted to promote cultural heritage conservation. Monetary and non-monetary tools raise very different economic issues and these will be sketched in what follows.

Sources of finance

There are various types of *direct public expenditure*, with different economic implications ranging from the purchasing of goods and services—for example, the salaries for government experts and staff involved in conservation, the purchasing of consumption goods, etc.—to capital expenditure—restoration activity and the purchasing of buildings of artistic interest—and to the subsidies and/or loans to cultural public or private institutions, as well as to private owners of historic buildings. In both cases—purchases and subsidies—government is directly involved in the provision of cultural heritage services, either producing them directly, through government departments or public institutions, or supporting other bodies. The decisions regarding what deserves to be conserved and enhanced lies with the public sector. Moreover, in theory, although rarely used as a form of support for cultural heritage, vouchers to visit archaeological sites or historical buildings may be given to individual visitors.

The choice among the different instruments may also be judged in terms of the outcome they generate. This is illustrated by the debate regarding the choice between public production and public provision, that is whether it is better to satisfy public needs by producing a service within the public sector (using the bureaucratic structure) or publicly financing the private provision of the service (contracting out to private suppliers). The choice is not straightforward, there being no 'best'

solution. Some support for contracting out comes from the positive analysis of the public sector, stressing the inefficiencies of bureaucratic production (the 'non-market failure' argument). On the other hand, it is widely agreed that contracting out does not necessarily ensure the satisfaction of society's needs because it is no simple matter for the purchasing authority to choose the most efficient contractor (the so-called adverse selection problem) and to ensure that every effort is put into the implementation of the contract (the so-called moral hazard problem). Suitable incentives have to be introduced, such as tendering procedures to assign the contract which provides information about the producer's costs. At the implementation stage, links have to be established between performance and financing. The identification of appropriate performance indicators is an open question (see Chapter 9). What matters here is to stress that any form of direct public expenditure needs to be designed to reduce the asymmetry of information between the funding body (the principal) and the funded body (the agent), regardless of whether the latter is public or private. In the absence of the correct incentives, the funded body will not produce the quality and quantity necessary to maximize consumers' utility. The balance between public production and public provision varies across countries. Public provision prevails in Italy where the majority of museums, historical buildings, and archaeological sites are run directly by the public sector, especially at state level. The opposite holds in UK where the role of not-for-profit organizations and NDPBs is widespread, an example being English Heritage, which acts on behalf of Government on the basis of a Public Service Agreement (PSA).

It is useful to remind ourselves that tax revenue is still the major source of financing for cultural heritage direct public expenditure. The fact that taxpayers' limited resources have to be used to finance cultural heritage conservation emphasizes the need to establish priorities among the competing goals of government action in which the cultural heritage is only one claimant for funding (the risks related to a supply-oriented approach have already been outlined (see Chapter 2) and also the need for evaluating the economic effects of public spending (Chapter 9) and community preferences (Chapter 7)).

However, it is interesting to note that, alongside tax revenue, lottery funds have begun to be an important source of financing in some countries. Whether lottery revenue really provides additional financing for culture is an open question, it being widely agreed that it

might, on the contrary, tempt government to reduce its obligation to finance spending from taxation.

Such funds mainly come from state-owned lotteries, although there are cases, such as the Netherlands, where the level of funding from private lotteries is quite substantial. According to the figures provided by a recent report of the European Parliament, the revenue coming from lotteries varies across countries as does its allocation to the different cultural fields. For instance, in the UK and Italy, current state expenditure on culture is supported by lottery funds, by 35 per cent and 38 per cent respectively, while in other countries (for example, Germany) the contribution of lottery funds is much less important. Moreover, the allocation of lottery funds for capital investment in museums and cultural heritage is dominant in Italy (72 per cent) and in the UK (53 per cent). Although in principle the use of lottery funds might be a useful device for a better understanding of citizens' preferences, in practice such an outcome depends on its implementation. In Italy, for instance, decisions on the allocation of lottery funds are highly centralized and the connection between lotteries and cultural heritage restoration is extremely tenuous. Alternatively, rather than receiving only ex-post information, citizens might become more involved if explicit links between lottery and specific restoration schemes were known in advance, a form of hypothecation in other words.

Government can also support cultural heritage indirectly, through *tax-expenditures*, that is by using fiscal devices to modify individual behaviour and to favour private donations and sponsorship, in cash as well as in kind (in the form of equipment, services, etc.), to cultural heritage institutions. Tax-expenditure has been applied on a major scale in the United States since the beginning of the twentieth century, while the quantitative impact in European countries has been much lower. These measures imply a favourable tax treatment which can take many forms—tax deductions, tax credits to companies and individuals for income tax, as well as tax exemptions, tax deductions, and special (lower) rates of gift and inheritance tax. Somewhat different is the rationale for the favourable tax treatment for the owners of historic buildings, mainly justified as compensation for the social benefits they produce in conserving their properties that have historical and artistic value and for allowing public access. Less specific to the cultural heritage field, but very relevant in quantitative term, is the provision of special VAT rates to favour the consumption

of cultural goods. An interesting measure that takes into account tax-payers' preferences and the priority assigned to heritage (when compared with alternative objectives) has been recently implemented in Italy. From 2006, taxpayers are allowed to allocate 5‰ of their income tax payments, and can choose to assign it to several non-profit organizations operating in various fields, ranging from social assistance to cultural heritage conservation, scientific research, civil rights, and so on.

Tax-expenditures raise several issues. First of all, tax relief does not have the same effect everywhere because private support, in whatever form, is the result not only of favourable tax arrangements but also of several other elements, such as social norms or a shared social recognition of cultural heritage benefits. Moreover, a controversial feature of tax expenditure is that, when it is implemented via a deduction from taxable income, it depends on the marginal tax rate of the donor, with the consequence that the size of the gift will be larger the higher a person's marginal tax rate (this being, for instance, the case in the USA charitable contribution deduction, which is somehow considered a benchmark as far as tax deductions are concerned (see Further reading below)). It might also be questionable whether the proceeds from tax relief should be added to direct spending, since such a simple procedure implies that the overall amount of tax relief represents a net increase in arts funding and ignores the fact that other tax or expenditure adjustments will therefore be required to compensate for the lost revenue.

Furthermore, there is a crucial difference between direct and indirect government intervention; in the former case, decisions regarding the size and the composition of heritage support, for example which monument should be restored, are taken by the public decision maker, while in the latter case, decisions are private and the policy outcome is likely to differ. In the case of tax expenditure, taxpayers incur a cost, in terms of the tax revenue forgone, and such a cost is not under government control, both in quantitative and qualitative terms since it depends upon donors' private decisions.

If the overall arts sector (including performing and visual arts) is taken into account, relying on private decisions could favour controversial and experimental artistic activities, since governments might prefer to avoid supporting arts which could give rise to controversy. This is not the case when dealing with cultural heritage, where experimentation is constrained by conservation rules (see below). On the contrary, private decisions might be driven by the prestige

of the monument or institution gaining support, thus directing intervention towards well-known objects and institutions. Therefore, tax expenditure is not only a means to raise funds for culture but also a way to shift the decision making from the general public, as represented by the public decision maker, to specific individuals or companies and the effects cannot be unambiguously identified. In fact, the comparison also depends on the functioning of the public decision making process, whether it is supply-oriented or demand-oriented, how powerful is lobbying in influencing it and to what extent participation by the public is allowed (e.g. through referenda or as members of the boards of government agencies).

The pattern of government intervention, indeed, differs according to the prevailing institutional features, because different incentives for 'agents' are generated. For instance in Europe, looking at culture in general, at least two different institutional systems can be identified: the state-driven, top-down 'bureaucratic' system, an example being Italy, where politicians and bureaucrats decide how to distribute public funds and the public production of heritage services is widespread; or the 'arms-length' approach, such as that seen in the UK, where the allocation of funds as well as the ownership and management of sites and building is in the hands of non-governmental bodies (see Chapter 4). Apart from the different labels, these institutional differences also affect the decision making process, because the set of incentives differ, and are likely to result in different outcomes. For instance, a very simple indicator of such a difference can be found in the quantity and quality of information generated from publicly funded cultural heritage institutions in the two systems: even a quick glance through official reports as well as to websites offers evidence of the different concern for accountability (see Chapter 9). Moreover, as we shall argue later, a further differentiation arises according to the degree of decentralization of heritage decisions.

How large is government financial support? Any discussion about government intervention is usually illustrated by data referring to its size as well as its qualitative features, but this turns out to be a big problem in the cultural heritage field. In fact, it is widely agreed that reliable cross-national data are almost unobtainable for culture, in general, and that the situation is even worse for the specific area of cultural heritage because of problems originating from a lack of harmonization in data collection. This is in line with the above mentioned enlargement of the concept of cultural heritage, and even more of culture in general, occurring in developed countries, which

makes the object of government support subject to change and, as a consequence, there is no consolidated definition available to guide data collection.

Data on public expenditure for culture as expressed as a ratio of GDP differ considerably, depending on the source, that is to say, the international organization providing them. For instance, the EU definition for cultural activities is somewhat narrower than the one adopted by the OECD (see Chapter 3) and, therefore, the data source adopted affects any comparison, since the relative weight of specific cultural activities varies across countries (this indeterminacy is stressed by a very recent report issued by the European Parliament, 'Financing the Arts and Culture in the EU', which advocates the gathering of 'appropriate' data at national, regional, and European levels).

Moreover, it is difficult to make a clear distinction between gross and net cultural expenditures as well as between current and capital expenditures, and to avoid 'double counting' as far as transfers to lower levels of government are concerned. Moreover, usually, at the level of central government, only the expenditure of the Ministry of Culture is taken into account, while other ministries are involved in pursuing specific priorities in this field it will be on a smaller scale and this leads to underestimating overall state expenditure and alters the basis of comparison.

With the above caveats in mind, Figure 8.1, derived from the above-mentioned EU report, is offered as just one example of what is available. It shows that in the EU countries, the size of direct government expenditure for culture in general, for the period 2000 to 2005, ranges between 0.3 per cent and 1.2 per cent (an exception is the higher percentage of Estonia; although the report does not offer a specific explanation, it seems that the total expenditure on culture also includes sport expenditures). These estimates differ from those offered by the OECD, ranging between 0.4 per cent and 2 per cent where a wider definition is adopted. The fact that no comparative data are available for tax expenditures leads to an underestimate of public intervention in some countries, such as, for instance, the Netherlands, where indirect intervention accounts for almost half of the total. The impact is even greater in the USA.

Caution should be used in reaching comparative conclusions: lower percentages of direct public spending do not necessarily mean that the overall support for culture is lower. The public–private mix could be different. Moreover, any evaluation of the country's effort

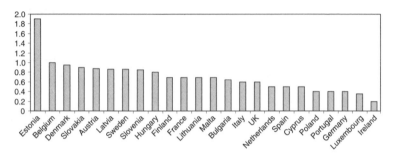

Fig. 8.1 Average annual public financing to culture as a percentage of GDP (2000–2005)*

*Public financing to culture refers to the central and all lower levels of governments for the latest available year of the period 2000–2005.

Source: European Parliament, 'Financing the Arts and Culture in the EU', 2006.

has to take into account the consistency of cultural heritage; if the artistic endowment is different, similar percentages imply a different public effort and this is a crucial element in evaluating the conservation sustainability of cultural heritage.

No specific data are offered for cultural heritage but the above mentioned report also suggests that, while priorities differ among countries, cultural heritage protection is a common feature for all countries, having a special emphasis in Italy, where expenditure for heritage conservation is still prevalent. This is not surprising, if the 'size' of cultural heritage in Italy is taken into account. A complementary explanation could be that cultural heritage spending is more centralized than public action on performing arts.

However, notwithstanding the above caveats, it is useful to point out that differences exist and cannot be explained by normative analysis. They appear to be the 'endogenous' outcome of the public decision making process; in other words, in practice, different institutional systems provide different incentives to the various actors—politicians, bureaucrats, heritage professionals, citizens—and, as a consequence, the output of such a decision making process will differ.

However, government expenditure on culture (whatever definition is used) is in reality very small when compared with major fields of expenditure (e.g. defence, law and order, health, education) and the great attention paid to it by articulate art lovers is in sharp contrast to that of specialists in the study government expenditure, who concentrate on what they regard as the 'real' issues.

This is not to say that government action is without relevance in the cultural heritage field; indeed, if the analysis is restricted to financial intervention there is a real risk of underestimating the 'size' of government, since the allocation of resources in the cultural heritage field is severely affected by regulation whose impact cannot be expressed in expenditure terms.

The crucial role of regulation

Regulation is a non-financial tool, imposing restrictions or modifications on the activities of economic agents in line with government policy objectives. The main objective of regulation is the control of the stock of heritage, both from the quantitative and qualitative point of view. The fulfilment of this objective is usually pursued through a wide set of instruments: listing or registering (a designation of lower significance) historical and archaeological sites, as well as individual buildings in order to preserve their existence (for instance to prevent demolition) and their character (for instance, by imposing on the owners of designated buildings restrictions on use, on their appearance and the way conservation is carried out) and imposing limitations on the use of land affecting heritage buildings. At the same time, control is exerted over the export of works of arts to preserve the designated national stock. Regulation, therefore, constrains the exercise of property rights. Owners are obliged to comply with regulatory rules and penalties are imposed for non-compliance.

In addition to these forms of regulation, which are defined as *hard regulation*, there are also forms of *soft regulation*, such as non-enforceable directives (charters, codes of practice, guidelines, etc.) implemented by agreement and not involving penalties, as well as listing, for example the UNESCO World Heritage List. Soft regulation mainly applies at international level and it is interesting to note that there is an enlargement through time of the list as well as an increasing bulk of conventions, charters, and recommendations, showing that, again at the international level, heritage experts are usually involved. The list of international documents is almost endless, ranging from what are known as ICOMOS documents, such as the *Venice Charter* (1964) or the *Charter for the Conservation of Historic Towns and Urban Areas* (1987), also known as the *Washington Charter,* or the Nara *Document on Authenticity* (1999) to the UNESCO *Vienna Memorandum on Historic*

Urban Landscapes (2005) or to the 2000 *Charter of Krakow* (produced via the cooperation of six European countries) or to the *Recommendation Concerning the Safeguarding and Contemporary Role of Historic Areas* (1976). A very long list is provided on the website of the Getty Foundation and it is interesting to observe that the list has grown at an ever increasing rate, the largest number of documents being produced in the last fifteen years. What the real impact of these documents may be is difficult to say: in many cases, charters and conventions are issued on the same topics and the overall impression is that there is no coordination among them, the huge number undermines their credibility and, at the same time, their coherence is questionable. In other words, each organization seems to pursue its own objectives with no great attention paid to those of the others. True, regulation can be considered a source of information about the social value of cultural heritage, offering room for voluntary action to conserve the listed items, but the effectiveness of such a tool is not guaranteed for that depends on the incentives in operation.

Regulation is variously linked to other government tools. It can be used as an independent tool as well as a complement or a substitute of other policies. A 'classic' technique is to modify the property rights of private owners in possession of heritage artefacts. Regulation may be used as a complement to other policies in order to prevent moral hazard when cultural private activities are publicly funded. For instance, a private owner receiving public financial support for the restoration of a historic building is usually compelled to carry it out according to precise rules and to allow public visits to the restored building. Finally, regulation may be considered a substitute for public funding whenever a public activity related to cultural heritage is privatized: for instance, if a publicly owned building is sold to the private sector, regulation can ensure that the private re-use conforms to architectural and artistic standards.

Regulation is a major tool in cultural heritage conservation since its adoption or removal takes less time than is required for financial tools, and because it can be extremely flexible when quick decisions are called for, as, for example, when an order to prevent the demolition of a historic building needs to be imposed very quickly. At the same time, cultural heritage regulation is highly subjective because, as has been pointed out in Chapter 6, the definition of cultural heritage is not straightforward, and experts have a monopoly on much of the necessary information. Clearly, the identification of the scope and the range of intervention is a matter of discretion to a greater extent than in other fields of public policy. Such discretion is likely to

vary according to the 'quality' of cultural heritage, being higher for minor cultural heritage, while for outstanding cultural heritage, characterized perhaps by uniqueness, such as many items on the World Heritage List, any decision about conservation comes under the scrutiny of public opinion. As a consequence, the type of expert (archaeologist, art historian, architect) involved in the decision making, and the features of the decision making process, can be important in determining the size and the composition of the stock of cultural heritage, as well as the type of conservation that can take place.

In France, there are approximately 40,000 listed monuments, most of them having been listed in the last four decades; in the UK there are roughly 500,000 listed monuments, with a high proportion added in the 1990s. In both countries, with slight differences, almost 45 per cent are privately owned. In USA there is a National Register of Historic places, containing more than 65,000 of buildings which are eligible for tax credits on preservation works. Moreover, there is evidence that the scope of regulation has increased through time, at least as far as the designation of 'local historic preservation districts' is concerned, that is areas where the changes to the exterior of buildings require official permission to prevent inconsistencies with the architectural features of the area. An example is provided by the American scholar, Dick Netzer, who shows that such districts numbered 20 in 1955, in the 1980s there were more than 800, and 2,000 by 1996. In Italy, apart from an unofficial and partial census such as the one provided within the *Risk Map of Cultural Heritage* project (57,000 monuments, including about 17,000 churches, 8,200 villas and palaces, and 2,000 museums and libraries), there is no well-defined comprehensive list, probably because, as it was pointed out earlier (Chapter 1) the concept of public heritage is very extensive. In this latter case, the building can be sold. As far as private buildings are concerned, lists are provided by each *Soprintendenza* (the public authority carrying out the state function of conservation at sub-central level). Overall, on the website of the Ministry of Heritage and Cultural Activities, a very general statement says 'In all the country there are *almost* 60,000 buildings, belonging to private owners, to the State or to other public institutions, which are preserved.'

A sustainability issue (see Chapter 6), therefore, clearly emerges while, at the same time, the remedy of de-listing any building appears to be highly unlikely. Risk averse bureaucrats have no incentive to take

decisions since they might be questioned about them in the future, and the procedure to de-list is usually more complicated and requires more justification than the decision to list. Reversing this tendency to use regulation as a way of controlling the size of the list seems to be beyond the competence, not to speak of the willingness, of administrators.

Moreover, not only is the scope of regulation being enlarged, but the concept of conservation is still not well defined, both from the point of view of doctrine and of practice. According to the World Bank definition reported in Chapter 6, conservation might involve very different types of intervention, covering preservation, restoration, reconstruction or adaptation, or any combination of these. None of the terms included in this definition is straightforward. For instance, the concept of restoration is controversial and even among professionals there is wide debate about whether accretions should be removed, although they may be representative of a historical period or of a technique, and how the 'original state' of a building should be defined. The debate on the adoption of standards for conservation offers another good example of how conservation choices can be controversial. Among practitioners, in fact, there is great resistance to accepting any technical standards of conservation since specialists' judgements are highly diversified, but most of them agree on the common tenet that each piece of heritage is unique and that conservation should be carried out case-by-case, the consequence being that actual choices inevitably turn out to be highly subjective.

Moreover, the choice between simply *preserving* cultural heritage or *adapting* it to a new state and, eventually, a new use, although clearly linked to cultural heritage features, offers a great deal of scope for discretion, since it is influenced by experts' knowledge, experience, and professional training. Cultural heritage conservation choices cannot be considered merely as a technical matter, because experts' value judgements go beyond artistic and historic implications, and affect property rights as well as the possibility of using cultural heritage for private and collective purposes thus generating a distributional impact.

Therefore, although regulation is not accounted for in the budgets, its financial impact cannot be disregarded, because of the costs it imposes on the regulated as well as on society as a whole. We refer to the administrative and bureaucratic costs related to the production of regulatory acts (permission, authorizations, demolition orders, standards, etc.) and the monitoring of their effective implementations, as well as to the compliance costs imposed on all the individuals or organizations

(regardless of whether they are private or public) who have to comply with the prescriptions. The size of these costs depends on the stance adopted by regulators and this is a crucial issue in the cultural heritage field, because of the discretion given to them in the decision-making process. For instance, in the case of restoration, some costs can be foreseen in advance (for example, the requirement to use special materials, qualified operators, etc. to ensure quality) while others are subject to a high degree of uncertainty as a consequence of the regulator's decisions. For instance, an adaptation allowed by urban planning might not be permitted by the regulator. Moreover, the indirect costs imposed on any activity that intereferes with cultural heritage regulation should not be undervalued such as, for instance, the considerable hidden costs involved by planning regulations calling for the diversion of roads to protect archaeological sites.

The type of conservation adopted is a fine example of the pains of choice. If regulators adopt a conservationist stance and heritage is simply preserved in a way, that prevents its full enjoyment and utilization, as for instance, when restrictions do not allow for alterations to ensure modern standards of comfort, a substantial amount of the potential benefit can be lost and the public–private mix is likely to be adversely affected, perhaps through private investment being discouraged. A different solution to the conservation problem, for instance, is offered by 'façadism', implemented notably in France. This reduces restrictions on owners by allowing the interiors of heritage properties to be altered, thereby creating more control over their commercial value. Empirical evidence offered in the literature shows that in France the value of listed buildings increases more than in the UK, where tighter restrictions are imposed, for such an increase may be the result of the combination of regulation with tax allowances and subsidies to the owner.

The extent of restrictions, which are not justified by the market failure argument, have consequences for the very possibility of conserving historical centres and for local economic development. Indeed, the sustainability of urban revitalization projects depends on the associated social and economic activities. For instance, old buildings located in historical districts increasingly play a role as natural incubators of small businesses.

Mutatis mutandis, similar considerations apply as far as the regulation of the international circulation of the works of arts is concerned. In most countries restrictions are advocated to preserve national identity and prestige and to protect future generations' interests. However, the

assumption that maintaining historical artefacts within domestic boundaries always ensures the fulfilment of the claimed objectives is undemonstrated. This might not necessarily be the case in all circumstances, the effectiveness of these restrictions mainly depending on the conditions under which trade occurs, that is the kind of artefact which is exchanged as well as the identity of the sellers and buyers. A detailed investigation of this topic is outside the scope of this chapter but, just to give an example of the kind of the issues involved, it might be useful to raise some questions: who is going to gain or lose from prohibiting the sale of archaeological items or historical artefacts belonging to public museums but not exhibited (see Chapter 5)? Would it not be better to allow museums (regardless of whether they are privately or publicly owned) to sell those works of art which are not essential to their artistic 'core' interests so that the proceeds could be used to enlarge collections through new acquisitions or for better conservation of the existing stock?

At the same time, if the scope of the restrictions preventing the export of works of arts is very wide, their effects on sellers' and buyers' behaviour should not be undervalued. Nor is its effectiveness guaranteed. In fact, tight regulation might induce collectors and/or dealers to leave the official economy and to undertake their exchanges 'underground'; if the scope of regulation is very wide and monitoring is too costly, restrictions tend to be ineffective. Moreover, protectionism, discouraging art transactions, or making them time-consuming because of complex bureaucratic procedures, implies a negative economic effect on the art market. The strength of the regulation of circulation varies across EU countries since each Member State has the right to adopt tighter regulation so that restrictions are not confined only to the list of relevant historical artefacts ('national treasures'), but also to a wider concept in 'national endowment'. This is the case of Italy which offers an example of tight regulation while the UK adopts a more deliberately liberal stance; it is probably not by chance that the UK art market is more widespread than the Italian one.

Decentralization

To what extent government action in cultural heritage is 'demand oriented' or 'supply oriented' is likely to vary according to the *degree of decentralization* characterizing public action. So far, the analysis has

been carried out referring to government as a unitary being while, in reality, the public sector may have many layers and the allocation of functions among them will vary across countries.

Reliable comparative data on the degree of decentralization of different countries, both in financial terms and in terms of their powers and autonomy, are very difficult to obtain. Apart from the above-mentioned measurement problems, further difficulties are encountered in finding homogeneity in the intermediate tier between national and local levels of government if comparisons are to be drawn and also to improve our understanding of the true content of their status and prerogatives.

Despite these difficulties, however, we can piece together a more or less coherent picture from various research sources. The Arts Council of England, using a narrow definition of direct public spending on culture, indicates that 'central government are majority stakeholders within direct public support for the arts and museums. With two exceptions, German and the USA, central government accounts for at least two fifths of total expenditure on culture in the countries for which data are available' (the countries are Australia, Canada, Finland, France, Germany, Ireland, Italy, the Netherlands, Sweden, the UK, and the USA).

Moreover, the same report suggests that in Europe, looking at changes over time, there is a general trend toward a devolution process, coupled with a crisis in central government spending and growth in importance of the private sector. These findings are more or less confirmed by the figures of the European Parliament Report, shown in Figure 8.2. What can be confidently stated is that in the EU, decentralization appears almost everywhere, apart from the polar cases of Luxembourg and Ireland.

The degree of decentralization, however, is not only a statistical matter and such an issue cannot be confined to the mere distinction between whether a given function regarding cultural heritage is carried out at central or local level. Clearly, we need to explore which institutional arrangement offers the 'best solutions' for government action in the cultural heritage field.

The normative argument for devolution stresses the desirability of geographical coincidence between taxpayers and beneficiaries of a given good and service, and such an argument is of particular relevance in the case of cultural heritage. Sub-central levels of government, in fact, are interested in internalizing spillover effects,

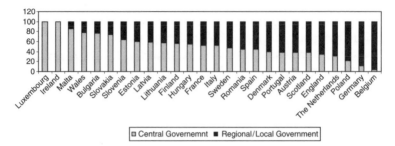

Fig. 8.2 —Percentages of public expenditure for culture by level of government (2000–2005)*

*Public expenditure for culture refers to the latest available year of the period 2000–2005 and includes all lower levels of government: länder (Austria, Germany), communities (Belgium), voivodship (Poland), regions, provinces, counties, municipalities.

Source: European Parliament, 'Financing the Arts and Culture in the EU', 2006.

that is in preserving cultural heritage; the wider its reputation the greater are the external benefits related to its existence, since it is beneficial to attract visitors and, as a consequence, to boost local development. A caveat must be entered: the cultural tourism argument, although appealing in theory (even if largely undemonstrated), might also be undesirable in practice, because, among other things, it might 'bias' policies by undervaluing the long-term benefits of cultural heritage policies, such as, for example, those directed towards educational objectives. The analysis of these issues is outside our chosen remit. In any case the existence of spillovers does not weaken the case for devolving powers to sub-central layers of government to support cultural heritage.

In positive terms, devolution can be helpful in the heritage field since the above-mentioned asymmetries of information in the decision making process can improve accountability. Indeed, it is widely agreed that devolution would allow for better control of the decision making process because it offers a variety of solutions and criteria for intervention, improves citizens' information through the comparison of different alternatives and also allows for the possibility of using methods derived from direct democracy. In the cultural heritage field the positive effects of devolution seems to be even stronger than is usually claimed because the links between regional/local communities' identity and cultural heritage are very close.

The remit of the argument that devolution improves the satisfaction of citizens might be limited if it were extended to multi-ethnic societies, where the concept of local identity is more controversial and the heterogeneity of preferences weakens the assumptions behind the case for devolution. In such a situation, to support cultural heritage as a testimony of local identity might be controversial and might reduce rather than strengthen the integration of ethnic minorities, who are likely to have other priorities as far as local public spending is concerned.

Devolution matters not only as far as public spending is concerned but also for regulation activities. This latter aspect is usually less explored but it merits attention. In fact, whenever a conservation decision is taken at the central level, conflicts may arise since regulation may circumscribe local government decisions on matters such as urban renovation and, therefore, might impinge upon local government development objectives. In such a case, strict rules adopted and carried out at central level, for instance aimed at cultural heritage preservation, would satisfy the demand of the overall population for preservation, with the cost—in terms of the forgone opportunities—borne only at local level.

In contrast, it is usually claimed that, if regulation is assigned to local governments, they might be more vulnerable to lobbying by special interest groups, aiming at the exploitation of heritage; however, such an argument, though deserving attention, is likely to underestimate the strength of organized 'conservationist' interests.

Evidence for this can be found in the number and variety of associations and groups operating in the field. These actors can be more effective at a local than a central level because the costs of providing information to the public are lower and, therefore, they can better contribute to the promotion of public participation in the decision-making process.

Italy offers an interesting example of centralized regulation coupled with localized devolution. In fact, notwithstanding recent constitutional reform moving toward federalism, the state fully retains its key role in protection and conservation, while allowing room for regional and local governments only in the field of management and the enhancement of cultural heritage. Such a perception of aptitude in cultural heritage policy is striking if it is compared with the different approach in other fields, such as health, which even heritage bureaucrats cannot argue is less relevant to citizens' welfare. In

other words, the central bureaucracy has succeeded in retaining its power to prevent 'barbaric' actions towards cultural heritage; such an aptitude is, somehow, linked with the above-mentioned Italian bureaucratic institutional arrangement and it is hard to believe that it can help the Italian decision making process to become more 'demand oriented' in the cultural heritage field.

Although England offers an example of the devolution of power to a government agency, it also illustrates the pressures that governments feel they must exercise to reflect their perception of making the built heritage more accessible to the taxpaying public. The nature of this pressure will change with changes in the composition of the government in power. However, it is in the nature of heritage supply that changes take time to implement. Thus, the Department for Culture, Media and Sports, at the time of writing, has issued a policy statement in *Heritage Protection for the 21st Century*, containing detailed proposals on the nature of the devolution of decisions to its agency, English Heritage, reflecting criteria decided by the government in power, the *commencement* of execution requires a three-year time lag. But, however hard they try, governments cannot pre-commit their successors and this applies as much, if not more so, to policies concerning culture and the arts.

Further reading

A comprehensive analysis of 'tax expenditures', from both a theoretical and an empirical point of view, with special attention to the US model, although in an international perspective, is offered by J. M. Schuster, in a 2006 article called 'Tax incentives in Cultural Policy'.

References for the quantitative and qualitative features of the financing of cultural policies in a comparative perspective are offered in the Further readings of chapter 3. Theoretical pros and cons of devolution are explored by Ilde Rizzo in her chapter 'The Relationship between Regional and National Policies in the Arts', in Ginsburgh's book *Economics of Art and Culture* while, using Sicily as a case study, the implementation problems are analysed in a book with Ruth Towse *The Economics of Heritage: A study in the Political Economiy of Culture in Sicily*.

Readers who are interested in exploring the various alternatives in relationships among public, private, and not-for-profit sectors in Europe will find an interesting patchwork of the main trends in a

book edited by Peter Boorsma, Annemon van Hemel, and Niki van der Wielen *Privatisation and Culture: Experiences in the Arts, Heritage and Cultural Industries in Europe*. This volume offers an interesting overview, using case studies of different countries' experiences and it approaches the cultural sector from a wide perspective, including heritage as well as the performing arts and cultural industries. The policy implications outlined in the book go beyond the conventional ones and international solidarity is advocated to support poorer countries' cultural and artistic traditions.

A very wide and thoughtful analysis of American cultural policy, is offered by Dick Netzer in his chapter in Ginsburgh and Throsby's *Handbook of the Economics of Art and Culture*, entitled 'Cultural Policy: an American View'.

References

Boorsma, Peter, Annemon van Hemel and Niki van der Wielen (eds). 1998. *Privatisation and Culture: Experiences in the Arts, Heritage and Cultural Industries in Europe*, Dordrecht: Kluwer Academic Publishers.

European Parliament. 2006. *Financing the Arts and Culture in the European Union*, (PE 375.309).

Netzer, Dick. 2006. 'Cultural Policy: an American View', in V. A. Ginsburgh and D. Throsby (eds), *Handbook of the Economics of Art and Culture*, Amsterdam: North Holland, pp. 1223–51.

Rizzo, I. 2004, 'The Relationship between Regional and National Policies in the Arts', in V. A. Ginsburg (ed), *Economics of Art and Culture*, Elsevier, pp. 203–219.

Rizzo, I. and R. Towse (eds). 2002. *The Economics of Heritage: A Study in the Political Economy of Culture in Sicily*, Cheltenham, Edward Elgar.

Schuster, J. M. 2006. 'Tax incentives in Cultural Policy', in V. A. Ginsburgh and D. Throsby (eds), *Handbook of the Economics of Art and Culture*, Amsterdam: North Holland, pp. 1253–98.

9

Investment and performance appraisal

Introduction

As heritage projects must employ resources that have alternative uses, heritage policies must be based on some definable rules about choosing whether any project is 'worth' pursuing and which artefact or combinations of artefacts will best fulfil its purpose. One might argue that the institutional requirement to meet our general principle would be to assign the task to some benevolent dictator who would have at her disposal full knowledge of individual preferences for heritage services and would then set in motion the required policies to meet individuals' wishes. We do not live in a world where one believes it possible for any public authority to obtain accurate knowledge of preferences without having a system which induces the public to reveal them in exchange for power to approve the methods for fulfilling them. Representative government, in some form or other, must be built into the system of public choice. As our previous analysis should make clear, decisions concerning investment in heritage artefacts and their efficient display crucially depend on how to induce the 'agent', the government, to act in the interests of the 'principal', the public supplying the funding.

The issue can be addressed in many ways and in the previous chapters different means have been indicated to improve the functioning of the political decision-making process and to enhance the participation of the public. In what follows attention will be concentrated on public spending appraisal, with respect both to investment projects and the production of cultural goods and services. In line with

the stance of the book, technicalities will be minimized (shifting the burden on to the authors listed in the Further reading section) but the meaning of appraisal in the different cases and the controversial issues, arising when applied to the heritage projects, will be examined.

Cost–benefit analysis: general issues

The rationale underlying the economic appraisal of public investments is that public intervention is justified only if social welfare increases. Policy makers have to choose the economic allocation of public funds which maximizes social welfare, depending on individual preferences. This should enable us to determine which of several competing projects to identify as the most efficient proposal, both at the macro level, when funds have to be allocated to the various fields (for instance, culture, health, education, etc.) as well as within each field (for instance, assessing which historical building or archaeological site should be chosen for investment).

Various evaluation methods have been proposed, a distinction being made between alternative types of measurement. Some methods are based on monetary measurement while others—such as multiple criteria methods—use different measures. These latter methods may seem attractive because no single measurement unit needs be used but if seeking measures for 'cultural values', not surprisingly, difficulties are encountered. The trade-off among the different criteria, which is needed to reach a conclusion, is usually based on the decision maker's subjective evaluation rather than on individuals' preferences with the inevitable risk of arbitrary weighting. In what follows, therefore, attention will be concentrated on the analysis of the valuation-based methods commonly used in economic analysis and known as Cost–Benefit Analysis (CBA). CBA is one of the most favoured techniques both for the appraisal of public projects and programmes and, more recently, for policy evaluation, as exemplified by so-called Regulatory Impact Assessment (RIA) (for details, see Further reading below).

CBA provides the theoretical framework for assessing the opportunity cost of the resources used: it is a widely used tool of applied welfare economics (see Chapter 1), designed to evaluate the economic effects of public decisions, in terms of the costs and benefits to members of society in order that the net economic benefit can be maximized.

In CBA operational manuals it is stressed that to evaluate a project two different possible situations, one *with* and one *without* the proposed project, should be compared. It is acknowledged that the situations *without* the project might be very different from one another. In theory, one situation might be the decay of the heritage and its disappearance if conservation is not implemented, in such a case the economic justification of the project rests on a comparison between the benefits, that is the total economic value of the heritage as determined by the sum of the use and non-use values that would be lost without the intervention of conservation, and the costs of the intervention itself. Apart from this extreme case, which is not likely to occur for buildings or sites which have been already recognized as heritage and, therefore, are protected, other situations might be the need for specific restoration or maintenance or, in case where the heritage is in good shape, the lack of proper facilities for visitors. The situation *with* the project should take into account all the activities of the project, and its effects depend heavily on how the project is designed, since it determines who is going to benefit from the project.

Given a certain amount of financial resources that are to be allocated to different projects, CBA allows an assessment to be made of the admissibility of a project, that is whether it is worth it in itself and, then, to rank the preferability of alternative courses of action that is assign a priority to different projects.

The most straightforward way to approach this issue is to start with the formula of Net Present Value (NPV) which, alongside the Internal Rate of Return (IRR), is the one most widely used to assess the admissibility as well as the preferability of a project. No one method of calculation is preferable to the other. Both lead to the same conclusion if the aim is to evaluate the admissibility of each project, but they might lead to different results when ranking is involved and the budget is not fixed, the result depending, among the other things, on the size of the project. Here, we will simply comment upon the NPV formula, disentangling its various elements to see what are the main issues underlying the implementation of CBA in the heritage sector.

The NPV of a project is obtained discounting the difference between the flows of the expected benefits and costs generated by the project over its life-period:

$$NPV = (B_0 - C_0) + \frac{(B_1 - C_1)}{1 + s} + \frac{(B_2 - C_2)}{(1 + s)^2} + \cdots + \frac{(B_n - C_n)}{(1 + s)^n}$$

In order to obtain the NPV of a project, its benefits (B) and its costs (C) have to be identified and measured and, at the same time, the interest rate(s) to be applied to the discount operation must be chosen.

A project is admissible, that is deserves to be taken into account, only if its NPV > 0 while the project with the highest NPV will be chosen, the intuitive meaning being that public resources have to be allocated where they offer the best contribution to the economy. In other words, the necessary condition for a project to be financed is that benefits must be at least greater than costs and, when a choice has to be made, the project offering the largest contribution has to be preferred.

CBA is an approach which is widely adopted in many fields (transport, health, environment, etc.) and, therefore, the analysis needs to be designed to fit the features of the specific field of application. This is also the case in cultural heritage, because of its peculiar features, a critical area being the extensive use of money value. Among various criticisms, it is worth mentioning here the claim that heritage has an 'intrinsic' value which is independent of individual evaluation. Without entering such a complex issue nor pretending to assess whether such a value exists, what matters here is to stress that such a concept cannot be used in the appraisal process if it cannot be measured, the only function being to provide an undemonstrated claim for increasing resources. Therefore, although it has some limitations, CBA seems to be a workable approach to provide a test of the 'economic profitability' of a project, the NPV of a project being the monetary value of the well-being that individuals obtain from the intervention.

CBA: identification and measurement of benefits and costs

An initial issue is the identification of the relevant benefits and costs. The importance of project evaluation is widely agreed both in the public and the private sectors, but relevant differences arise between the two cases. In fact, unlike the private decisions, which are subject to a *financial* appraisal, the public decisions are subject to an *economic* appraisal. In other words, CBA takes into account not only private (internal)

benefits and costs of projects which concern the promoter, but also social benefits and costs (external effects), the latter being relevant in the case of heritage (see Chapter 2). More precisely, the benefits of heritage conservation are several and depend on the specific heritage which is the object of the project as well as on the characteristics of intervention, conservation having various dimensions: maintenance, full restoration, renovation to improve visitor facilities, etc. Moreover, the benefits produced by heritage projects may differ as far as their spatial dimension is concerned, depending on the 'quality' of heritage (see Chapter 6) and may have an international dimension (which is usually not taken into account when a national stance is adopted) as well as only a local one, when 'minor' heritage is involved. Following the terminology adopted earlier (see Chapter 7), to define the benefits of heritage conservation we can draw a distinction between use and non-use values. The use values can be directly derived from sales of cultural services such as proceeds from shops and performances, including tourist expenditure. Use values can also be indirectly derived from some estimate of the aesthetic pleasure derived from heritage artefacts as reflected, for instance, in improvements in the quality of life and in increases in the value of property near the heritage location. The non-use values refer to benefits that arise independently from the use of heritage, the most widely accepted being existence values and bequest values (see Chapter 7). The value attributed by people to the existence of heritage is strongly influenced by their level of education as well as by their income. Trade-offs may arise between different types of benefits; for instance, an intervention aimed at enhancing the recreational use of a site might negatively affect its aesthetic value.

The economic justification of a specific project rests on a comparison between benefits and costs. As outlined above, it is not only the financial costs of the project activities but also the external costs that need to be taken into account. In heritage projects, relevant costs might be opportunity costs, referring to activities which are modified or even reduced because of the project. Moreover, some economic benefits derived as a result of the project, for instance because of increased flows, might have negative effects and/or costs for residents and for the physical state of heritage.

Once benefits and costs have been identified, the measurement of the project's effects is a crucial issue. In line with the rationale underlying CBA, market prices represent the true measure of social opportunity costs and have to be used, whenever possible, to measure these effects.

For instance, if a historical building is restored and opened to the public, the benefits for the visitors can be measured by the fees which will be paid for access, or are paid for similar heritage. However, life is more complicated than that and in many circumstances economists have to look for alternative solutions. This is the case when severe market distortions exist (e.g. monopoly) or when other factors, like taxation, distort prices from marginal social cost so that prices can no longer be considered as indicators of resource scarcity and the so-called *shadow prices*, that is theoretical prices that would exist in the absence of market imperfections, have to be invented. Moreover, market prices are only able to reflect use values but not non-use values, which, being not marketable, do not have a market price and this is where methods such as Contingent Valuation (CV), are usually employed to provide a monetary measure for these non-market benefits. Non-market benefits are particularly common and relevant in the heritage field. In other words, CV estimates are crucial inputs for CBA analysis and, therefore, all the caveats already exposed in Chapter 7 apply.

CBA: the choice of the rate of discount

Once a money value has been assigned to benefits and costs, to obtain NPV a rate of discount has to be used. In fact, in any project appraisal time is a further dimension to be taken into account, given that the project life period will span over several years and, therefore, costs and benefits refer to different time periods. Since rational individuals do not consider monetary values of equal amounts that accrue in different time periods to be equivalent, a discounting operation is called for in order to determine the present value of the future flows of benefits and costs. The market evaluation for the inter-temporal reference is represented by the interest rate, that is the price of money, but in CBA this is a case where the use of such a market price is highly controversial. Apart from the existence of imperfections in the functioning of the financial market and by the distortions deriving through regulation and taxation, it is claimed that market interest rates are inadequate for evaluating public investments and many reasons for this are put forward. Here, it is worth mentioning the argument based on the existence of externalities, such a position being often synthesized of the well known statement by Pigou that market rates reflect an 'insufficient telescopic capacity' and, therefore,

underestimate future generations' needs. The bequest value concept mentioned above offers some further support to this argument in the heritage field. Moreover, another argument is based on the differences in the risk involved in private and public projects, since, in the latter case, risk is shared among all the individuals in a society and, therefore, a lower interest rate can be applied. One approach to overcome the inadequacy of the market interest rate might be to devise a 'shadow price' for the resources according with purely economic criteria, notwithstanding the difficulties involved. This theoretical approach, however, is not strictly applied and the operational solution to such an issue which is adopted in most countries—the UK and Italy offering evidence in this direction—is to use a 'social discount rate' chosen at the political level and somehow linked with social time preferences. This is a form of delegation which might not necessarily fit with the welfare economics rationale of CBA.

CBA: normative limits and positive implications

Our analysis so far has shown that CBA calculations cannot be a purely technical matter (some of our references in the Further reading section explore this question and its implications for the use of CBA in policy situations in some detail, but we shall stick to examples rather than lead the reader through the labyrinth of profession discussion!). Some specific issues concerning CBA will now be examined, the most relevant being the distributional issue. Indeed, being an efficiency-oriented method, it does not pay attention to distributional problems and, therefore, to the efficiency–equity trade-off implied by public decisions, although a public project aimed at correcting market failure is likely in practice to have to take into account equity issues. Adjustments are desirable, for instance, in cases where a choice has to be made between competing heritage projects, and if the situation is in an area designated for urban regeneration, there will be issues of different socio-economic demographics that might influence the decision making. It can hardly be denied that the impact of a project on an individual's well-being varies according to the individual's income. One common assumption found in welfare economics analysis that can be tested empirically and which is widely accepted is that, after a certain point, an incremental rise in an individual's income affords a diminishing increment in personal welfare and diminishes

at an incremental rate. However individuals' well-being, as measured by income level, must also be affected by how any project is financed. The incidence of the cost on income distribution will frequently be a complicated matter of examining the income groups affected as compared to the distribution of any benefits from the project that it is claimed that they enjoy. Any adjustment in the CBA calculus to take account of distributional factors is bound to be no more than an approximation and therefore controversial both technically and politically.

The implementation of CBA raises some other issues. A crucial role is played by the analyst. The view that CBA allows for a separation of technical and political evaluation is rather optimistic, since it assumes that the results of the method are unique and that the analysts are free to do their best in applying neutral evaluation criteria. Indeed, the result is affected by the institutional structure of the decision making process as well as by the features of the analyst's appointment, such as whether informal exchanges occur with the other actors of the process. What is also relevant is public awareness of the work done by the analyst, since it may oblige the decision maker to take a decision which is different from the one advised by the analysis. For instance, reaction by those who perceive that their real income may decline when account is taken of the costs and benefits of any project, as they affect them, may induce adverse political feedback. The decision maker may fear a decline in political support as a reason for rejecting the advice of the specialists who have prepared the CBA report.

The implementation of CBA might face other political constraints: for instance, when the financial year is about to finish, each department tries to spend as much as possible, to avoid the risk that its funds might be cut in the next year on the grounds that there are available residual funds, and this might lead a department to finance projects which would not pass the CBA tests under other circumstances.

Further problems arise when there are sites that are considered so valuable that they must be conserved, regardless of the cost. In such a case CBA is not an appropriate approach and a Cost-Effectiveness Analysis (CEA) is more suitable, since the problem now becomes how to achieve the conservation objective at the lowest cost. CEA is an approach which compares the costs of alternative ways of producing the same or similar outputs to prevent resources being wasted, but it cannot say which decision should be adopted, for instance, how much conservation should be financed. However, if conservation requires one to choose among different courses of action, CBA is still required.

Even allowing for the theoretical shortcomings of such an approach, when the features of the decision-making process are taken into account, CBA may still be considered worth using but with a different perspective: rather than being considered an ambitious tool for optimal social choices, it can be taken into account as a useful informative system for public opinion. The existence of 'political constraints', indeed, provides further arguments to support the use of CBA because it makes clear the value judgement underlying the political decision making process. At the same time, increased information helps to reveal self-interested bureaucratic behaviour.

Performance appraisal: general issues

Some form of appraisal is needed as far as the production of cultural goods and services is concerned. In fact, as has been shown earlier (see Chapters 4 and 5) production can be financed to a considerable extent by public contributions representing some measure of the 'worth' of cultural activities to the community at large. In consequence, policy relies on production carried out by organizations which are non-profit making, work only partially under a market environment in the commercial sense, and are not exposed to the continuing evaluation of their activities through the expression of choices made via a competitive system. Whatever the perceived advantages of these financial arrangements, heritage provision being a noteworthy and important example, the cultural producers conduct their negotiations with government within a principal–agent framework, giving rise to the problems, exemplified in previous chapters, of asymmetric information and moral hazard.

Until very recently, these organizations were only subject to the evaluation of other heritage professionals, as it was considered that only peer review was appropriate for their activities. More recently, however, the scarcity of public funds coupled with a changing social attitude towards the 'value for money' principle have led to a greater awareness of the need for their accountability (see Chapters 4, 5, and 8). The use of some form of measurement of the activities carried out by cultural organizations is increasingly advocated, although not always adequately practised.

Performance indicators can be considered a sort of 'virtual' measure of cultural activities, but we must be aware of the fact that measure-

ment is not straightforward. Many issues are involved. It is important to define the object of measurement, its final aim, which methodology should be used and how to interpret the indicators. A closely related issue is the design of consistent information flows to identify the data needed for the implementation of those measures and the related costs. The kind of problems involved in the design and the implementation of performance indicators are well expressed by Schuster: 'in the arts and culture the tensions that arise in implementing such indicators have been rooted less in the *theory* than in the *practice* of performance indicators... opposition has come not from disagreement in theory but from actual issues arising out of practice.'

Performance appraisal: the object of measurement

A first question to consider is what is 'performance'. Various shades of meaning are involved, ranging from a mere quantitative description of the size of activity—the output—to more elaborate concepts such as efficiency or effectiveness. Even if the different components of performance can somehow be related, it is hard to believe that one single number can properly describe all these aspects and, therefore, it is necessary to single out the different uses of separate indicators.

In previous chapters (Chapters 5 and 6) the various aspects of the activities related to museums and to built heritage have been outlined. Although the concept of output is apparently straightforward, problems arise when we want to measure it. In fact, museum output cannot be adequately represented by just one indicator, as many different dimensions are involved and a single measure would be misleading. The problem is made more difficult when comparing different institutions as the different dimensions would not have the same composition and, therefore, any indicator measuring only one of them might be misleading. Economists view cultural institutions as multi-product firms which transform inputs into a mix of outputs to meet certain objectives, using technology. Therefore, when we come to measure them, such variety has to be reflected in the indicators. The literature has mainly paid attention to museums. Different types of outputs (for instance, visits, acquisition, conservation, research, temporary exhibitions, ancillary services) have been outlined and a long list of possible physical as well as monetary indicators of output devised to express each aspect of such a complex

activity (e.g. number of visitors, number of days open per year, number of publications, number of restored objects, etc.). In addition, it is also evident that each indicator, in turn, could be refined, taking into account a quality dimension; for instance, a distinction could be drawn among different kinds of visits depending on whether they are supported by a specialized guide, by educational support for children, etc. The sophistication of output indicators can be pursued almost endlessly, the only constraints being the availability of data (see below) and the costs of such an activity.

Less attention has been paid in the literature to the definition of the output of the activities related to built heritage conservation and, as a consequence, to their measurement. One of the authors has tried to explore such an elusive subject, suggesting a distinction between the regulatory output, that is the administrative acts provided by the regulator (such as listing, demolition orders, authorizations) and the direct conservation activity (such as archaeological excavations, restoration) put into practice with a direct expenditure. The construction of indicators has to take into account the variegated nature of the output. On the one hand, the number of administrative acts can be considered a suitable measure of regulatory activity but, since these acts are not homogeneous, one needs to account for the different levels of difficulty and the effort faced in their production and implementation. On the other hand, the number of restored buildings could be considered a suitable measure, but because of the differences existing between them (dimension, relevance of the restoration, technical difficulties involved, etc.) a weighting has to be introduced. A good example can be found in capital expenditure related to restoration or archaeological excavations where there is no guarantee that resources are used efficiently and greater expenditure is not necessarily representative of a larger or more difficult restoration. Being capital expenditure, however, some form of *ex ante* evaluation of the investment may have been carried out, perhaps using the above mentioned CBA.

When many different activities are undertaken by the same producer (as in the above examples), each indicator merely represents a single dimension, or a part of it, of the overall output and, therefore, a single measure to represent the overall activity cannot be used unless weights are assigned to each part of it, with the related technical as well as institutional difficulties.

Even if the above issues concerning the identification and measurement of output are solved, the measurement of output by itself still does not tell us very much. In fact, the indicators acquire relevance only if they illustrate the relation between the volume of activity and the resources employed, that is the productivity of the cultural organization. The ratio of quantity of output to the quantity of input employed to produce that output is only a partial indicator of productivity which is easy to construct but which does not help in evaluating the overall efficiency of the production process. Indeed, the high productivity of one single input factor may depend on the production level of the *other* inputs available and, therefore, may depend on their relative weighting. At the same time, it is also widely agreed that it is not advisable merely to compare different production processes using partial productivity indicators because the comparison is affected by the quality of the output. For instance, the cost per visit to two different museums tells us nothing if the quality of the visit offered is different, as expressed by the length of time, the additional services available, and so on.

The most common indicators, such as those outlined above, usually offer information on one single aspect of heritage services production activities, represented by numbers or ratios. However, because of the multidimensional features of heritage activities, several numerical indicators would be needed to evaluate the overall efficiency, that is to say that for any given level of output and of input prices, resources are used in such a way as to minimize costs. To grasp such complexity, the method of efficiency frontiers has been 'imported' by scholars from other fields of analysis and applied mainly in the museum sector, although there have been recent attempts to use it also for built heritage. There are different techniques for estimating the frontiers, the common objective being the identification of the production processes that can be considered efficient—taking into account all the relevant inputs and outputs of the production process—and, then, the measurement of the distance of each observation from the frontier. The frontier, therefore, is the set of the efficient organizations. Indeed, these theoretical developments, taking into account simultaneously multiple outputs and inputs, address the problems related to the above mentioned partial productivity indicators with sophisticated techniques to overcome their limitations. The construction of the frontiers, however, is rather deterministic and is a tricky exercise, since it may crucially depend on the set of the available

observations; for instance, the presence of outliers might drastically affect the frontier and, therefore, offer a 'biased' reference. At the same time, all the difficulties related to the measurement of output in a comparative perspective acquire crucial importance for the construction of the frontier, especially when the quality of output varies greatly across the different organizations and is not adequately captured by the indicators of output adopted. No closer analysis of efficiency frontiers will be offered here; as far as we know their use has been confined to specialized journals and, being interested in the implementation issues of performance indicators, we leave any further analysis of this subject to the suggested further reading at the end of the chapter.

A rather different range of issues arises if one wants to measure the outcome, rather than the output. The outcome is represented by the goals of cultural organizations or, at a higher level, of cultural policies and this measurement is aimed at evaluating the effectiveness of the production process—its capability for meeting the objectives. For instance, a museum might receive a subsidy to pursue educational objectives for school children; the output, therefore, will be the number of visits or any other output measure described above while the outcome may be that children and young people learn through the consumption of culture. Outcome is clearly a more elusive concept than output, for its qualitative dimension is particularly relevant since it is not simply related to quantity of output but also to some subjective measure. While data collection to measure output is fairly standardized (costs, visits, restoration), the source of data for outcome indicators has to be geared to subjective criteria.

Similar issues appear at a macro level, for example referring to the various effects or impacts of cultural policies—participation, social cohesion, social capital, social exclusion or inclusion, community development, quality of life, and well-being. When trying to design performance indicators in terms of effectiveness, however, a major problem is that cultural policy objectives tend to be expressed in broad, abstract, or even vague terms, although a clear definition of the objectives is crucial to an understanding of the real impact of any policy. It could be the case that such a blurring of objectives is a necessary requirement in policy statements because of the difficulties of measuring performance, but this would be a confession of failure. Whatever the reason, indeterminacy of cultural policy objectives

clearly undermine the development of clear policy outcome indicators (see Chapter 3).

Performance appraisal: the uses of measurement

As it has been pointed out in the literature, performance indicators can be used for different purposes and, in order to provide a consistent system, the various functions of measurement need to be stated clearly. Different classifications have been used by different scholars to identify the various uses of performance indicators. No attempt is made here to enter the terminological minefield, since our main concern is to try to focus attention upon implementation.

In line with the principal–agent framework recalled above, performance indicators can be used to influence the behaviour of organizations, notably when government wants to use these indicators as a planning tool in providing funds for cultural organizations. When examining such a subject, it is advisable to try to figure out the relationships existing between the funding authority and the cultural organizations in realistic terms and avoid suggesting a 'deterministic' approach. The fact that indicators can influence organizations' behaviour—according to the incentives deriving from the prediction concerning their utilization—is a well known problem, widely recognized in the literature, as well as the awareness that such an influence can exert undesirable or unintended effects. A typical example is offered by matching grant programmes, indirectly offering room to institutions to be involved in strategies of optimizing the time profile of sponsorships with the final aim of maximizing grants from government. Similarly, public organizations 'playing' with deficit figures is a common tactic to maximize public funding. Therefore, caution is needed in the use of indicators to affect organizations' performance, since even the simplest one might have undesirable effects.

Indicators can also be used to evaluate managerial behaviour and, from this perspective, suitable indicators are those measuring the use of the different resources to produce the different outputs. In principle, such an evaluation can best be carried out not as if the organization was the only one performing a given type of activity, but from a comparative perspective, that is taking into account the performance of other institutions operating in similar circumstances

and at the same time. Comparison enhances the information content of indicators, offers some form of benchmarking which can improve the interpretation of the values of the different indicators. However, the requirement of 'similar circumstances', which underlies the soundness of the comparison, is not easy to fulfil, additional information being necessary on the factors that can influence differences in performance. Institutional factors as well as the features of the social and economic context in which cultural organizations operate may have a relevant role in affecting performance, other things being equal; for example, the organizations to be compared should enjoy the same degree of autonomy and independence so that the same inputs fall under the control of organizations' managers or, to put it in other words, that organizations are fairly homogenous from the institutional point of view. This is crucial in international comparisons—for instance, the performance of museums operating in a bureaucratic system such as the Italian one, where directors cannot control strategic input like staffing requirements, cannot reasonably be compared with the performance of museums in Anglo-Saxon countries. In addition similar difficulties arise within each country, when comparison is made between public and private organizations. At the same time, operating in a stimulating and creative environment may offer positive externalities which can promote differences in performance between countries.

Performance indicators can also be used to monitor the behaviour of organizations, for instance, to ascertain whether the *ex ante* plans, for which funding was requested, are indeed reflected in the *ex post* activities or, in other words, how well do its activities match what the organization claims to be its intention. The fact that sometimes the form used to draw up plans might not allow for such a comparison puts pressure on organizations to clarify objectives, activities, and outcomes. Performance indicators can also have an internal use, since the data collected might be utilized as a tool for management education provided there are incentives in place.

Finally in a very general way, the descriptive and measurement attributes of indicators should not be undervalued so that they can play a role in affecting the policy development cycle. The perception of culture and cultural policy is likely to change when data reveal new perspectives and challenges.

From theory to practice in performance appraisal

Any discussion on performance indicators is based on the assumption that information is available and of good quality. Information is so crucial that performance indicators have been defined as a 'convenient phrase used to represent the information that one would want in an information-rich decision-making environment. That information might take the form of highly refined aggregate performance indicators, or it might take the form of less manipulated but still highly relevant qualitative and quantitative data. The key here is keeping our eye on what information one needs to make choices well' (Schuster, 2001).

Once the actual characteristics of the relevant production process are identified, systematic flows of information are needed on the different segments of activity, that is on the different outputs and the different inputs. Correspondence is needed between the financial items, notably costs, and outputs and inputs, so that a coherent information set is available for the different purposes of measurement. One might want to collect time series data as well as cross-sectional data so that the behaviour of the same organizations can be evaluated through time and compared with similar organizations at a given point in time. Moreover, qualitative data representing the demand, such as those deriving from surveys 'are useful' especially for the construction of outcome indicators. But moving from theory (what is needed) to practice (what is available), one has to face the possibility that data are not available or, if they exist, they are not necessarily accurate, reliable, and of good quality. Additionally, in the design of performance indicators, the costs of producing data and processing them to construct the chosen measures should not be undervalued, in other words the opportunity cost of the indicators has to be taken into account.

The need for better cultural data is a familiar complaint of those involved in the analysis of cultural policies at the micro as well as the micro level although it is also argued that, sometimes, the problem is less in the lack of data and more in the inadequate use of the existing data. From this perspective, many different situations occur in reality. Sometimes, as happens in Italy, it is true that, for public cultural organizations at central level, data are not easily obtainable apart from very basic measures of output. This is itself an indication of the very scarce

degree of accountability of cultural organizations within the system and it is not, of course, an independent variable or something that happens by chance, being, on the contrary, one of the consequences of the bureaucratic approach developed in that country (see Chapter 8). It follows that indicators of performance do not play any significant role for Italian state funded museums and even less for Heritage Authorities, although this seems to be changing at regional level.

Even when data are available, one should not forget that these data are provided by the agents who might try to 'cook the books' so that their bargaining with the principal, the funding authority, can be more successful from their point of view (see Chapter 4). If the above mentioned benefits of comparative evaluation have to be captured, a further issue is that the production of information from cultural organizations needs coordination, if not partnership, for the implementation of a workable performance-monitoring system. The content of this book, however, suggests that such an aptitude is not likely to be spontaneously generated by the organizations within the system, unless the institutional framework provides adequate incentives.

From this perspective, the British experience provides an interesting benchmark. In the 1990s a marked tendency toward evidence-based policy developed. Publicly funded organizations have been obliged to deliver government objectives through sets of agreed targets and a number of mechanisms, intended to monitor the effectiveness of cultural funding, have also been introduced. An interesting example of such a concern is offered by the discussion on 'evidence' on the website of the Council for Museums, Archives and Libraries (MLA), where a wide range of 'initiatives to increase knowledge of the sector and provide solid evidence on which to base policies and action' is reported, ranging from the evaluation of the outcomes and impact of learning at the museums to surveys on visitors to museums.

Shifting attention to the other issue, whether data are used properly or not is a 'hot' issue in many fields, especially those in which mainly peer evaluation is still practised and, therefore, any attempt at economic evaluation is regarded with suspicion. There is a widespread concern among professionals that indicators may not necessarily be helpful in making decisions or even that they may lead to biased decisions. Numbers need to be interpreted and, therefore, the decision maker must resist the temptation to promote consensus or create transparency by paying attention only to a single indicator which measures a

The following text is a translation of a document alleged to have been found recently in the Vatican archives by a British art historian.

NAME: Michelangelo Buonarroti

ASSIGNMENT: Protection and decorative coating of concave structural surface.

PERFORMANCE INDICATORS	COMMENTS
1. QUALITY	
a) Achievement of Targets	Result did not correspond to sketches issued by HIS HOLINESS THE POPE (hereinafter HHTP)
b) Peer Group Assessment	Report by Da Vinci rates performance 'mediocre'
c) Equal Opportunities	Failed to meet targets on representation of women, ethnic minorities and people with disabilities
2. EFFICIENCY	
a) Time Management	Project overran schedule
b) Total Cost Variance	Project exceeded budget
3. EFFECTIVENESS	
a) Management performance	Assistant complained of 'manic perfectionism' and failure to give credit to junior staff
b) Health and Safety	Ignored guidelines on 'working at heights' and 'comfortable working positions'
4. ACCOUNTABILITY	
a) Responsiveness to Feedback	Helpful suggestions offered by HHTP ignored. Depiction of God shows no facial resemblance to HHTP
b) Awareness of Competitors	MB showed little interest in comparison with work and genre producer in other sectors of the industry
c) Viewer Appreciation	Comments ranged from 'excessive nudity' to 'breasts not big enough'. Accident authorities point out that depiction of people flying were not accompanied by warnings against trying this at home
5. OVERALL ASSESSMENT	Very disappointing. Recommend termination of contract

specific weakness in performance and using it in a prescriptive way. When an appraisal of performance is based on comparisons, another temptation is likely to arise and that is to use indicators to rank institutions without regard to any special circumstances which makes for differences in the balance of objectives that they are designed to achieve.

Summing up, the limitations in the practice of performance indicators in the heritage field are somehow affected by its specific features: the lack of clearly identified objectives as well as of clarity in the identification of the nature of heritage activities (for instance, is conservation the relevant output for a museum?) the need for well defined priorities to a limited number of indicators and for better communication—and even coordination—between the researchers, organizations, and policy makers involved in developing indicators are just some of the open issues. In other words, performance indicators as such must be 'handled with care' and should not be considered a 'panacea' to solve the accountability problems of cultural organizations an amusing example of the necessary caveats is offered in the box.

Further reading

This chapter has tried to give the reader an insight into the general issues economists tackle when dealing with CBA and performance indicators, offering some insights on the implementation issues. In this field it is advisable to explore the subject with the help of both academic papers and official Reports since they can be considered the 'two sides of the same coin'.

Most of the suggestions offered in the Further reading section of Chapter 7 are relevant also for this chapter.

With specific reference to CBA, since the literature in the field is almost endless, rather than providing a long list of references we suggest a book, offering a critical overview of the role of CBA both from a normative as well as a positive point of view and rich in bibliographic suggestions: E. Giardina and A. Williams, *Efficiency in the Public Sector. The Theory and Practice of Cost–Benefit Analysis*.

The methodological issues of CBA applied to heritage and the similarities arising with the environmental field are clearly explored

in a working paper issued within the World Bank (by S. Pagiola, 'Economic Analysis of Investments in Cultural Heritage: Insights from Environmental Economics'.

In broad terms, the pros and cons of using economic valuation methods in the heritage field are explored in a Report issued by the Getty Conservation Institute entitled 'Economics and Heritage Conservation'. This Report stresses that these methods are unable to take into account historical, aesthetic, symbolic, and spiritual values of heritage.

As far as official Reports are concerned, a good recent example is given by the UK Treasury Green Book, *Appraisal and Evaluation in Central Government*, which indicates that where possible, efforts should be made to directly compare the costs of projects and polices with their benefits and that CBA is recommended in place of CEA. Supplementary techniques are advocated for weighing up costs and benefits which remain unvalued. In UK, as was mentioned in Chapter 8, the Department for Culture, Media and Sports has provided a report entitled 'Heritage Protection for the 21st Century Regulatory Impact Assessment' to prepare a new heritage protection legislation in the 2008–9 session to be implemented in 2010–11, offering an example of RIA implementation.

Turning to performance appraisal, no attempt is made here to revise the various contributions offered in the academic literature, starting from the 1980s, as well as in the several Reports provided by Arts Councils and Institutions. A good list of both is provided by J. M. Schuster in a 1997 article 'The Performance of Performance Indicators' and in a Working paper in 2001 entitled 'Policy and Planning with a Purpose or The Art of Making Choices in Arts Funding'. The quotations in the chapter come from there.

Those readers with a background in economics might be interested in exploring the theoretical as well as the empirical implications of the efficiency frontiers and of the different techniques which can be used. An application of Data Envelopment Analysis (DEA) to museums is offered by G. Pignataro in 'Measuring the efficiency of museums in Sicily'.

References

Department for Culture, Media and Sports. 2007. 'Heritage Protection for the 21st Century Regulatory Impact Assessment'.

Getty Conservation Institute. 1998. 'Economics and Heritage Conservation', Los Angeles (http://www.getty.edu/conservation/publications/pdf_publications/econrpt.pdf, accessed 24 June 2007).

Giardina, E. and A. Williams. 1993. *Efficiency in the Public Sector. The Theory and Practice of Cost–Benefit Analysis*, Aldershot: Edward Elgar.

Museums, Librarires and Archives Council (MLA). http://www.mla.gov.uk

Pagiola, S. 1996. 'Economic Analysis of Investments in Cultural Heritage: Insights from Environmental Economics', Environment Department, World Bank, June (http://siteresources.worldbank.org/INTEEI/214574-115331622 6850/20486327/EconomicAnalysisofInvestmentsinCulturalHeritageInsights-fromEnvironmentalEconomics1996.pdf, accessed 21 June 2007).

Pignataro, G. 2002. 'Measuring the Efficiency of Museums in Sicily', in I. Rizzo and R. Towse (eds), *The Economics of Heritage: A Study in the Political Economy of Culture in Sicily*, Cheltenham, UK and Northampton, MA, USA: Edward Elgar.

Schuster, J. M. 1997. 'The Performance of Performance Indicators', *Nonprofit Management and Leadership*, 7(3), pp. 253–69.

Schuster, J. M. 2001. 'Policy and Planning with a Purpose or The Art of Making Choices in Arts Funding', Working paper, The Cultural Policy Center, at the University of Chicago, September.

UK Treasury Green Book. 2003. *Appraisal and Evaluation in Central Government*, London: The Stationery Office.

10

A possible agenda for heritage policy

Introduction

The social history of the growing interest in and concern for preserving man-made heritage is periodically punctuated with striking statements with a Ruskinian flavour about the national and international responsibility for extending state support and therefore, inevitably, state control. Insofar as economic issues of the kind already discussed in previous chapters arise, this has not lead to professional support for apprising administrators of heritage institutions of their importance and the implicit denial of any right for economists to sit 'around the table' where these might be raised. In this chapter we use the evidence that we have provided to make a case for looking at the agenda of heritage policies through the economist's (beady?) eyes.

Nevertheless, the case for excluding economists from the round table discussion on major policy issues may seem to be fairly watertight. The professionals in the world of architecture, art history and aesthetics have specialized knowledge. What is more they are allied to members of their professions with years of experience in the use of the scientific and engineering knowledge required in choosing what forms of preservation and restoration are feasible, and experts in design who can join them in advising on how the new can blend with the old in planning the built environment. The better informed, with suitable experience in translating the aspirations of policy makers at national or regional level into heritage artefacts, will be aware that the careful costing of alternative schemes is essential. An indication that their heads are not in the clouds and accept that preservation and restoration work has budgetary implications may be a better way of pressing the case for extra funding than keeping

quiet about financial questions. Of course, professionals have had to come to accept, amply demonstrated in Chapters 7, 8, and 9, that economists will be listened to on broader questions such as the methodology of valuing the social and economic contribution of heritage and in devising and appraising performance indicators. At most, this may place them in the position of being called from time to time to the 'round table' but not to be directly concerned with the major policy issues themselves. Too often, it seems, the hoped-for end result of calling in economists is to buttress the case for emphasizing the 'positive externalities' afforded by heritage services, such as the material benefits from encouraging tourism, and which appear to support the case for more generous funding. Economists do not necessarily come up with results which offer such support and can refuse to act as 'hired guns'.

Of course, the expert designers and engineers in restoration and preservation work are the major source of judgement on what *can* be done within the budget afforded by the public authorities but not on what *ought* to be done, although their persuasive powers may tempt the public authorities both to accept the orders of priority that they specify and to succumb to the understandable temptation to revise the budget upwards. However, the very fact that heritage providers are so influential provides arguments for assigning the economist a greater role in the formulation of policy, if not a decisive one.

What, then, are these arguments? The first is that economists are trained nowadays and are engaged in several branches of government in the business of developing policy models without themselves specifying what the aims of policy should be. In broad terms such models review the costs and benefits of government programmes, publicly better known in more familiar areas such as attempts to mitigate the effects of possible global warming and, at a more down-to-earth level, in particular investment projects such as whether or not to subsidize energy conservation devices, for example solar panelling. This technique is readily *transferable* to other situations where comparisons have to be made between alternative ways of achieving given policy aims or where aims themselves are 'competitors' for the attention of policy makers. It also extends to being conversant with the type of statistical information necessary to transform such models into the *quantitative form* necessary for policies to be translated into projected costs of programmes made necessary in specifying and, if possible, measuring costs and benefits.

So much for the theory but what about the practice? The second argument is a by-product of the first. Devising and presenting a model requires a particular expertise, but the very experience of doing so makes the economist well aware of its difficulties and therefore policy makers and those with a vested interest in the results may find reasons for scepticism at its value. The field of arts and culture offers a wealth of illustration. In Chapter 3, we have given a brief account of the disparity between the information that a policy maker may seek to aid decision making and the information that is available. Making the necessary adjustment to improve the content of the relevant policy model runs into the familiar trouble that different sections or a state of regional cultural department may have conflicting statistical requirements and that the adaptation of them to the particular needs suggested by economic analysis involves either extra technical resources or the reallocation of statistical tasks which must deprive existing 'customers'.

Another practical consideration revealed by the economist's approach is that no policy model can be complete unless account is taken of the 'feedback' effects resulting from the reactions of those who have to conform to the measures that the policy prescribes. It is not that the administrators who are or will be responsible for carrying out policies will not be aware of such effects and learn to anticipate the difficulties that they create. It is that, as already explained in Chapters 4 and 5, economists have a specialist knowledge of how to categorize and analyse the strategic behaviour employed by those with an interest in getting the best bargain possible within the context of the policies which affect them. This leads to rather tense situations when policy makers are beset by strict budgetary limits and those 'round the table' making decisions include interested parties!

A third and vital practical difficulty in policy making, of which economists are only too well aware, is that considerable *uncertainty* may attach to attempts to measure the relation between changes in the magnitude of policy measures, such as grants to heritage institutions, and the expected changes that policy embodies. For example, grants to MGs to subsidize the costs of admission may be designed to increase attendances, and this relies on a calculation of the effect of a change in the price of admission (which may now be zero) on the expected change in the number of museum visits. Considerations other than price may determine the demand for visits and the circumstances governing their incidence may also be changing, such as the prices of alternative cultural pursuits. The 'all depends' judgement of economists will not have great

appeal for administrators who have to argue the case for particular estimates of expenditure to be embodied in a heritage budget. In any case, this form of uncertainty may be even more marked in the case of other and much more transparent forms of government expenditure, notably in the case of the costs of defence contracts, but estimates cannot wait until economists have overcome their hesitation. In the context of this book, where unusual emphasis is given to the influence of the aspirations of those supplying heritage services on the efficiency of their provision, the economist may be more inclined to argue that the influence of uncertainty on the outcome of bargaining process between suppliers and users of cultural funding requires more attention than the difficulty of supplying pinpoint expenditure estimates (various subterfuges can be used to cope with the difficulties encountered in dealing with uncertainty, notably the provision of a 'contingency fund' of some kind available to the funding body with clear rules about applications made from grantees for supplementary finance).

The case may now have been made for more attention to be paid to the economist's expertise acting as a counterweight to the professional interest groups who often have the dual role of helping to form policy and of implementing it as directors of major heritage providers. Nevertheless, it is not clear that either logic or operational experience make a sufficient case for adding the economist to 'round table membership'. However, as indicated in Chapter 2, the particular emphasis in economic thought on exploring the logic of choice and the rules that it offers for the economic organization of cultural services points towards important additions to the agenda of policy discussion. Coupled with that is the practical experience of the two present authors as consultants to both government departments concerned with cultural matters and those affected by their decisions. These are our reasons for concluding this volume with an exploration of possible changes in the aims and methods of providing access to heritage services. In particular we are interested in the closer linking of the choices of those who provide the resources to support heritage and those who use them according to their view of the future of the cultural past.

A reform agenda 1: The background

As already discussed in Chapter 2, we place great emphasis on developing the links between what the public perceives to be the benefits of heritage

provision and those who supply it and whose value judgements, coupled with their deep knowledge of history, architecture, and painting lead to the understandable conviction that they should ignore public opinion or perhaps, more circumspectly, should lead rather than follow it. This is because we adopt the principle that those who are willing to pay to support heritage, either through direct payment or through their taxes and donations, are entitled to be the main beneficiaries from its supply and whose tastes and preferences should influence what they hope to enjoy from its provision. But this is not a precondition for reform but its aim. We recognize that the quality of choices in matters concerning culture depends on the engendering of confidence in the choosers based on their growing contact with the providers of heritage services. This will take time in the course of which consumer tastes and preferences change, so that any 'market' bringing about the coincidence of the wants of providers and the beneficiaries of heritage services, like all markets, will involve constant adjustment between supply and demand. Although this aim is based on a value judgement of our own, there is surely a prospect that it can be widely accepted. It accords with the best traditions of those democracies which place a high value of having an educated electorate capable of making intelligent and responsible choices and with a belief in the preservation of the past as a cardinal element in any self-assessment of their achievements. It is consonant with the widespread acceptance amongst directors of cultural institutions that one of their prime obligations is to create and retain the interest of the public in what they have to offer. Their success may be judged by the extent to which their public develop a sustained interest in their activities and wish to have a part to play in the decision making process, other than through the remote method of the ballot box or the appointment of trustees or directors of cultural institutions by government on the recommendation of public officials. There may be understandable reluctance by such directors to accept this part of the evolutionary process, even though it is a measure of their own success in developing educational programmes which extend the public's critical appreciation of the value of heritage artefacts.

One must resist the temptation of extending this perception of the sovereignty of the consumer to describe the economy which would be most likely to achieve some optimal position. We think it more helpful to the reader to describe the path along which reform might travel rather than to produce a vision of some cultural utopia. In any case, if we did so, we would get into a methodological argument far beyond the

scope of this work but it is perhaps important for the reader to know that we are dodging an important issue in the economics of public policy. The starting point in this argument is that the satisfaction of consumers rests on freedom of choice over the whole range of goods and services available, including services provided by government, and that therefore it has to be proved by our argument that the general satisfaction of consumers will be greater by providing financial support for provision of heritage services than by using funding for other purposes, including the reduction of taxation. The problem does not end there because a logical consequence of achieving some 'first best' position would be to consider in detail whether or not the public sector is the best medium for producing goods and services at all, including those with an element of publicness in their make-up, rather than the private sector, albeit within some legal framework administered by the public authorities but based on the rule of law. On the grounds of the arguments developed in Chapter 2, we simply assume that the case has been made for public support for heritage provision and approved if only implicitly by the electorate, without considering whether the electoral system is able fully to reflect consumer preferences in accordance with the sovereignty requirement. We see our task as that of reviewing a possible improvement in how public support is achieved and moved closer towards a better fulfilment of consumer satisfaction.

There are two main institutional assumptions governing our ideas on reform. The first is that we assume that government policy decisions are made by a single political unit. Once again this is an action designed to avoid a digression requiring us to write a discourse on the form of government which would best allow the fullest expression of consumer choice through the political system. This rules out what constitutional economists who support federal government and devolution of power in decision making would consider to be an integral part of the design of governmental institutions sensitive to voter preferences. This still allows us to devise a role for regional and local governments in decisions concerning heritage provision.

The second assumption is that the standard methods of accounting control of government expenditure, already referred to in Chapter 4, are in place and do not require extensive modification to take care of the financing of heritage. Nevertheless, it is as well to be reminded of their content, and the inevitable problems of trying to strengthen the bonds of financial control which ensure that public money is 'well spent'. We refer to what public finance experts call 'the budget cycle'.

The cycle begins with the calculation of expenditure estimates by individual government departments which are built 'from the bottom up' from proposals submitted to their heads from their various divisions. In the case of heritage finance, as with other branches of government, the growth of public expenditure in major countries has been accompanied by growing attention to its components because of political pressure to prevent waste. For example, over the last decades public institutions providing heritage services, such as national galleries, have had to pay increasing attention to the preparation of estimates which are linked, where possible, to performance targets. In some countries, this has entailed not only one-year forward estimates to meet the requirement of legislative approval, but 'forward looks' for a longer period with a view to speculating on the impact of the budget on the economy and how it may have to be modified to take account of economic trends and how these might be influenced by the budget itself, in the light of possible policy alternatives. The change that this has introduced in 'cultural accounting' is quite remarkable. We were astonished to find that up until 1996, the British Museum produced neither an annual report nor a corporate plan (actually, it is not so surprising when one considers the prestige of its Trustees and their support for the proposition that the BM's activities were to be judged almost entirely in terms of its reputation with scholars). Even within the last decade, the corporate plans of the National Galleries of Scotland seemed more like a form of sophisticated propaganda designed to influence their paymaster than a fully worked out attempt to relate alternative plans for change (and, of course expansion!) to defendable projections of expenditure. As we have seen in Chapter 4, where the 'arms' length' principle is at work, detailed accounts and projections are now an integral part of the activities of heritage providers dependent on public financing while 'cultural accounting' is still in its infancy where a centralized system is at work.

The cycle continues coming to a climax, after internal debate reaching Cabinet level, when the annual budget report is produced in advance of discussion in the legislature, within which its specialist committees have the chance to consider its findings and call witnesses, usually from individual departments, to answer questions on the estimates. Additionally, when public reports are public knowledge, professional commentary on budgetary proposals will be rife particularly in the financial press, which will be matched by the

commentaries and criticisms of special interest groups. Looking, as at before, recent trends in concern for state support for culture and the arts, it is at this stage that one becomes particularly aware of the mustering of the forces of NGOs (Non-Governmental Organizations) to put forward proposals designed to further their particular causes. They are increasingly noticeable in debates on heritage matters, although perhaps not so prominent as in the natural heritage field. Some of them have reached the stage of becoming officially 'recognized' in consultations on policy questions, both at national and, increasingly, at international level (e.g. in advising UNESCO). Such groups are professional associations of artists, art dealers, museum and gallery directors, owners of historic properties and learned societies concerned with cultural matters and the media. They may have diverse interests, but usually with a common concern for the interests of suppliers of heritage services. They may from time to time, particularly when governments propose radical changes in cultural provision—usually involving more rigorous control of public expenditure— combine forces where their interests coincide knowing that politicians are particularly vulnerable to accusations of 'philistinism' (we have a particular reason for singling out NGOs for special mention which is considered in our later examination of the consumer role in the determination of the size and structure of heritage services).

We pass rapidly through the next stages of budget approval and embodiment of the financial proposals in legislation through the process of implementation of heritage policies, taking account of the government's relations with the private sector through the regulatory measures in place, and concentrate on the long tail at the end of the cycle when the *ex post* results of financial control become apparent. These may extend well beyond the commencement of the next cycle so that the policy outcomes in the first cycle are not available, at least in detail, for scrutiny and comparison with the *ex ante* estimates for the next cycle. It is here that the system of auditing of accounts becomes a crucial part of the process of financial control. In some countries, the auditing process is continuous, with the auditing authorities having the power to initiate investigation of the methods used to identify performance targets and the extent to which such targets are achieved. In general, all national auditing authorities will report to the government, more particularly to the Minister of Finance and to the legislature, as to whether the

expenditure incurred is in accordance with the powers granted by law taking account of how miscalculations of expenditure requirements are covered by approved supplementary estimates.

There is no doubt that an efficient auditing process is a binding condition for ensuring that those administering heritage policy act in a responsible manner. The process has come a long way from when it was simply an arm of accounting practice with audit authorities now equipped to carry out analytical and statistical studies of the kind already described in Chapters 5–9. This also extends to such matters as the principles governing the award of contracts, as, for example, the use of competitive tendering for restoration work. In the UK it has been known for social surveys to be conducted in order to acquire information on public attitudes to government services and for their results to be published. However, the auditing authorities cannot assume responsibility for the laying down of general principles governing financial control, for this would be to assume the role in government assigned to the Ministry of Finance which makes such control a political matter. A matter which is more apposite to our approach to policy questions is that the principle of consumer sovereignty entails a judgement on both the form and the content of public funding and on the division of responsibility for heritage provision between the public and private sector. It could therefore imply major changes in the political and administrative organization of the provision of cultural services, which goes well beyond the normal remit of the audit authorities who should, in principle at least, accept the aims as given.

It would be foolish to try to offer a detailed plan of the administrative system implied by our conception of the place of heritage in public policy.

Although conscious of the fact that a common weakness in putting forward schemes for reform is to clarify the aims without describing in detail the path to reach them, we are equally aware that, even if the aims are widely acceptable, the distance and the terrain governing the route of the path can be markedly different, even for countries at a broadly similar stage in their development. To be as precise as to meet the requirement of describing the institutional arrangements implied by our policy views in detail would be to leave nothing to challenge others better fitted to use our views as a test. Declaring that our policy scenario is politically and administratively impossible is a challenge not so much to us as to those enjoined by their political masters to

take it seriously. Whether it will be or ought to be taken seriously depends on reactions to what we now offer as an epilogue of this book.

Agenda for reform 2: Some principles of operation

Our agenda is set out in the form of a kind of Manifesto, less rhetorical but more detailed than the striking one by William Morris (see Bernard Feilden, Chapter 6) which inspired the Victorian movement to promote careful restoration and preservation of historic buildings. Our agenda is designed for discussion with the limited purpose of defining the importance of the role of economic analysis in the development of 'suitable' heritage policies.

Principle 1: Given that the built and moveable heritage have public goods characteristics, there is a clear case for government support to influence their supply.

Comment: In mature societies we expect that individuals are the best judges of how to satisfy their own needs but also derive satisfaction from promoting the welfare of others (cf. Chapter 2). It comes as no surprise if the public value the arts, including their heritage, and wish them to be provided by professional staff and have a common interest in making them widely available. Matching aspirations with action cannot normally be fully achieved by direct payment by customers and, although private philanthropy can help to fill the gap, it will understandably reflect the donors' perception of whose welfare is to be improved. Some form of public support, normally entailing public funding and based on consistent rules, will be required.

Principle 2: In common with policies for the arts in general, heritage policies must reflect the freedom of individual choice.

Comment: This principle is separately identified because it requires that, if individuals support public intervention in order to give expression to their choices, then there must be appropriate means by which they can influence the public authorities. As already explained, we do not pursue the question of whether mature economies have decision rules which take as full account as possible of what must be diverse views on public action to support the arts. For example, one might commend the use of referenda whereby any vote must represent a request emanating from a considerable proportion of the electorate in the individual unit of government, is preceded

by a formalized discussion of the issues and that it reflects and must be binding on the legislature, given the decision rule (in short a genuine referendum system is in place and not a plebiscite). The political choice mechanisms will differ from country to country and must be taken as given. That means that the degree to which ordinary citizens can express their preferences will vary although we can assume that in all cases the ballot box determines the election of representatives. The overriding requirement is that the public must be kept fully informed about the rationale of financial provisions and regulations made in their interest, and are represented not only in the legislature but also on the public institutions that advise and manage cultural activities. As knowledge of heritage policies and practice is extended, tastes may broaden and preferences expand, so care must be taken that public action does not control and circumscribe public criticism of policies. Such an aim may be fostered by ensuring that representatives of the arts-enjoying public and those whose creative skills determine what is on offer to the public must change fairly rapidly in order to provide the impetus for innovation and experiment.

Principle 3: Public policy decisions concerning heritage, along with cultural services in general, should be devolved to regional authorities, so far as possible.

Comment: There can be a marked diversity of artistic tastes and talents between regions within a country as well as between countries and in the interest of the public in particular kinds of cultural endeavours. Within regions, however, popular choices are likely to be more homogenous and the public more ready and able to influence political decisions. Additionally, regional differences in the emphasis on the balance of public support for the arts promote more choice, thereby encouraging healthy competition. Where regional governments are able to operate independent cultural policies, including the use of local financing, the role of the national government should be confined to specifying overall funding levels, possibly confined to setting minimum standards, and rules governing the efficiency of cultural services. It is likely, nevertheless, that the national government will be required to play a more active role in the promotion of services designed to preserve the national built heritage, as already outlined in Chapter 6.

Principle 4: Incentives and opportunities should be offered to the public to develop interest, understanding, and participation in arts events and their promotion.

Comment: It will be evident as our narrative proceeds that we have to think of fixed and moveable artefacts which symbolize heritage as one in a range of cultural services, given that individuals will differ in how they wish to develop their tastes. There will therefore be differing opportunities in the various art forms for applying this principle. This should not divert us from considering how various forms of subsidies are compatible with the aims of this Principle to increase demand and interest in participation in the operation of built heritage services. Direct subsidies which enable museums, galleries, and historic buildings to lower their prices is a common way to achieve this end but while improving access (at the cost of other ways in which government funding could be used), it does little directly to promote individuals' interest in extending the range of their tastes. Voucher schemes which allow the individual to decide which particular art forms he or she wishes to enjoy, could offer a better alternative for supporting community efforts to encourage the arts as found with local drama and musical societies and in schools, although this method appears to be not so easy to implement as a form of encouragement for an interest in heritage. Perhaps voucher systems as a condition for the award of tax relief to businesses might offer a satisfactory solution to the standard objection that existing concessions do not support those who would benefit from them the most. Businesses expect some return in the form of positive reactions to their generosity, and there seems to be no reason why they could not be designed to have this kind of appeal.

However, active participation by the public in the production of cultural services could have an important long-term effect on their development, so far as heritage is concerned. An example is found in the employment of volunteers acting as guides to historical buildings and MGs offering an important sources of 'feedback' for closer analysis of what forms of active participation are appropriate. Our argument takes us a step further towards devising suitable means for active participation. This will take us beyond the commendable support by MGs and authorities responsible for the preservation and restoration of historic buildings in the form of their educational programmes which can embrace amateur participation in such activities as archaeological 'digs'. In highly centralized mature democracies the public only have tenuous control over the allocation of expenditure on the arts in general, including heritage. Pressure group action through NGOs often results in an NGO being represented on advisory bodies

at least, a method commonly employed by UNESCO in arriving at its magisterial statements on World Heritage Sites, but NGOs are not representatives of the public and do not normally encourage active participation by the public in their own affairs. It is worth exploring whether the problem can be solved, at least partially, by the representation of consumers on the governing bodies of MGs and their heritage equivalents. Many of these bodies do canvass for public support through creating a category of 'Friends' who, in return for an annual subscription, receive various extra services, often of an educational nature, and may be a potential source of nominations to the governing bodies themselves. It can reasonably be argued that they are, or can easily become, specialized pressure groups, and one must recognize the problem of how to increase any claim that they could make to be true representatives of those who pay for heritage services through taxes rather than through a pricing system.

Principle 5: Policies designed to develop interest, understanding and participation in the arts should take full advantage of new technologies.

Comment: Public authorities in mature economies do not always welcome the extraordinary effect of new technologies as, for instance, in broadcasting and telecommunications generally. These have increasingly eroded the argument that there are technical limitations to the use of the radio spectrum which justify government restrictions on the issue of licences and favouring their award to official radio and TV channels. Technology has made it difficult for official control over the range of programmes available to the home and whose intrusive nature is claimed as justification for censorship, increasingly so as individual viewers now have the means to build their own programmes.

Certainly, public regulation of the availability and of the content of arts programmes should be minimized and this is important if the emphasis on arts policies is to increase understanding and appreciation of cultural services. The real issue which is of critical importance is whether or not 'canned' presentation of the arts—think of the many excellent programmes on the history of art and on archaeological discovery—are substitutes for or complements to 'live' ones. On this issue we are bound to have an open mind because the evidence is patchy and inconclusive. What we can say is that TV offers a first class opportunity for those in charge of heritage services to interest and excite potential audiences in the benefits that they offer them. This is

a necessary condition for attempts to expand individuals' interest in their past, but clearly not a sufficient condition for ensuring that it will have a permanent effect on the 'quality' of their choices.

Principle 6: Free international exchange of cultural goods and services should be encouraged and, where necessary, fostered by intergovernmental negotiation.

Comment: As we have stressed throughout this book, demand for heritage services has been inextricably bound up with international tourism, offering the opportunity, with rapid communication and the fall in the relative price of overseas travel, of becoming aware at closer quarters of differences in cultural traditions and appreciating them more fully. Rather bland statements about the promotion of international understanding through the medium of overseas travel may be regarded with growing cynicism. International sports such as football are punctuated with pitched battles between supporters of different nationalities which at least seem to offer a safety valve, releasing any demand for a renewal of military action between major powers, but they seem to foster international misunderstanding rather than harmony of interests. In contrast, there are striking instances where citizens of some countries have acquired such an understanding and appreciation of cultural heritage in others, to recognize that it is in their interests to support them through voluntary financial support, Venice being the supreme example. A more contentious example is to be found in the argument concerning the ownership of what may be regarded as national treasures in one country and which are now claimed as owned by persons or authorities in another, the Elgin Marbles in the British Museum being the obvious case. The interesting aspect of this development is that it reveals the extent to which nationalism governs public opinion on whether or not such treasures should be returned to their original place of creation, whatever the extent to which they were originally sold, stolen, or exchanged for other goods and services. There are many of those interested in heritage in the country of present location of such artefacts who would support the claims of those who wish them to be returned 'home', which probably represents a considerable change in public attitudes.

Of course, free international exchange means, strictly speaking, the actual transfer of artefacts and the process of exchange in this sense has proceeded apace in the form of sales through the international art and property markets and also the loan of pictures and other moveable artefacts as material for temporary, often large-scale, exhibitions

in MGs. This increase in access to overseas perceptions of what is worth preserving and restoring is fully in keeping with the objective of extending individuals' experience of the supply of heritage services and restrictions on the international passage of the personnel required to assist in their presentation and in the ancillary services, such as books, periodicals, DVD recordings and so on, should be minimized. Governments may have a particular interest in promoting national prestige and offer financial support for this purpose to MGs willing to cooperate. Cooperation may be more readily achieved by employing state institutions to undertake this task, but it is imperative that governments should not assume the role of being the only arbiters in deciding on the selection of those artefacts, buildings and historic sites which are to represent what is regarded as best in the heritage of the country under consideration.

Epilogue

It was many years ago that a very senior official in the British Treasury expressed his exasperation with (to him) an obstinate economic adviser that 'the trouble with economists is that they spread a fog around whenever they give advice'. This remark was addressed to a rather quick-witted economic adviser who had the temerity to reply 'that, Sir, is the natural result of the injection of cold air into hot!'

Our hope is that this form of confrontation—and it does continue in respect of sensitive areas of government policy such as culture— can become a thing of the past. That requires a sustained attempt to reach agreement between those who seek to maintain artistic standards and to preserve our cultural heritage and those who have to bear the costs of change in whatever form. We have demonstrated that the economists' skills have to extend beyond that of simply offering as firm a judgement as is possible on the proposals made to balance the costs and the benefits of proposals to develop and implement heritage policies. This view does not command professional consensus. Economists find it convenient to argue that it is not their business to arrange for those affected by their advice to study in detail why they are competent to do so. However, our own experience suggests that we do have a professional responsibility to try to clarify the role of the economist in the examination of cultural heritage. It is not that those who are the custodians of past treasures and of their revelation may still believe that

economic analysis will simply be ignored in their negotiations with any of their suppliers of finance. For instance, they could claim that the amount of public resources required to support and expand their efforts is still a relatively small item in the government expenditure accounts. That cannot be sufficient reason why standard methods of government expenditure control will not be applied to the support of cultural heritage; in any case this is to forget, that the policy context now has to take account of the potent and growing influence on the use and disposal of property and land made necessary to meet the professional standard of provision that specialists in heritage provision claim as necessary. Clearly, the ramifications of regulatory control for support of cultural heritage extend well beyond those immediately affected by the regulations themselves.

There are indicators of a change in attitude that allows us to introduce a note—sounded perhaps 'piano' rather than 'forte'—of optimism in our concluding observations. Intellectual progress in the development of economic analysis is regarded by economists themselves as associated to a large degree with an ever-intensive use of modelling devices derived from mathematics and physics and methods of testing that employ highly sophisticated statistical theory. The opportunity cost of concentrating academic study in economics on a system of 'gradum ad parnassum', which means that the pinnacle of understanding in even a first degree is an introduction to these higher reaches of economics learning, can be measured by the fall in demand for specialized economics degrees relative to other studies in the social sciences. This development is closely tied to the employment prospects for those trained in economics which in turn are tied to the perception of the role of the economist as perceived by business, including economic consultancy, and government, including international governmental institutions. Such prospective employers, if requiring economics input to their production schedules, rarely need pure specialists but lively-minded recruits who perceive very quickly how their knowledge of economics can be brought to bear on the range of possible decisions. An important basic component of such knowledge is knowing what relevant economics information is available, where it may be found and how to make it 'sing'. Making it 'sing' also means that the 'tune' is recognizable to those who have to base decisions on its use. Acquiring these skills can, of course, be obtained by further study but this increases the length of study and therefore the opportunity cost to the student of further years in academe. Not surprisingly, students may prefer to seek university

first degree courses with a firm economics content but which introduce them at a much earlier stage to the realities of modern living and the role that they may play within it. Such are degrees in environmental economics—which, incidentally, may pay some attention to the natural and built heritage—and social economics, including health and education problems. The continuation of economics as a major educational rather than research force in universities may depend on adapting to the realities of the student job market.

Our book stresses the importance of seeking a coalescence of interests between economics and the world of cultural heritage. That this requires a readjustment of economists' pedagogic and research activities goes without saying, but at least the study of culture is not without its appeal to professional economists and the pressures to teach non-economics students the fundamentals of our discipline are growing, as already indicated.

But the pressures are not simply one way. One need only consider what we have said about devising an Agenda for Heritage Policy to be at least informed on the extent to which the development of cultural heritage policy depends on attention to its economic dimension. In our own experience of teaching cultural economics in arts management courses, it soon becomes clear that once students who have initially trained as art historians, architects, and planners have overcome an understandable resistance to subjecting preservation and restoration work to some opportunity cost test, they soon become aware of how an acceptable line of defence of proposals for expanding the range and volume of historical artefacts might have to be mounted. Again, judging from the advertisements for top posts in MGs and heritage provision, the 'job specification' is gradually changing to emphasize the importance of managerial skills alongside professional reputation as scholars.

A straw in the wind can be observed in the fact that the present Director of the British Museum, obviously one of the 'top brass' in our area of discourse, began his career as a Scots lawyer before further training as an art historian lead him quickly up the ladder of promotion (as ATP knows from personal experience, he is a formidable debater on questions of cultural policy. His forensic skills are put to good use in steering his audience, treated like a jury in court, to decide in favour of his concept of the arts as the pinnacle of human achievement. A mere economist is not normally practised in such persuasive techniques and hardly stands a chance!). The nearest we know of

progress into positions of artistic prominence by economists are as appointments as Trustees of the National Gallery in London which have included Lionel Robbins and, also from the LSE, Basil Yamey, already referred to as the author of *Accounting and Art*. Economists are not necessarily noted for their managerial or forensic skills and, therefore, are better confined to advising on specific issues concerning heritage matters. It is still possible to look forward to the day when a trained economist, suitably qualified in the professional skills required in order to act as a custodian and manager of historical artefacts, might be appointed to run a major concern in the heritage sector and where it would be a positive advantage to be versed in the principles of the allegedly 'dismal science'.

Index